Christmas '91 Farron & Rick

Adirondack Park 。

THE HUDSON RIVER

o Glens Falls

Saratoga Springs 🜼

o Waterford

Albany O

o Hudson

o Catskill

₀ Annandale

₀ Hyde Park

Minnewaska State Park 。

Newburgh $_{\circ}$

o Storm King

Garrison $_{\circ}$

Harriman State Park $_{\circ}$

o Tarrytown

Palisades $_{\circ}$

Manhattan $_{\circ}$

Catskill Mountains o

。 Germantown

Catskill Park o

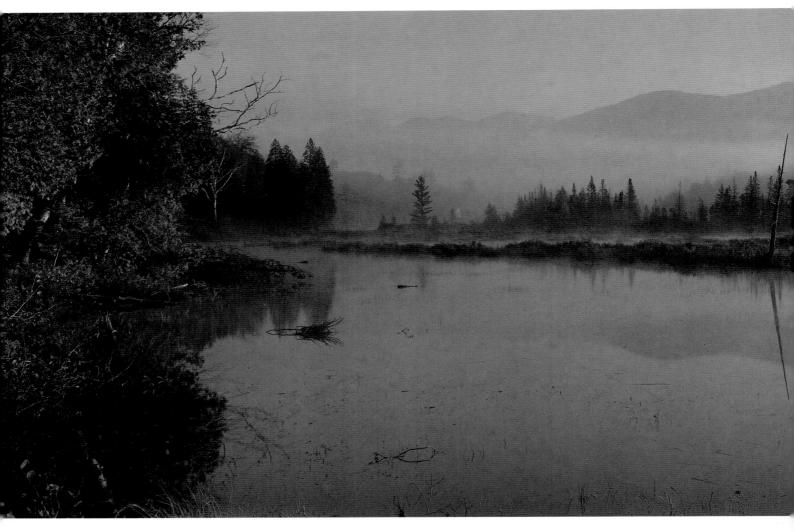

Sanford Lake.

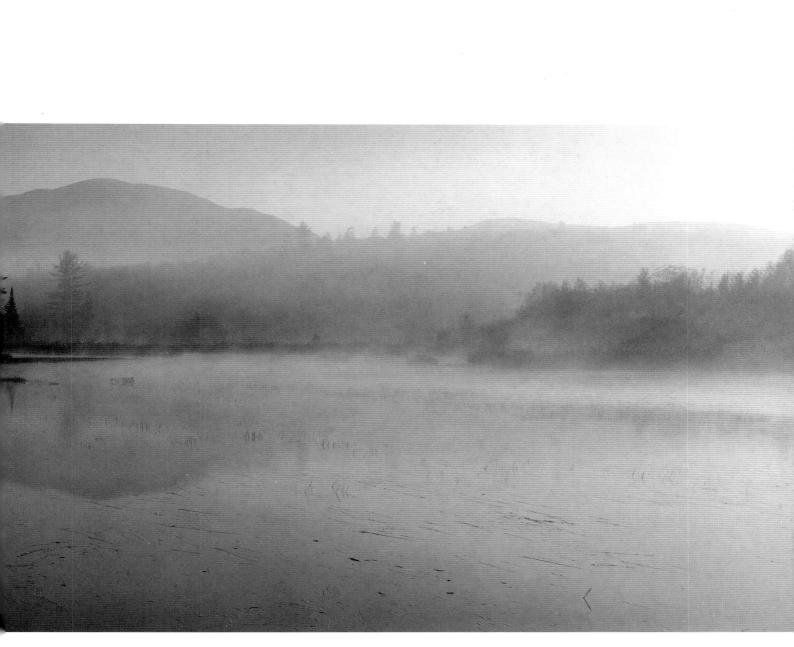

Adirondack Park.

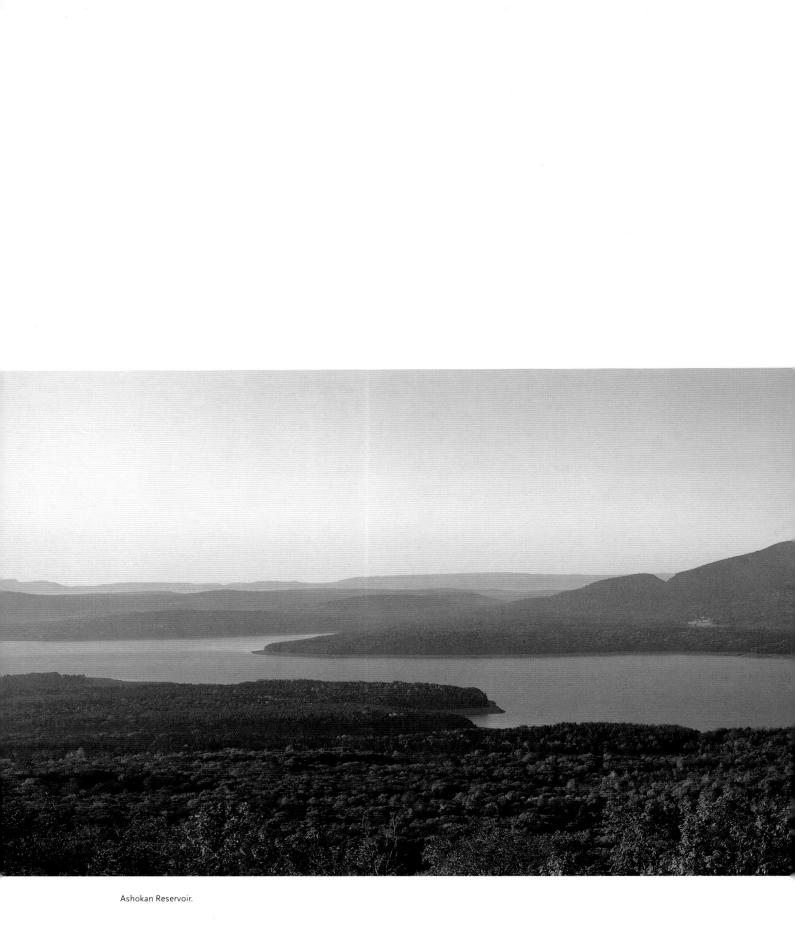

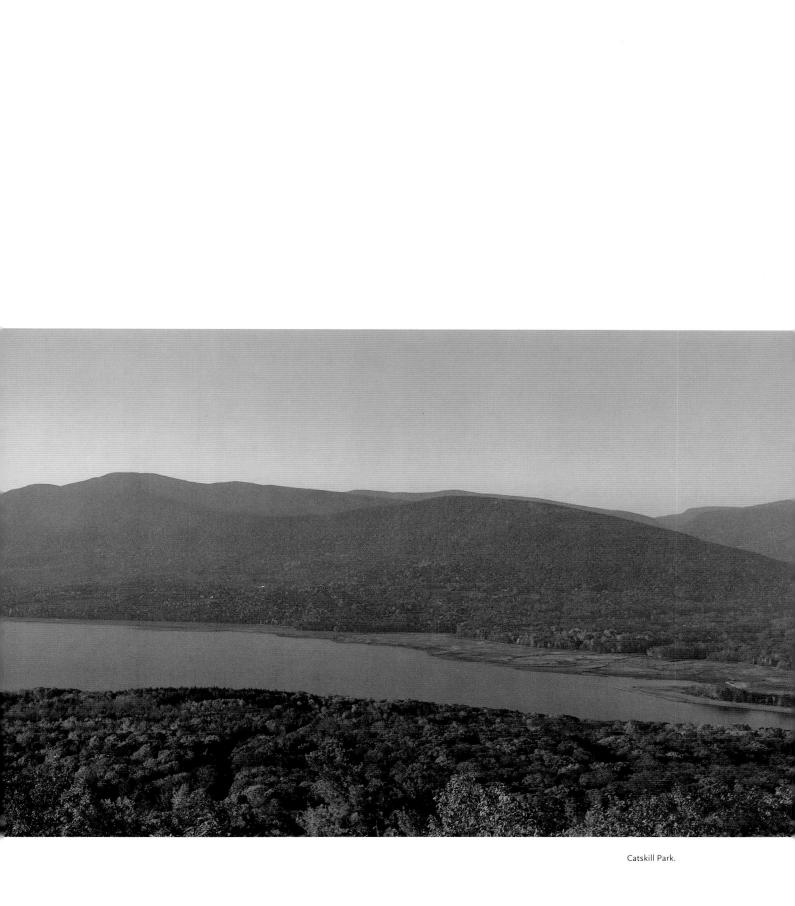

Constitution Marsh.

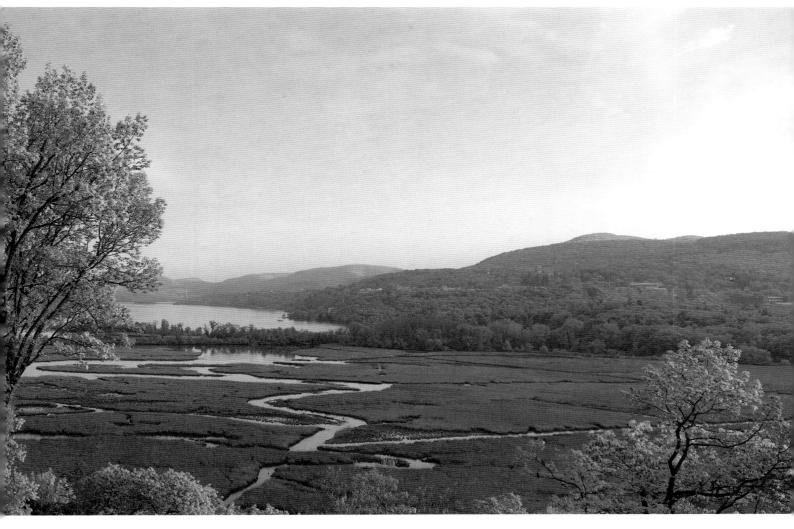

Garrison.

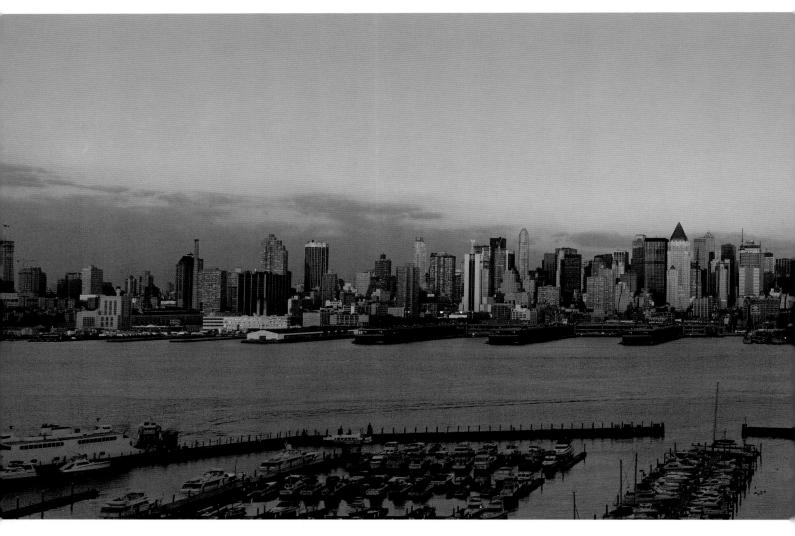

West Side waterfront.

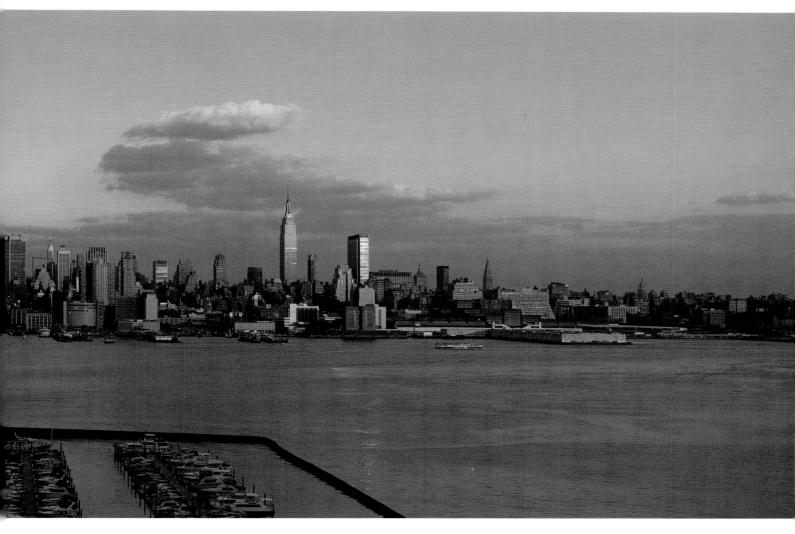

Manhattan.

THE HUDSON RIVER

FROM TEAR OF THE CLOUDS TO MANHATTAN

INTRODUCTION BY JOAN K. DAVIDSON

ANTHOLOGY OF WRITINGS EDITED BY ARTHUR G. ADAMS

The Monacelli Press

First published in the United States of America in 1995 by The Monacelli Press, Inc., 10 East 92nd Street, New York, New York 10128.

Copyright © 1995 The Monacelli Press, Inc. Photographs © 1995 Jake Rajs

All rights reserved under International and Pan-American Copyright Conventions. No part of this book may be reproduced or utilized in any form or by any means, electronic or mechanical, including photocopying, recording, or by any information storage retrieval system, without permission in writing from the publisher. Inquiries should be sent to The Monacelli Press, Inc.

Page 272 constitutes an extension of this page.

Library of Congress Cataloging-in-Publication Data Rajs, Jake. The Hudson River : from Tear of the Clouds to Manhattan / Jake Rajs ; introduction by Joan K. Davidson ; edited by Arthur G. Adams. p. cm. Includes bibliographical references. ISBN 1-885254-10-5 (hc) 1. Hudson River Valley (N.Y. and N.J.) – Pictorial works. 2. Hudson River Valley (N.Y. and N.J.) – Description and travel. 3. Hudson River Valley (N.Y. and N.J.) – Literary collections. 4. Hudson River (N.Y. and N.J.) – Pictorial works. 5. Hudson River (N.Y. and N.J.) – Description and travel. 6. Hudson River (N.Y. and N.J.) – Literary collections. 1. Adams, Arthur G. II. Title.

95-30605

F127.H8 IN PROCESS 974.7'3 - dc20

Designed by Michael Rock.Susan Sellers

Printed and bound in Hong Kong

$\mathsf{C} \ \mathsf{O} \ \mathsf{N} \ \mathsf{T} \ \mathsf{E} \ \mathsf{N} \ \mathsf{T} \ \mathsf{S}$

15 INTRODUCTION Joan K. Davidson

18 THE HUDSON OF BEAUTY: FROM LAKE TEAR OF THE CLOUDS TO SARATOGA SPRINGS With selections from Nathaniel Parker Willis, Verplanck Colvin, Benson John Lossing, Thomas Cole, James Kirke Paulding, Cecil R. Roseberry, Edna Ferber

64 THE HUDSON OF HISTORY: FROM WATERFORD TO KINGSTON

With selections from DeWitt Clinton, Paul Wilstach, Benson John Lossing, Jim Shaughnessy, Nathaniel Parker Willis, Mariana Griswold van Rensselaer, Washington Irving, Wallace Bruce, John K. Howat, Cynthia Owen Philip, William Leete Stone, James Fenimore Cooper, Robert P. McIntosh, John Burroughs

132 THE HUDSON OF LITERATURE: FROM HYDE PARK TO TARRYTOWN With selections from John W. Harrington, Harriet Martineau, Irving Elting, Carole Decker, Charles S. Bannerman, John Beardsley, Charles Dickens, William Cullen Bryant, Benson John Lossing, Clay Lancaster

204 THE HUDSON OF COMMERCE: FROM THE TAPPAN ZEE BRIDGE TO THE STATUE OF LIBERTY With selections from Christopher Morley, Washington Irving, Raymond L. O'Brien, Hildegarde H. Swift and Lynd Ward, Robert A. Caro, John Gunther, Charles Lindbergh, Charles Dickens, George Sidney Hellman

267 AFTERWORD Arthur G. Adams

269 POSTSCRIPT Jake Rajs

271 CREDITS/ACKNOWLEDGMENTS

THE HUDSON, MORE THAN ANY OTHER RIVER, HAS A DISTINCT personality – an absolute soul-quality. With moods as various as the longings of human life she responds to our joys in sympathetic sweetness, and soothes our sorrows as by a gentle companionship. If the Mississippi is the King of Rivers, the Hudson is, par excellence, the Queen, and continually charms by her "infinite variety." It often seems that there are in reality four separate Hudsons – the Hudson of Beauty, the Hudson of History, the Hudson of Literature, and the Hudson of Commerce. To blend them all into a loving cable reaching from heart to heart is the purpose of the writer. It has been his privilege to walk again and again every foot of its course from the wilderness to the sea, to linger beside her fountains and dream amid her historic shrines, and from many braided threads of memory it has been his hope to set forth with affectionate enthusiasm what the student or traveler wishes to see and know of her majesty and glory.

WALLACE BRUCE

The Hudson, 1907

INTRODUCTION

JOAN K. DAVIDSON

New York's Hudson Valley belongs to all Americans - and to me alone.

For decades I have known and revered the valley from afar for the beauty of its mountains and waterways, for its grand and vernacular architecture, its classic river towns, broad farmlands, redolent history, and the most splendid of vistas – and for the mysterious symbolic power it appears to hold in the American psyche. Today it is my good fortune to live there.

The Hudson Valley of legend provides inspiration and engenders pride while never letting us forget that natural and historic resources, marvels on so vast a scale, are always vulnerable to depredation and loss. Here, intimations of our national future can be caught, if we attend.

The centerpiece of the region is the great river that runs from the Adirondacks to the sea. Only three hundred miles long, it is deep and wide. Its nether reaches ebb and flow with the salty tides of the Atlantic; and its upper end drains bubbling springs and lakes of the Catskills, Shawangunks, and Taconics.

The valley is a large-scale, integrated economy – a historic area in which natural and cultural resources, a population diverse in background and talent, and public and private sector forces are endeavoring to come together in common cause. This is an experiment of immense importance for and potential benefit to states, regions, and communities throughout the land, attempting to discover if local authority and character can be preserved at the same time that more wide-ranging societal goals are pursued.

There is much to learn in the Hudson Valley about land – how it fares in the care of public and private entities and in the face of competing claims. Seventeenth- and eighteenth-century ownership of land on a colossal scale by families of rank and fortune has – through the passage of time, through circumstance, through changing mores and values – been translated from patrician excess into populist benefaction, even entitlement. The great Dutch and English Hudson Valley estates, some exceeding hundreds of thousands of acres, once marched side by side along the Hudson shoreline. In some pockets, their remembrance is still surprisingly intact – and in one spectacular instance, more than twenty miles of their glorious riverfront, distinguished by dazzling natural and cultural resources, have been enshrined since 1990 as the Hudson River National Historic Landmark District, the first and one of the largest such protected areas in the country. Some properties within this official district have entered the public realm as parks; most remain in private hands. Together they protect air and water quality, plant and animal life, open views, and human-scale communities.

The Hudson Valley lays out dramatic lessons not only in landscape, agriculture, and land management, but also in the story of human habitation and in how the War for Independence was won. There is much to learn here about our culture, its early literary and visual aspects as evinced in the Knickerbocker writers and the Hudson River School of painters; about specialized industry; and about the modern environmental movement, which arose out of the 1960s struggle to save Storm King Mountain from despoliation by power plant.

We live in unsettled times when hard-won environmental advances are being rolled back in state and national legislatures, fast-moving sprawl is engulfing cities, towns, and open space across America, and the future of our communal holdings is in doubt. Never has there been more urgent need to uphold the public interest in the way Americans organize their neighborhoods, their local economies, their surrounding environments, and the quality of their lives.

Sharing these beliefs and working to these ends is New York State's spirited population of citizen activists. They are the energetic battalions in land trusts, environmental and preservation societies, park advocacy organizations, enlightened businesses and public agencies, philanthropies, and editorial pages. In the Hudson Valley, where their voice is especially loud and clear, they have so far made it possible to protect, maintain, and preserve for future generations streams and wetlands, historic buildings in towns and in rural places, acres of park and farmland, and scenic views in record number – although not yet enough.

Jake Rajs's elegant photographs along with the apt words chosen by Arthur Adams bring to life the heart and soul of a unique landscape. In this handsome and dramatic book we see the richness of natural resources – wildlife, fish, deer; mountains and forests, marshes, rocks; uplands, islands, farm country. We read the everlasting account of work and events and the passage of time as marked by battlefields and forts, old ships, bridges and dams, lighthouses, docks, factories, and silos. We rejoice in the dailiness of it, attested by country roads, wood fences, vegetable gardens. We acknowledge the red brick commercial buildings and distinctive houses of historic river towns, and we find New York, the ultimate city, revealed in a fresh way.

Perhaps most remarkably, here we can almost taste Hudson Valley weather – a striking atmosphere constantly astir: emphatic seasons, grandeur of cloud and sunset, free-flowing waters in river and stream, cataract and bay, mist and rain, ever-changing images of land and sky, the calm and the storm, the distant view . . .

16

These are the wonders that inform my own more modest Hudson Valley.

The life of the river and my own life seem to have become one. Even as the tidal river progresses relentlessly to New York's great harbor, surging southward to the city when natural forces propel it, and even as the tide reverses course, sending the river northward again, just so are my own days shaped by this primeval pattern.

Some ten years ago a perfect property came into my life and I into its life. My sprawling house is more than a hundred years old, solidly built to an idiosyncratic plan for life as it should be lived. Beautiful waste space, as only the late-nineteenth-century house knew how to waste it, fills the house, manifesting in everyday life the Hudson Valley's spaciousness, historic aspect, and joyous eccentricity. My rolling acres encompass woods and pond and open fields and a long dirt road. They sit on a bluff above the river, facing the Catskills – the view so beloved of the painters Thomas Cole, Frederic Church, John Frederick Kensett, and their aesthetic brethren – keeping the river with me, early and late.

I also live in a small cozy apartment in the heart of Manhattan, and will never relinquish the city, expecting to cherish and rely on its boons to the end: the city as *souk* – where everything material and non-material can be found, bought, secured, arranged; the city as *freedom* – where particular interests, modi operandi, and socializing instincts can go unremarked and where solitude can be satisfying and productive; and the city as *health*, with its international cornucopia of food and the pleasure of New York walking.

Nor would I ever want to give up the valley, bestower of so many other rewards. The Hudson River house is gregarious. Its wide river porch cheerfully gathers local folk, neighbors, to make plans for a town picnic or to fret about an impending gravel pit down the road. For family and friends in summer, the cool house celebrates local tomatoes and corn and peaches; in cold months, it warmly welcomes woods-clearers, football players, skiers, iceboaters, readers, and snoozers. And it offers the best chance to contemplate the miracle of one's own children now parents . . .

The devout wish of all who love it is that the Hudson Valley in its many parts will thrive and go on representing for future generations, as it does for our own, a gift of infinite value. The worry (that small black cloud on the horizon) is that the ever-present specters of indifference, short-sightedness, and worse will finally, despite all effort, alter and diminish the cherished valley beyond the point of no return.

This is the profound American dilemma being faced in so many parts of our country as the twenty-first century looms: must we inevitably lose what we love, or might it yet be possible to summon the vision, the generosity of spirit, the grit to think about what we are doing, and to find the way to pass on to others the good things that those who went before have passed on to us?

This provoking question lurks within the evocation of a magnificent river, even as the natural and manmade glories in the book you hold in your hand are cause for rejoicing.

The Hudson of

BEAUTY

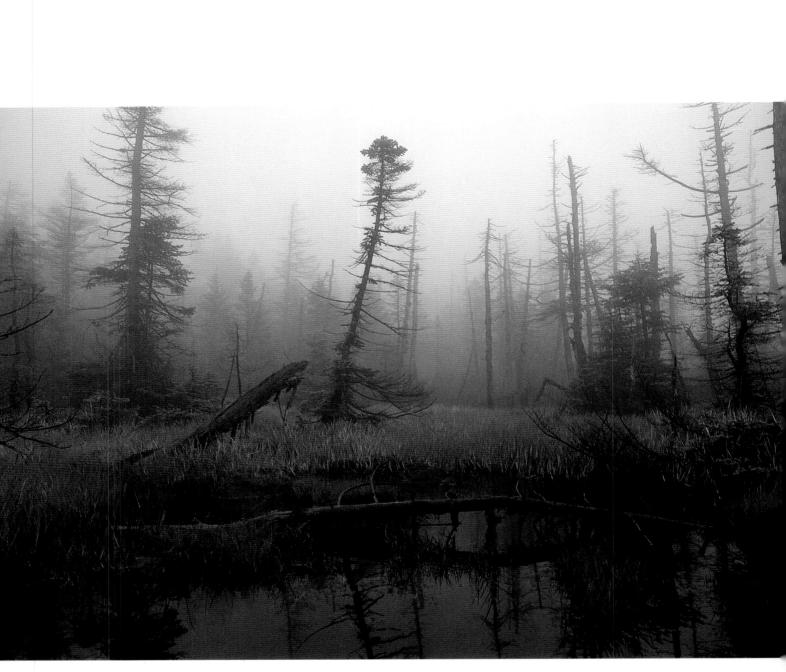

Lake Tear of the Clouds, Adirondack Park, the source of the Hudson River.

SOME OBSERVER OF NATURE OFFERED A CONSIDERABLE REWARD FOR two blades of striped grass exactly similar. The infinite diversity, of which this is one instance, exists in a thousand other features of Nature, but in none more strikingly than in the scenery of rivers. What two in the world are alike? How often does the attempt fail to compare the Hudson with the Rhine – the two, perhaps among celebrated rivers, which are the nearest in resemblance? Yet looking at the first determination of a river's course, and the natural operation of its search for the sea, one would suppose that, in a thousand features, their valleys would scarce be distinguishable.

I think, of all excitements in the world, that of the first discovery and exploration of a noble river, must be the most eager and enjoyable. Fancy "the bold Englishman," as the Dutch called Hendrich Hudson, steering his little yacht, the Halve-Mane, for the first time through the Highlands! Imagine his anxiety for the channel, forgotten as he gazed up at the towering rocks, and round the green shores, and onward, past point and opening bend, miles away into the heart of the country; yet with no lessening of the glorious stream beneath him, and no decrease of promise in the bold and luxuriant shores! Picture him lying at anchor below Newburgh, with the dark pass of the "Wey-Gat" frowning behind him, the lofty and blue Cattskills beyond, and the hillsides around covered with the red lords of the soil, exhibiting only less wonder than friendliness. And how beautifully was the assurance of welcome expressed, when the "very kind old man" brought a bunch of arrows, and broke them before the stranger, to induce him to partake fearlessly of his hospitality!

The qualities of the Hudson are those most likely to impress a stranger. It chances felicitously that the traveller's first entrance beyond the sea-board is usually made by the steamer to Albany. The grand and imposing outlines of rock and horizon answer to his anticipations of the magnificence of a new world; and if he finds smaller rivers and softer scenery beyond, it strikes him but as a slighter lineament of a more enlarged design.

To the great majority of tastes, this, too, is the scenery to live among. The stronger lines cf natural beauty affect most tastes; and there are few who would select country residence by beauty at all, who would not sacrifice something to their preference for the neighborhood of sublime scenery. The quiet, the merely rural – a thread of a rivulet instead of a broad river – a small and secluded valley, rather than a wide extent of view, bounded by bold mountains, is the choice of but few. The Hudson, therefore, stands usually foremost in men's aspirations for escape from the turmoil of cities, but, to my taste, though there are none more desireable to see, there are sweeter rivers to live upon.

NATHANIEL PARKER WILLIS

The Four Rivers: The Hudson, the Chenango, the Mohawk, the Susquehanna, 1849

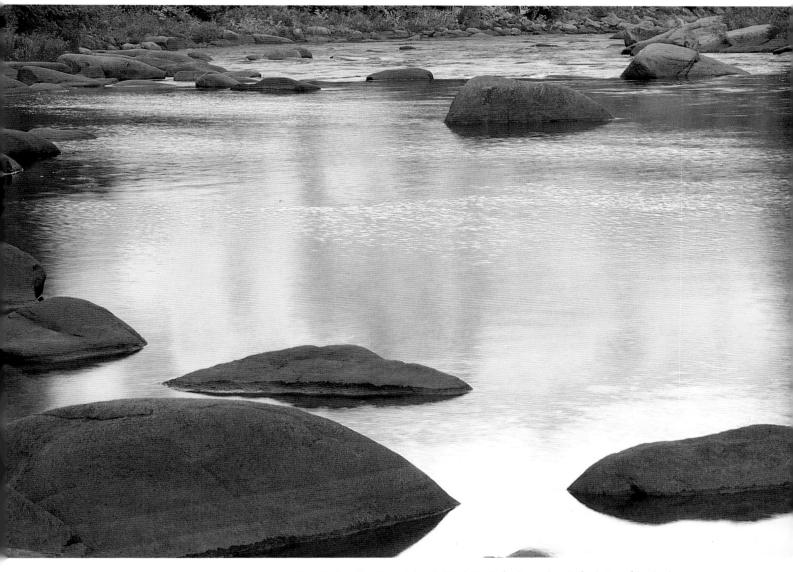

Above: Hudson River Gorge, Adirondack Park. Overleaf and second overleaf: Lake Tear of the Clouds.

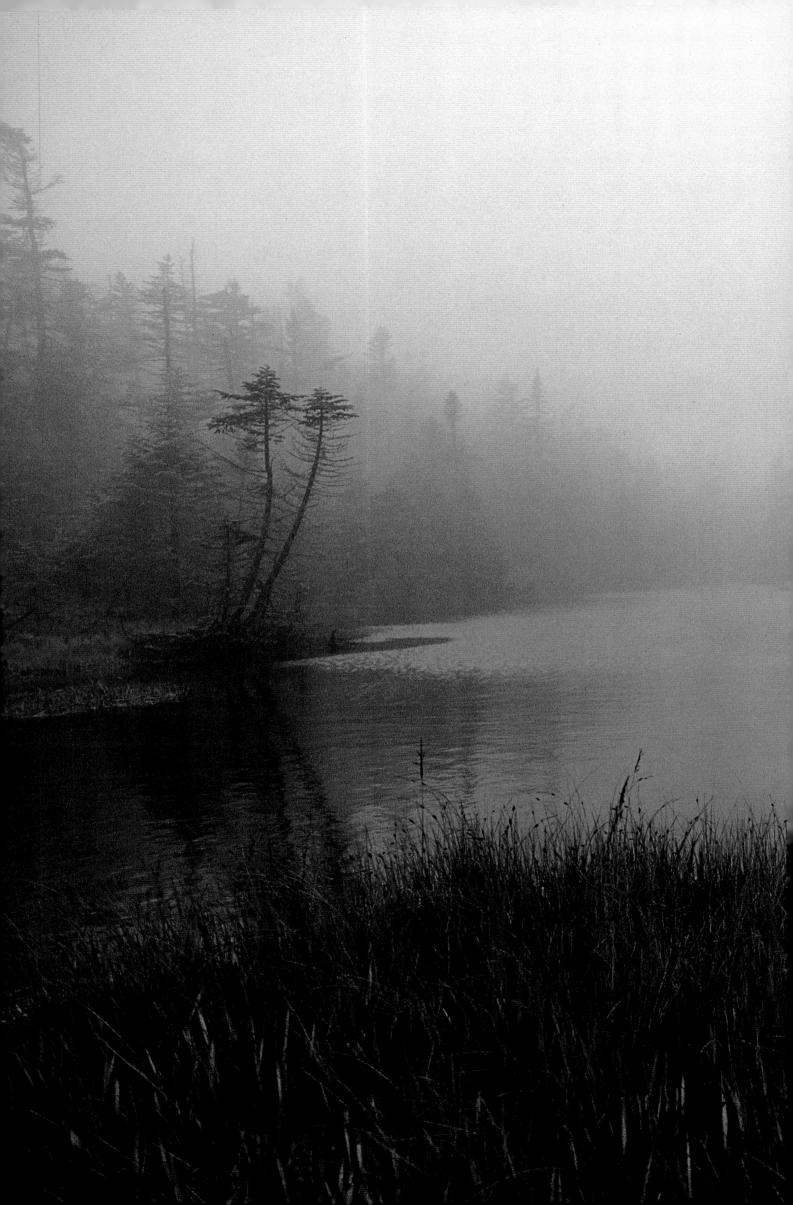

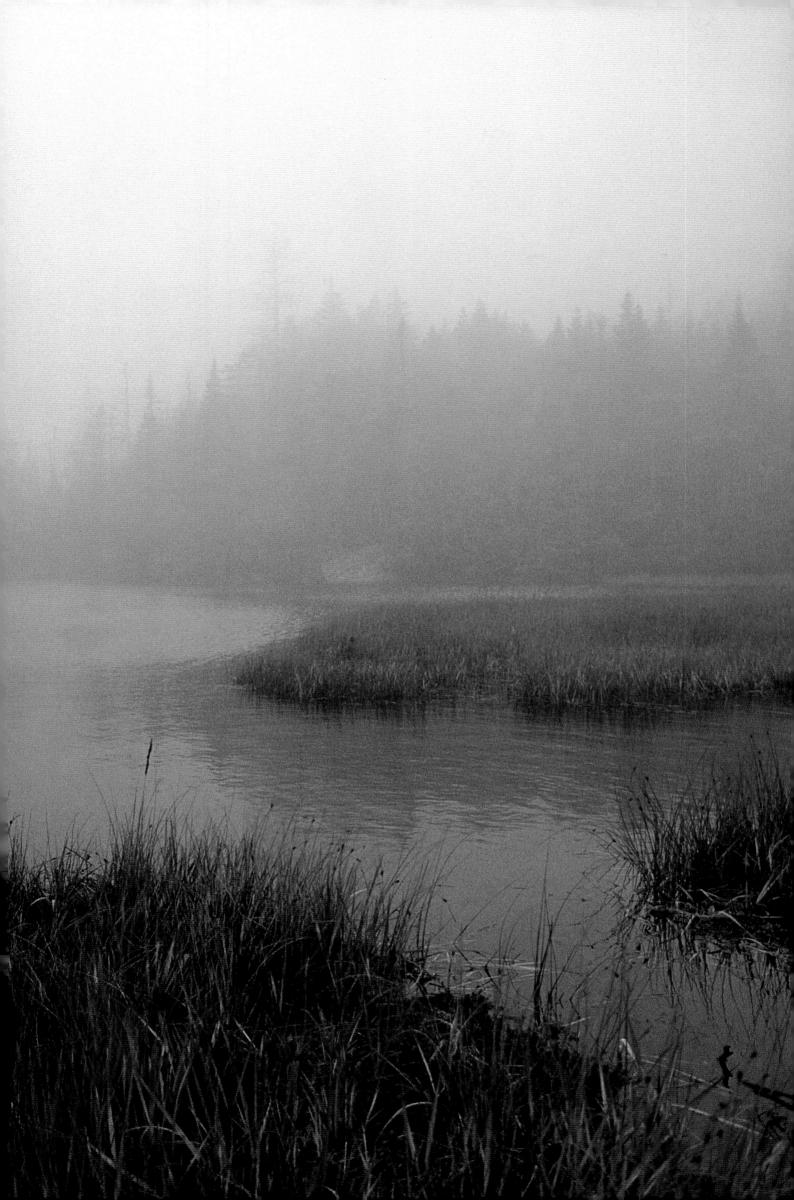

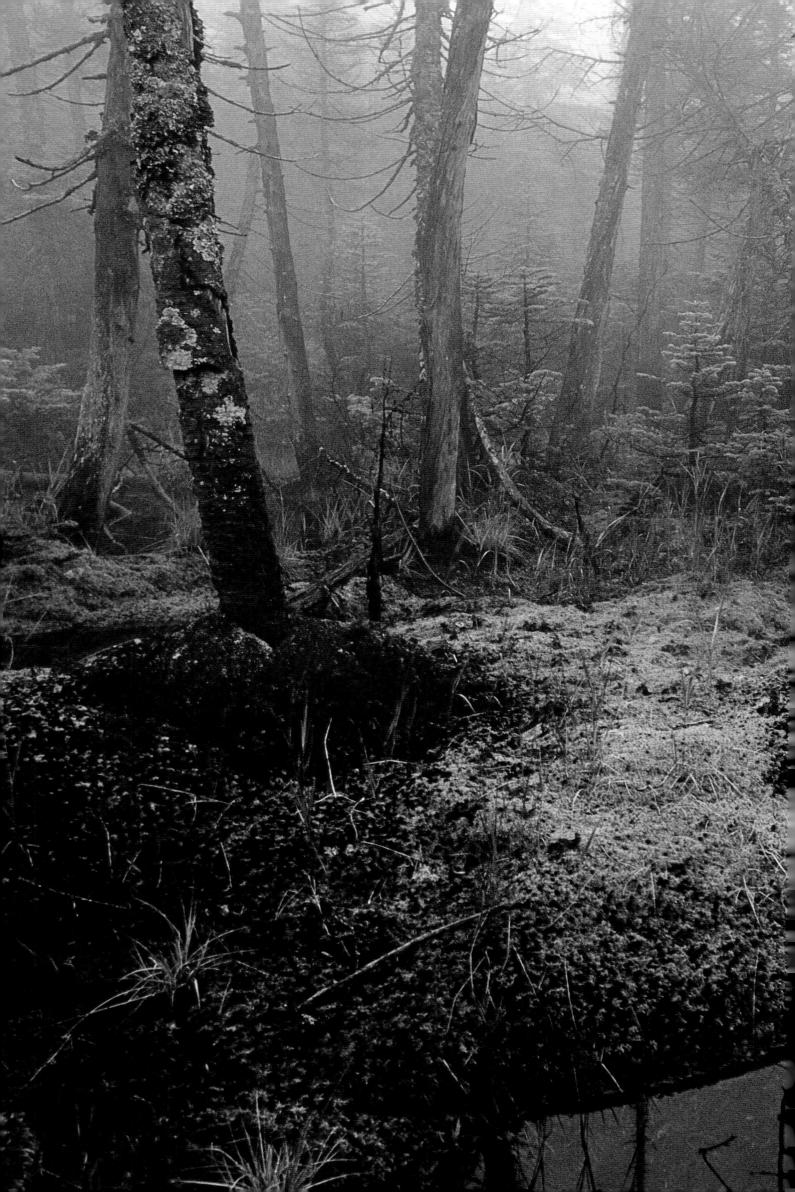

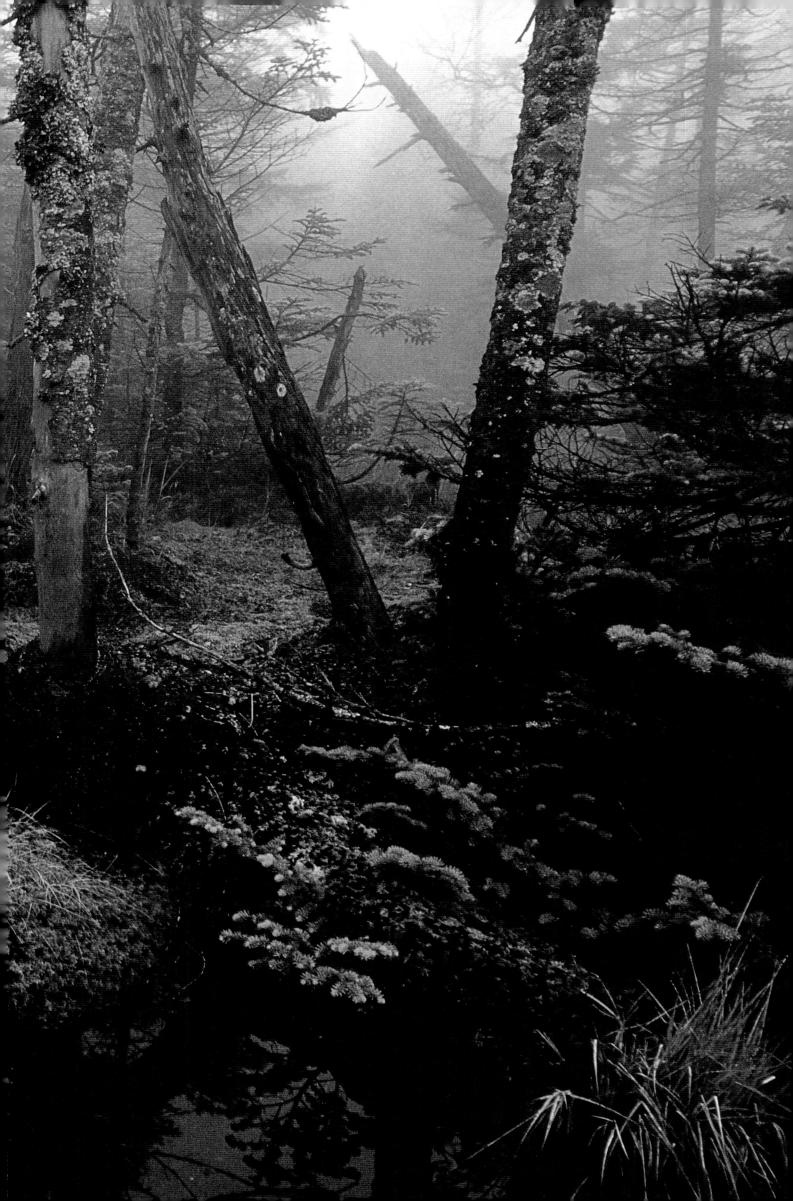

 \ldots A minute, unpretending tear of the clouds, as it were, a lonely pool,

shivering in the breezes of the mountains, and sending

its limpid surplus through Feldspar Brook to the Opalescent River,

the wellspring of the Hudson.

VERPLANCK COLVIN

Annual Report on the Topographical Survey of the Adirondack Region, 1872

28

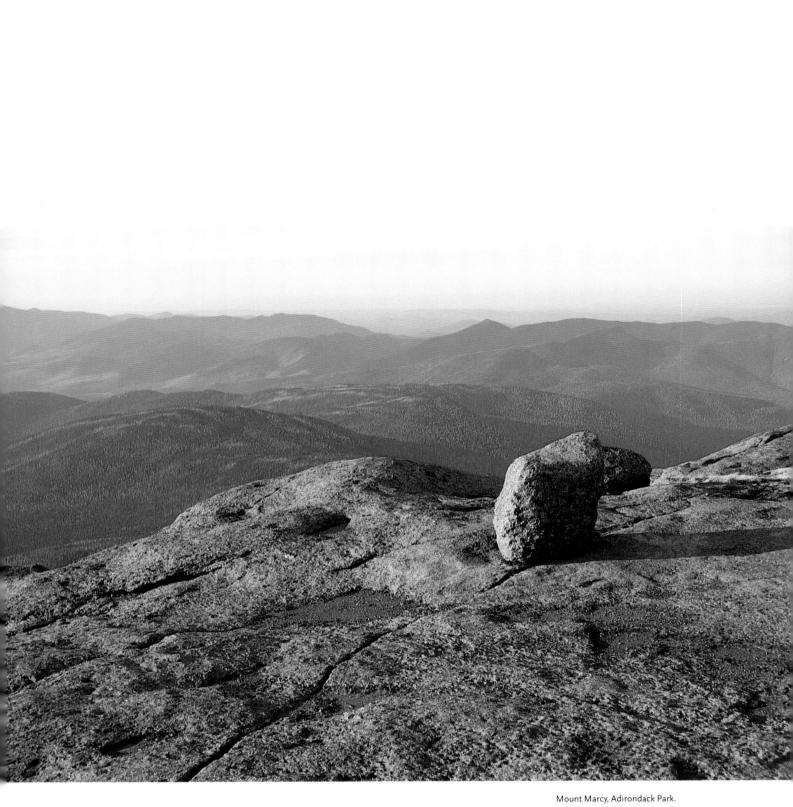

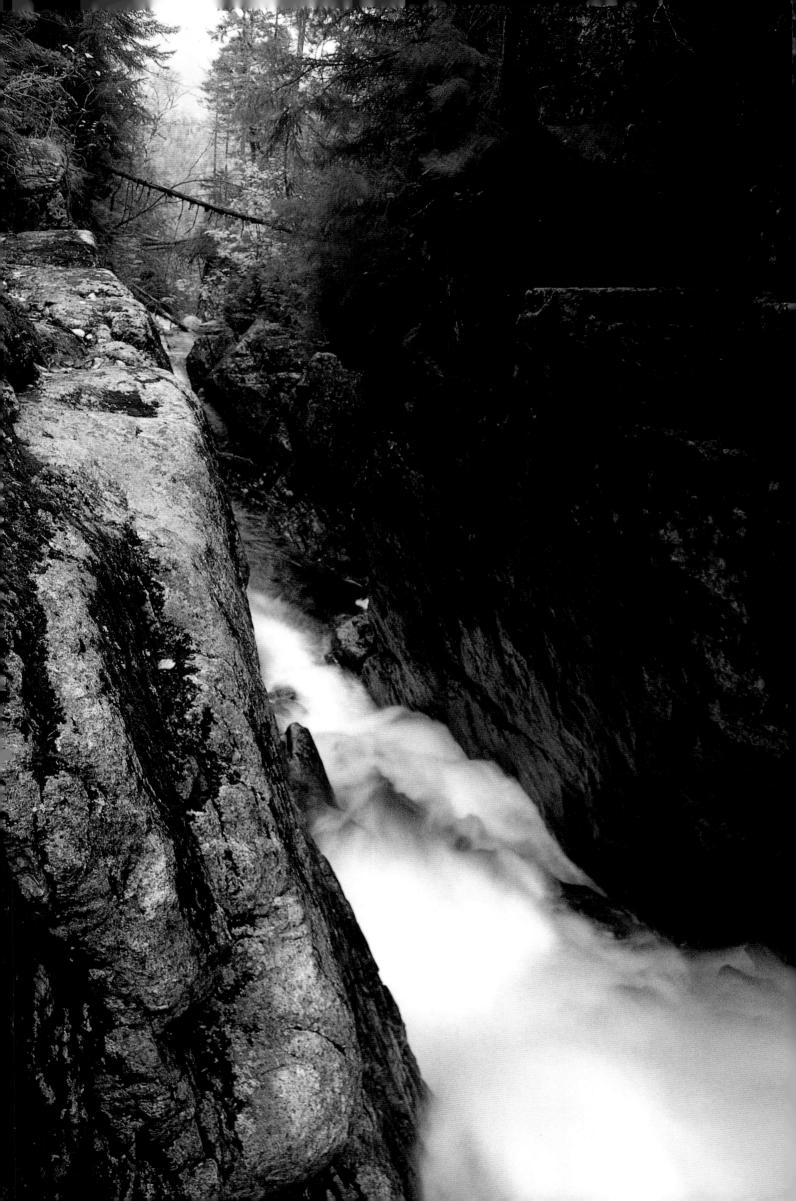

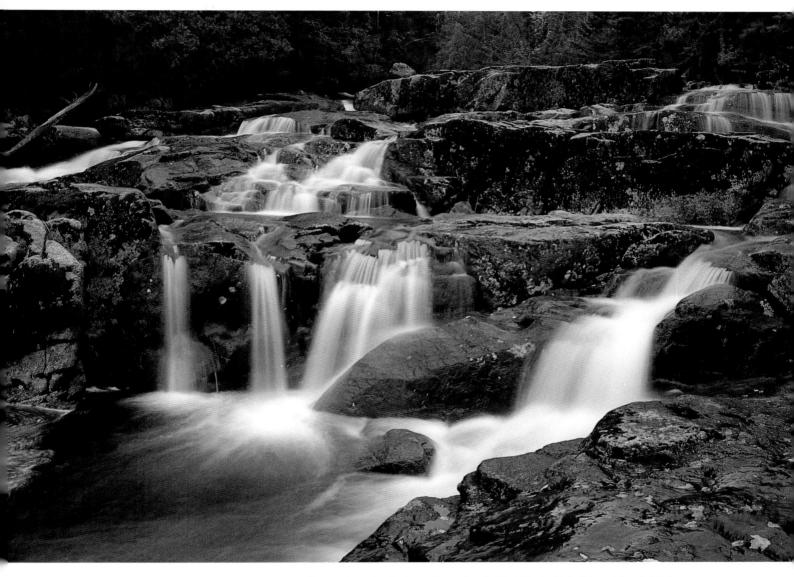

Above and opposite: Opalescent River, Adirondack Park. Overleaf: Lake Colden, Adirondack Park.

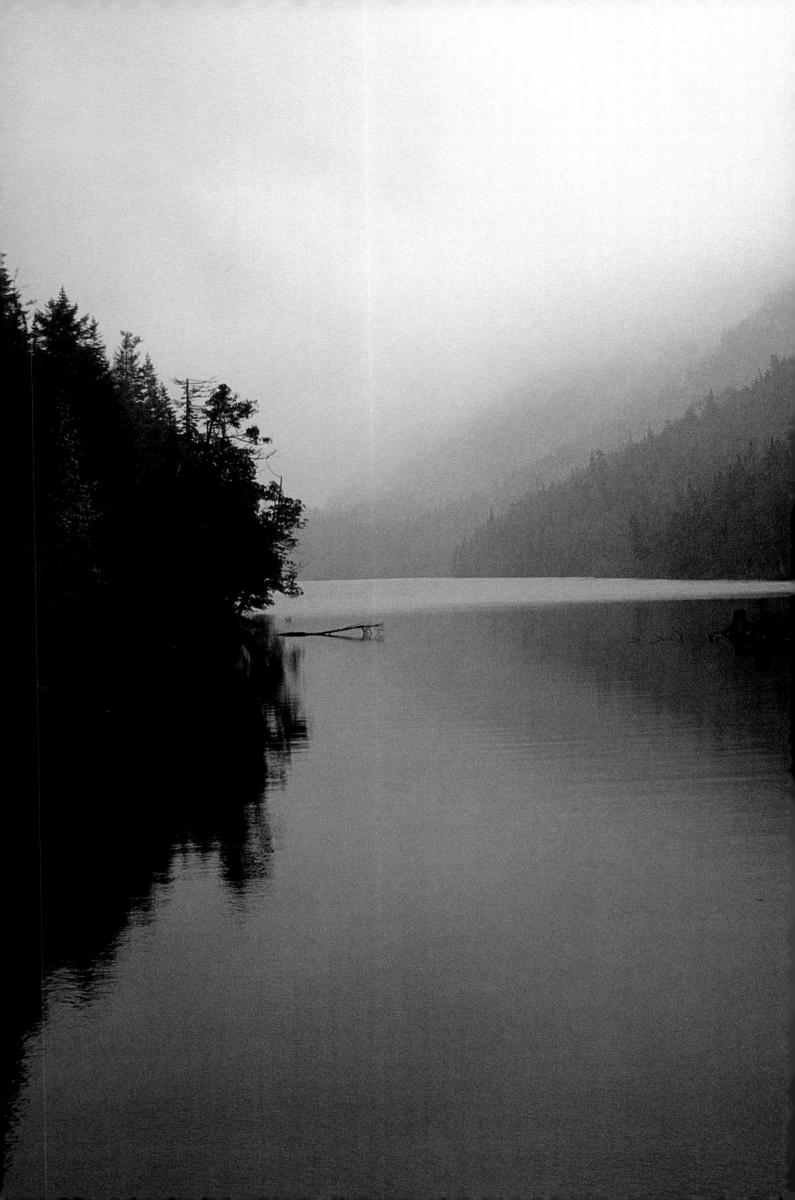

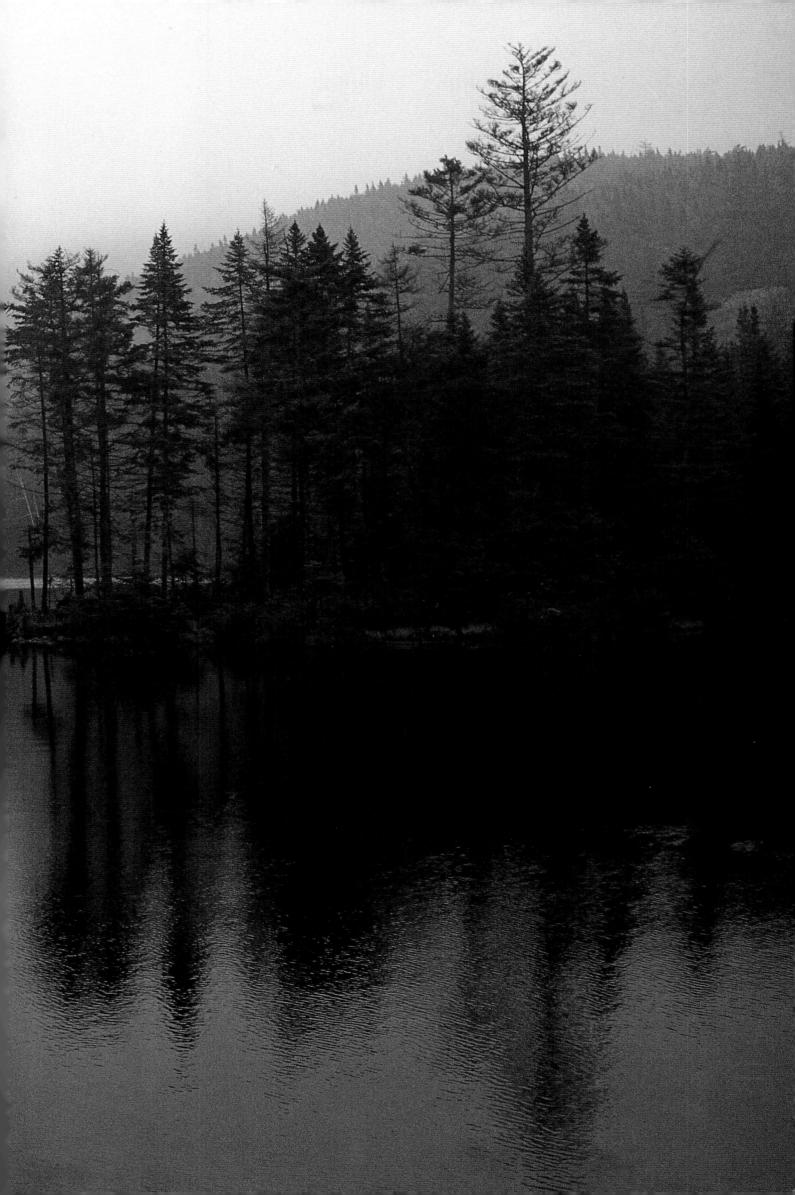

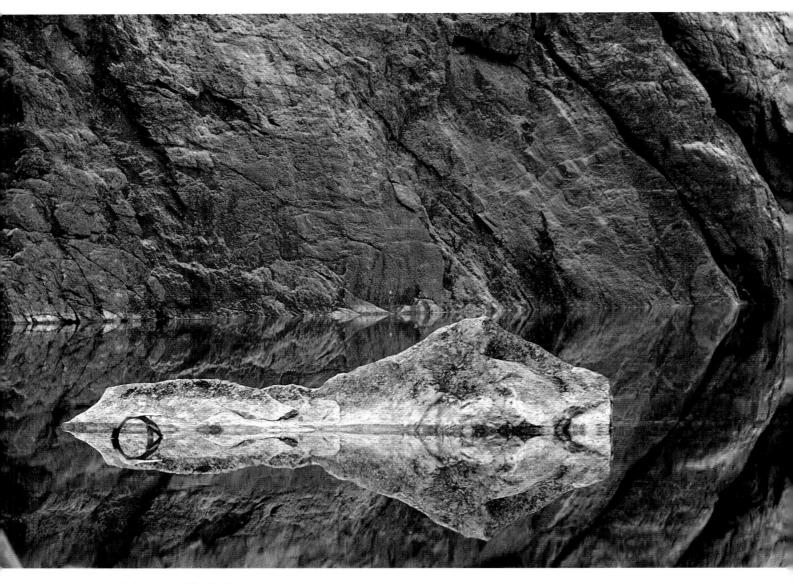

Avalanche Lake, Adirondack Park.

WELL PREPARED WITH ALL NECESSARIES EXCEPTING FLANNEL OVERshirts, we set out from Adirondack on the afternoon of the 30th of August, our guides with their packs leading the way. The morning had been misty, but the atmosphere was then clear and cool. We crossed the Hudson three-fourths of a mile below Henderson Lake, upon a rude bridge, made our way through a clearing tangled with tall raspberry shrubs full of fruit, for nearly half a mile, and then entered the deep and solemn forest, composed of birch, maple, cedar, hemlock, spruce, and tall pine trees. Our way was over a level for three-fourths of a mile, to the outlet of Calamity Pond. We crossed it at a beautiful cascade, and then commenced ascending by a sinuous mountain path, across which many a huge tree had been cast by the wind. It was a weary journey of almost four miles ... for in many places the soil was hidden by boulders covered with thick moss, over which we were compelled to climb. Towards sunset we reached a pleasant little lake, emblossomed in the dense forest, its low wet margin fringed with brilliant yellow flowers, beautiful in form but without perfume ... That tiny lake was called Calamity Pond ...

BENSON JOHN LOSSING

The Hudson: From the Wilderness to the Sea, 1866

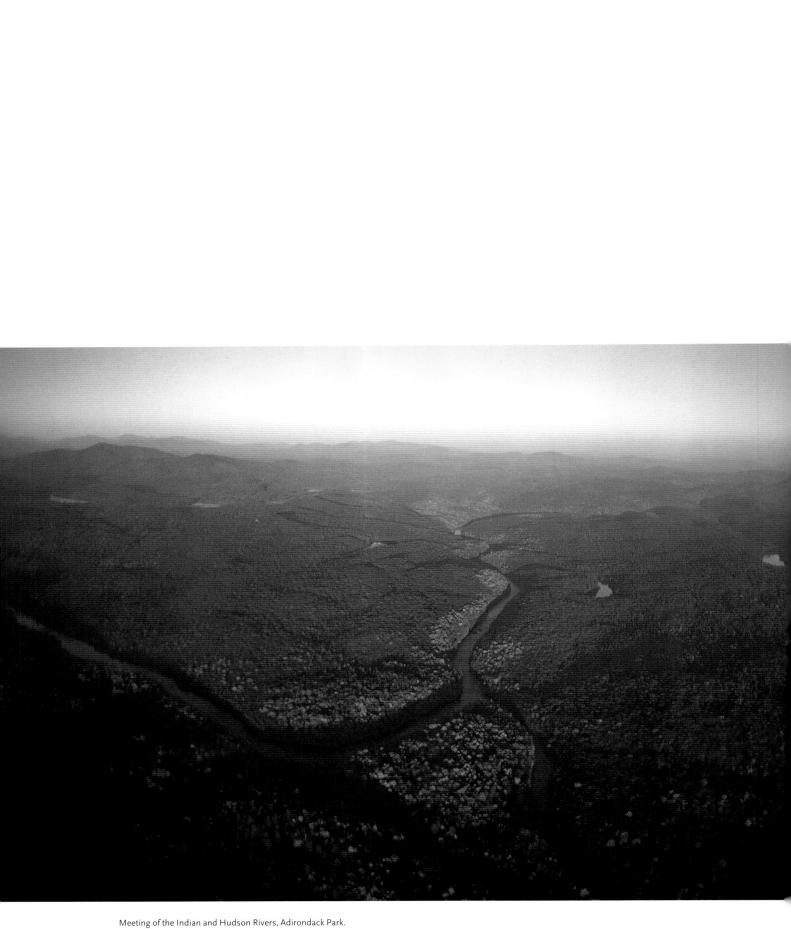

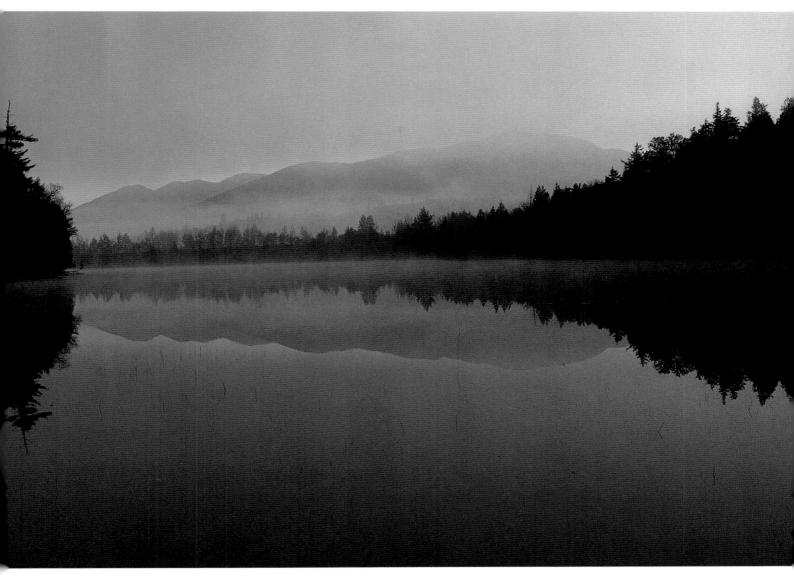

Above: Sanford Lake, Adirondack Park. Overleaf: Lake Harris, Adirondack Park.

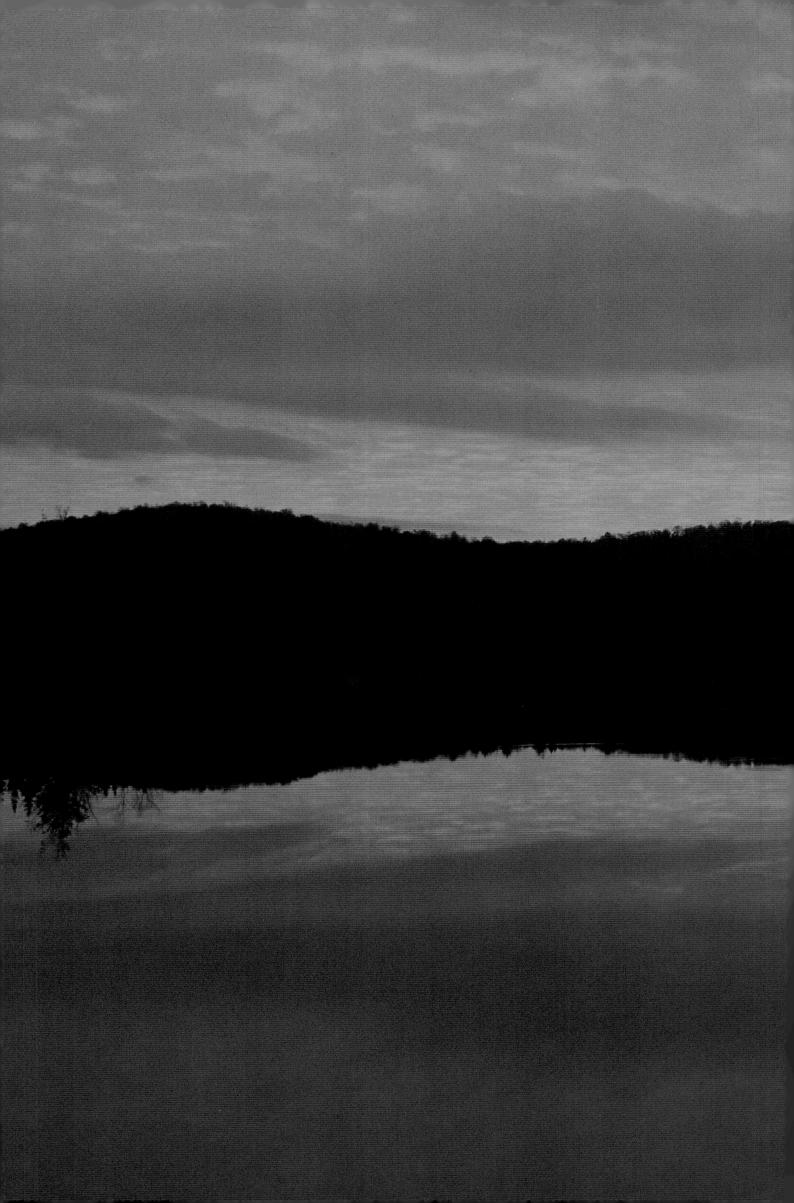

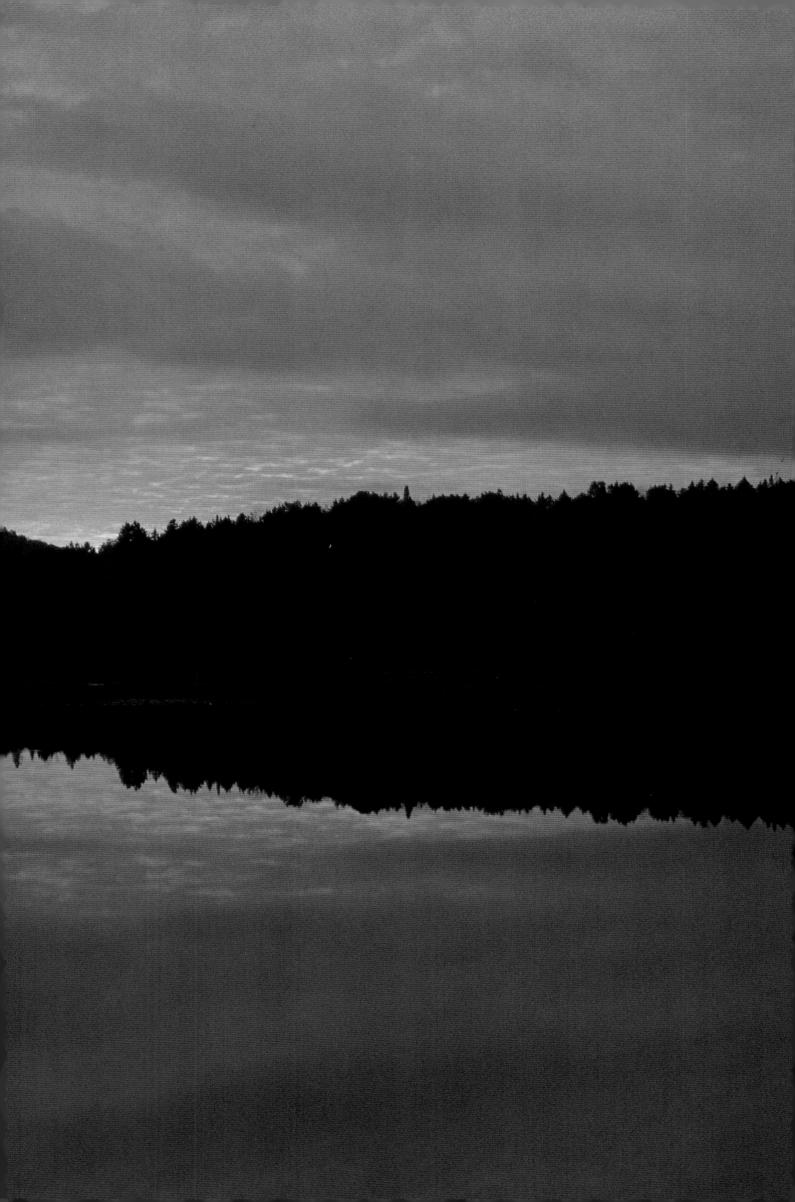

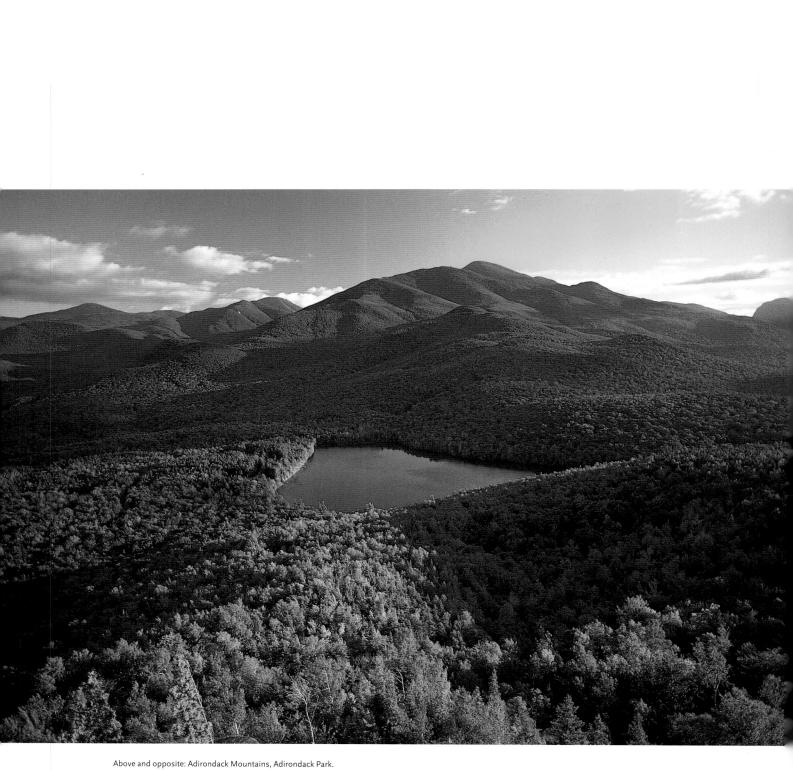

Friends of my heart, lover of Nature's works, Let me transport you to those wild blue mountains That rear their summits near the Hudson's wave Though not the loftiest that begirt the land, They yet sublimely rise, and on their heights Your souls may have a sweet foretaste of heaven, And traverse wide the boundless.

THOMAS COLE

"The Wild"

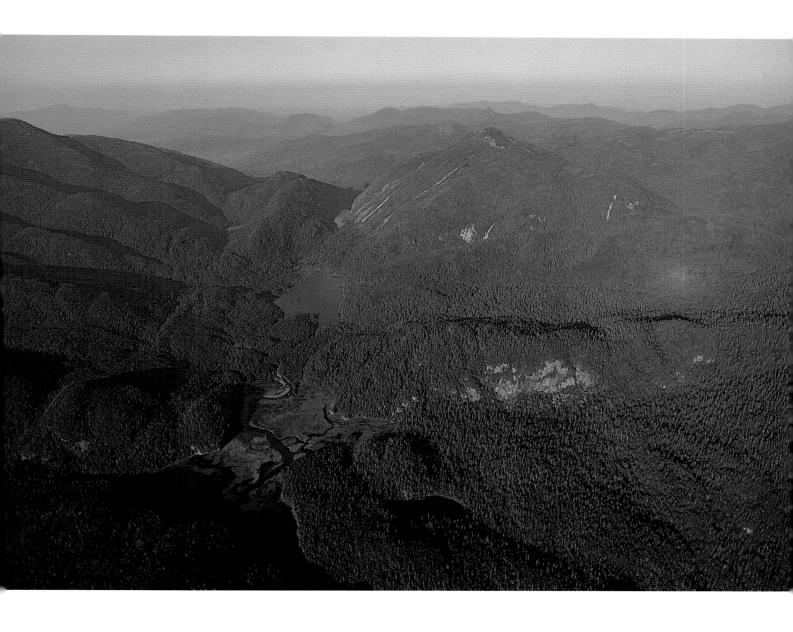

THE LABOURS OF OUR HERO'S VOYAGE WERE FAR GREATER THAN THE dangers. He and his trusty squire had to breast the swift current from morning until night, and win every foot of their way by skill and exertion combined. Sometimes the current swept through a long, narrow reach, between ledges of rocks that crowded it into increasing depth and velocity, – at others it wound its devious way by sudden, abrupt turnings, bristling on every side with sharp projections either just above or just below the surface; and at others they were obliged to unlade their light canoe, and carry its lading fairly round some impassable obstruction. In this manner they proceeded, winning their way inch by inch – watching with an attention, an anxiety never to be relaxed for a moment without the danger, nay, the certainty, of the shipwreck of their frail canoe, the loss of their cargo, and the disgrace of an unsuccessful voyage. This last was what every young man feared beyond the dangers and privations of his enterprise.

JAMES KIRKE PAULDING

The Dutchman's Fireside, 1831

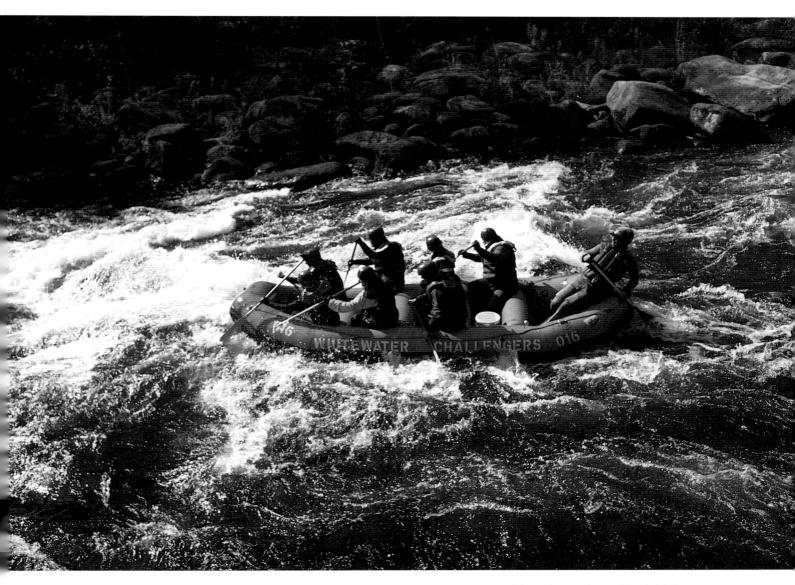

Rafters in the Blue Ledge area, Adirondack Park

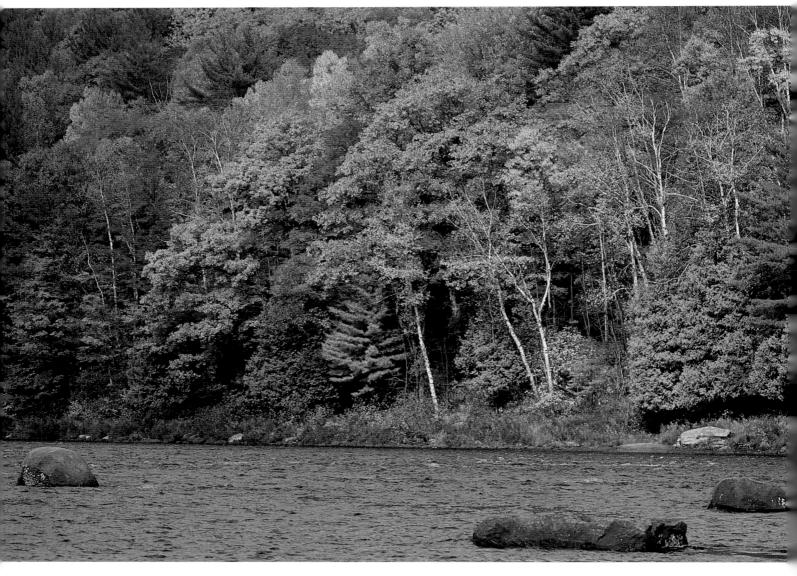

Above and opposite: North Creek, Adirondack Park. Overleaf: Chapel Lake, Adirondack Park.

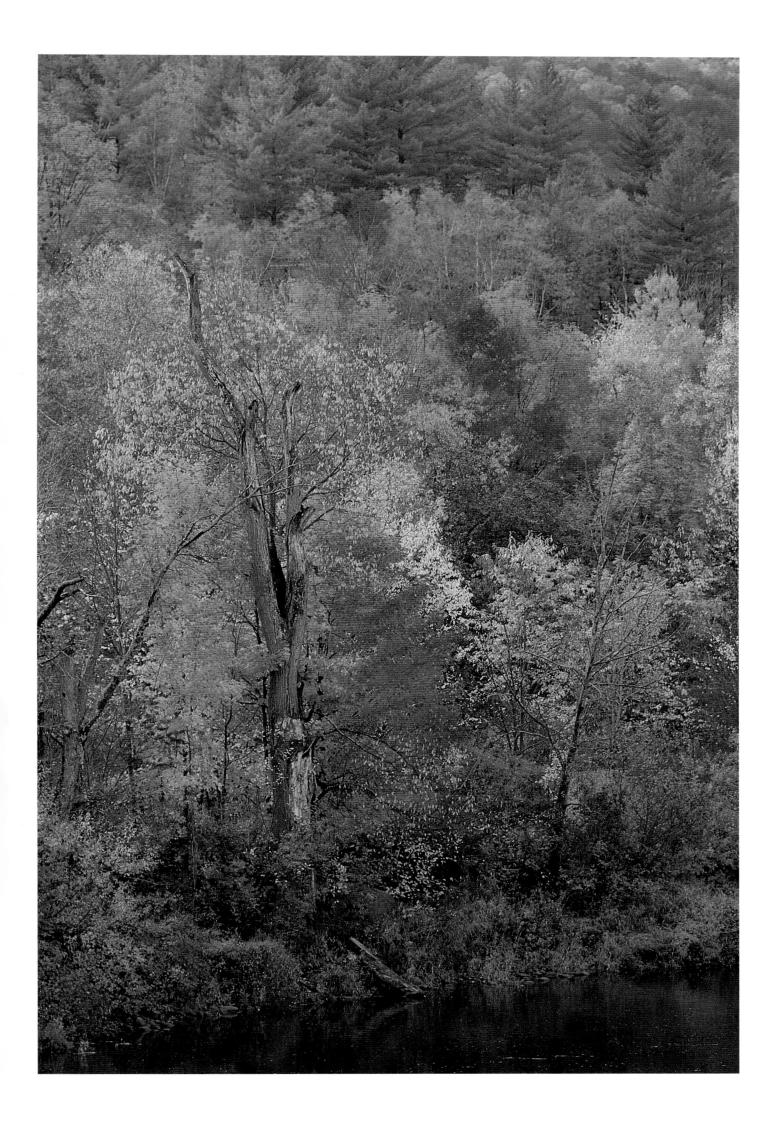

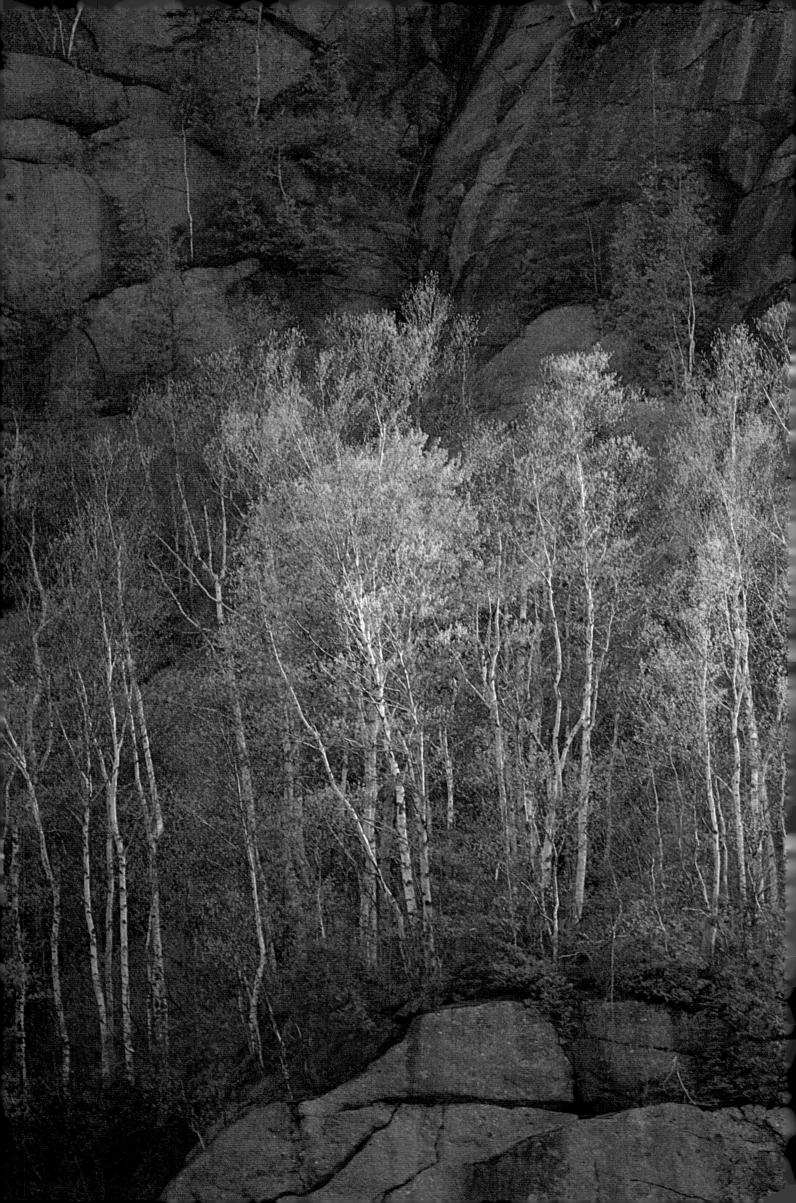

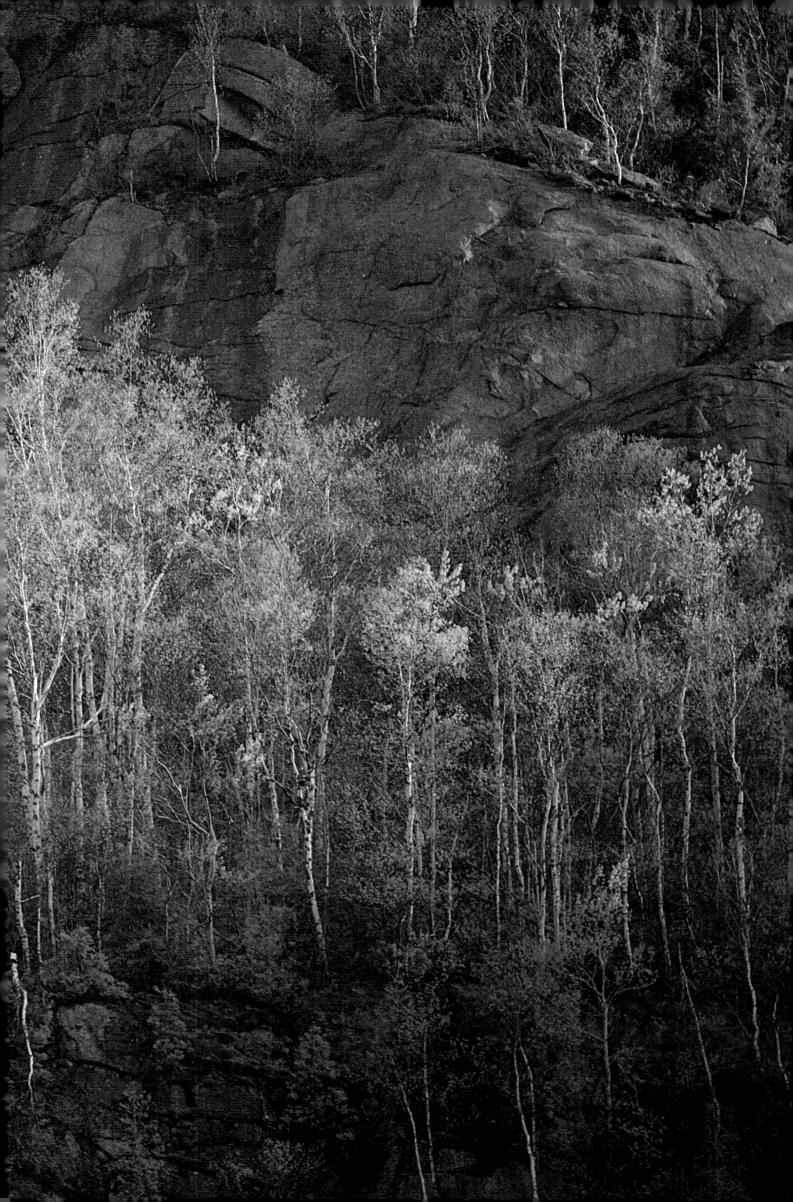

Fall in Adirondack Park.

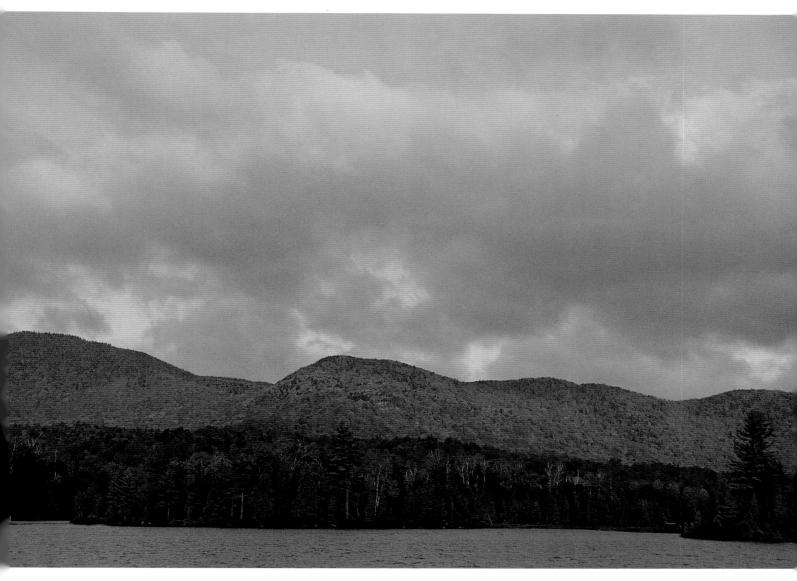

Elk Lake, Adirondack Park.

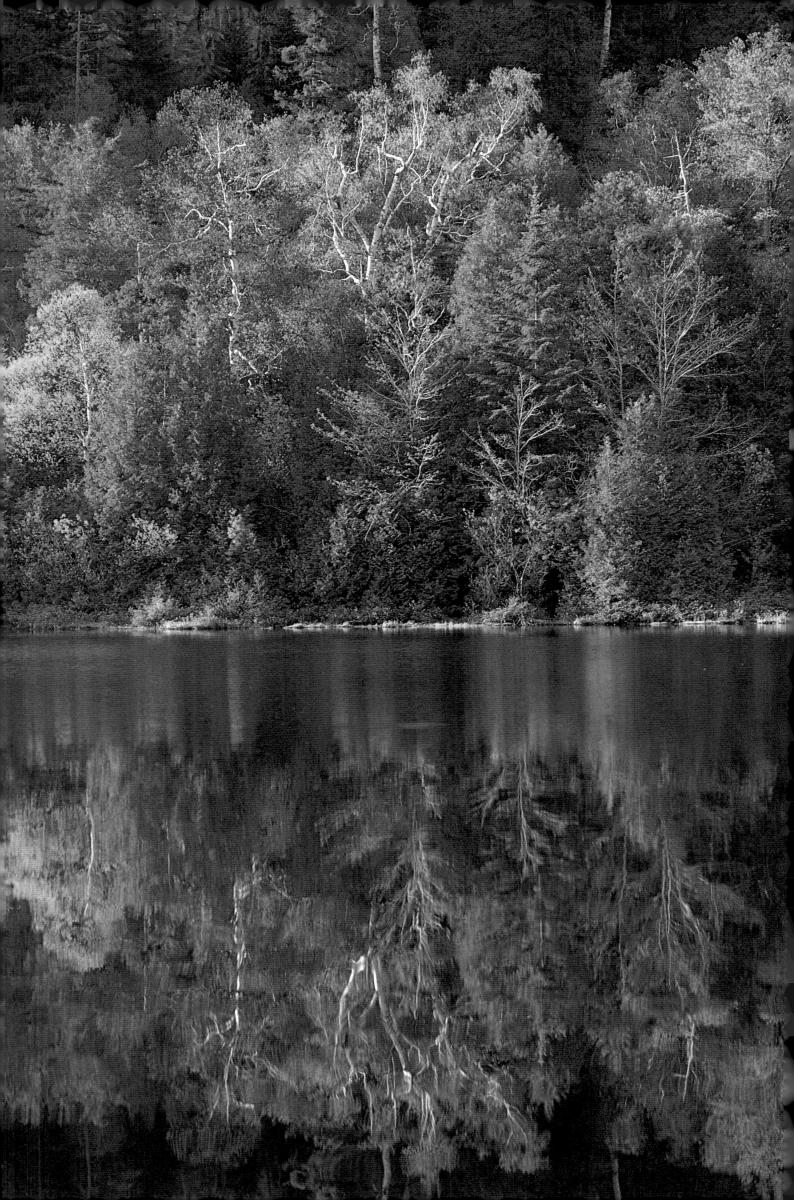

IT IS AN INDEX TO THE AUSTERE RUGGEDNESS OF THE ADIRONDACK Mountains that they were the last region of New York State to be systematically explored and surveyed. The true stature of their aloof peaks was not recognized until near the middle of the nineteenth century. They had been largely despoiled for lumber before the public began to develop a real appreciation of their scenic grandeur.

Scientists have long known that the basic rocks composing these mountains are of extremely ancient origin – more than a billion years. Mainly for this reason, the Adirondacks have been misconstrued until quite recently as being among the oldest mountains on earth, gnarled and rumpled in their ups and downs. This notion has now been discarded. Considered simply as mountains – regardless of the age of their component rocks – they are now believed to be relatively young in fact; compared to Rockies, Andes, and Alps, they are juvenile...

CECIL R. ROSEBERRY

From Niagara to Montauk: The Scenic Pleasures of New York, 1982

Washbowl Lake, Adirondack Park.

FROM THE SPOT WHERE WE NOW STAND – THE TURBULENT GLEN'S FALLS – to the sea, the banks of the beautiful river have voices innumerable for the ear of the patient listener; telling of joy and woe, of life and beauty, of noble heroism, and more noble fortitude, of glory, and high renown, worthy of the sweetest cadences of the minstrel, the glowing numbers of the poet, the deepest investigations of the philosopher, and the gravest records of the historian. Let us listen to those voices.

BENSON JOHN LOSSING

The Hudson: From the Wilderness to the Sea, 1866

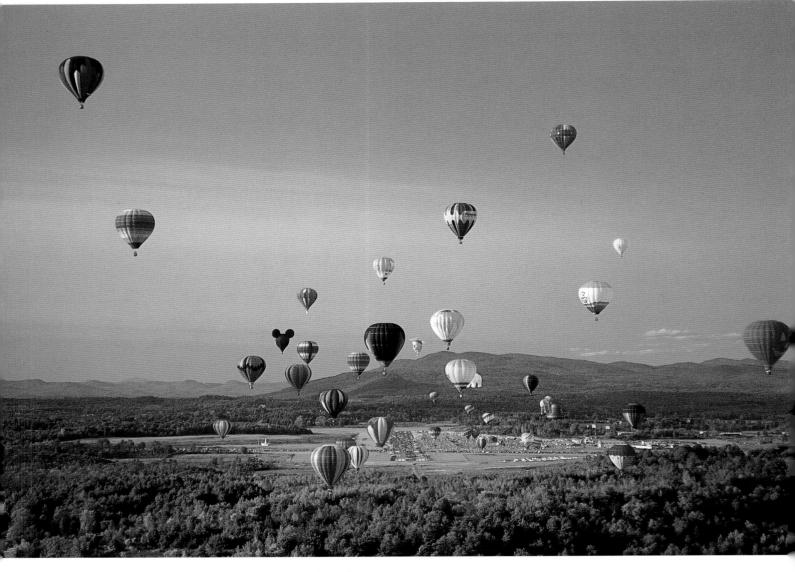

Above and opposite: Adirondack Balloon Festival, Glen's Falls.

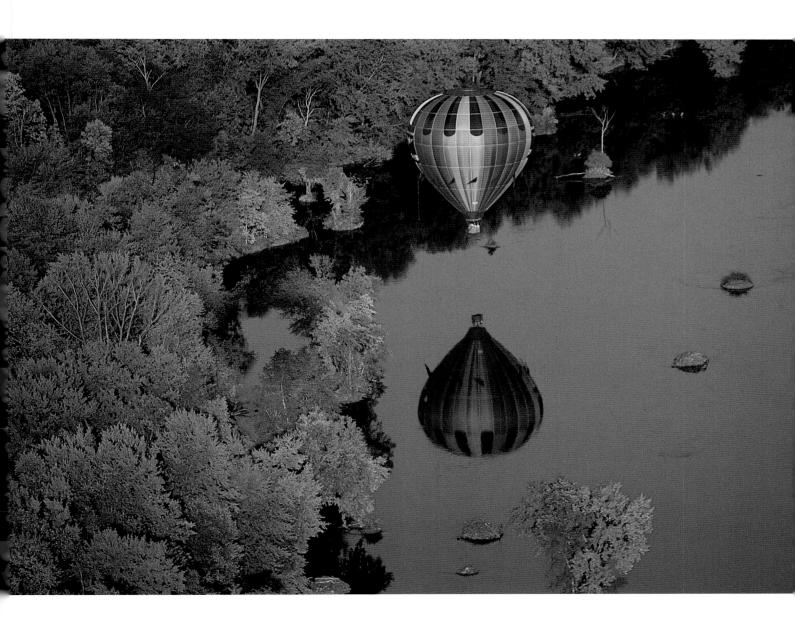

BAKER'S [HUDSON] FALLS ARE ABOUT HALF-WAY BETWEEN SANDY HILL AND Fort Edward. The river is about four hundred feet in width, and the entire descent of water, in the course of a mile, is between seventy and eighty feet. As at Glen's Falls, the course of the river is made irregular by huge masses of rocks, and it rushes in foaming cascades to the chasm below. The best view is from the foot of the falls, but ... these could not be reached from the eastern side, on which the paper-mills stand, without much difficulty and some danger.

BENSON JOHN LOSSING

The Hudson: From the Wilderness to the Sea, 1866

Opposite: Hudson Falls. Overleaf: Wildflowers in Schuylerville.

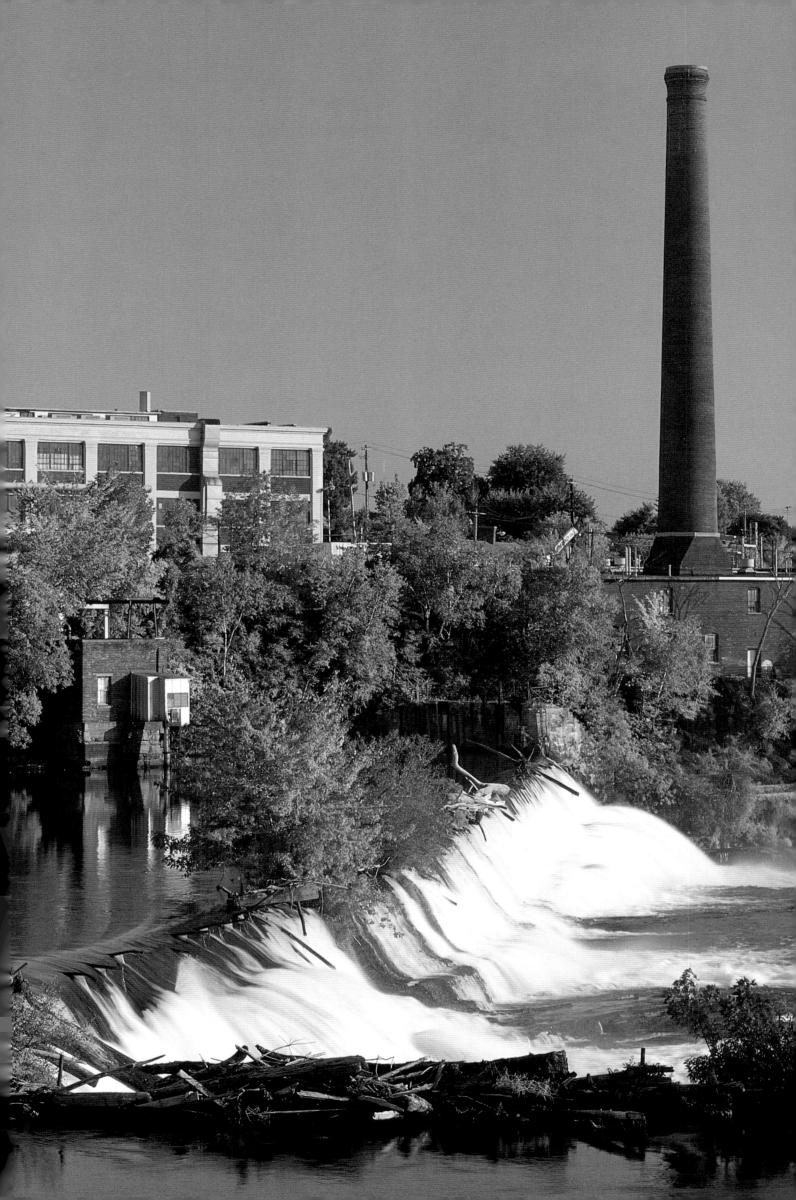

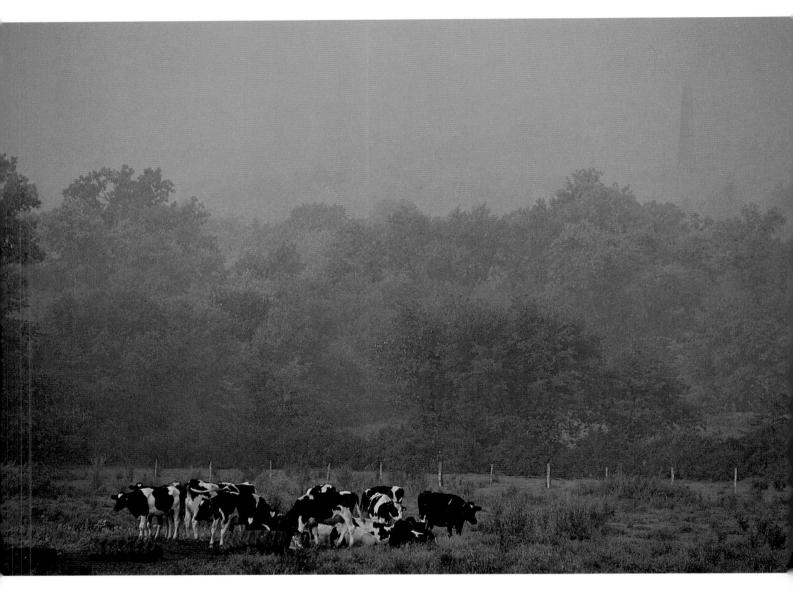

Above: Cows in Washington County. Opposite: Saratoga National Historic Monument.

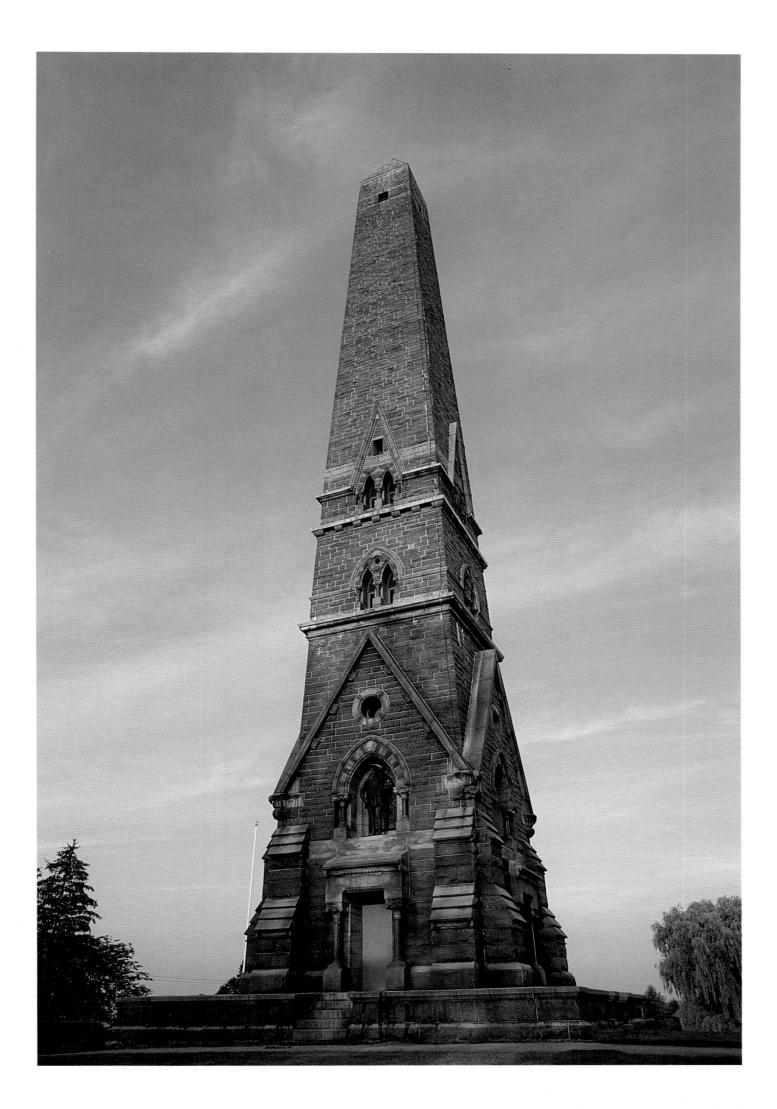

THE MORNING BROKE WITH AN UNCLOUDED SKY, AND BEFORE THE DEW WAS off the grass I was upon Bemis's Heights ... A more beautiful view ... I have seldom beheld. The ground there is higher than any in the vicinity, except the range of hills on the east side of the Hudson, and the eye takes in a varied landscape of a score of miles in almost every direction. Bounding the horizon on the north and west are the heights of Saratoga and the high mountains on the eastern shore of Lake George. On the south stretch away into the blue distance toward Albany the gentle hills and pleasant valley of the Hudson. On the east, not far distant, rises Willadr's Mountain, and over and beyond its southern neighbors of less altitude may be seen the heights of Bennington on the Walloomscoik, the Green Mountains, and the lofty summit of for-famed Mount Tom ...

At the time of the Revolution, the whole country in this vicinity was covered with a dense forest, having only an occasional clearing of a few acres; and deep ravines furrowed the land in various directions. Fronting the river, a high bluff of rocks and soil covered with stately oaks and maples, presented an excellent place on which to plant fortification to command the passage of the river and the narrow valley below. The bluff is still there, but the forest is gone and many of the smaller ravines have been filled up by the busy hand of cultivation.

BENSON JOHN LOSSING

The Pictorial Field-Book of the Revolution, 1859

Saratoga National Historic Park.

Saratoga Springs.

... passed the last half-mile,

passed the last five in the field of seven,

passed the favorite Oh Susanna,

reached the post and kept steadily on \ldots

EDNA FERBER

Saratoga Trunk, 1941

Saratoga racetrack.

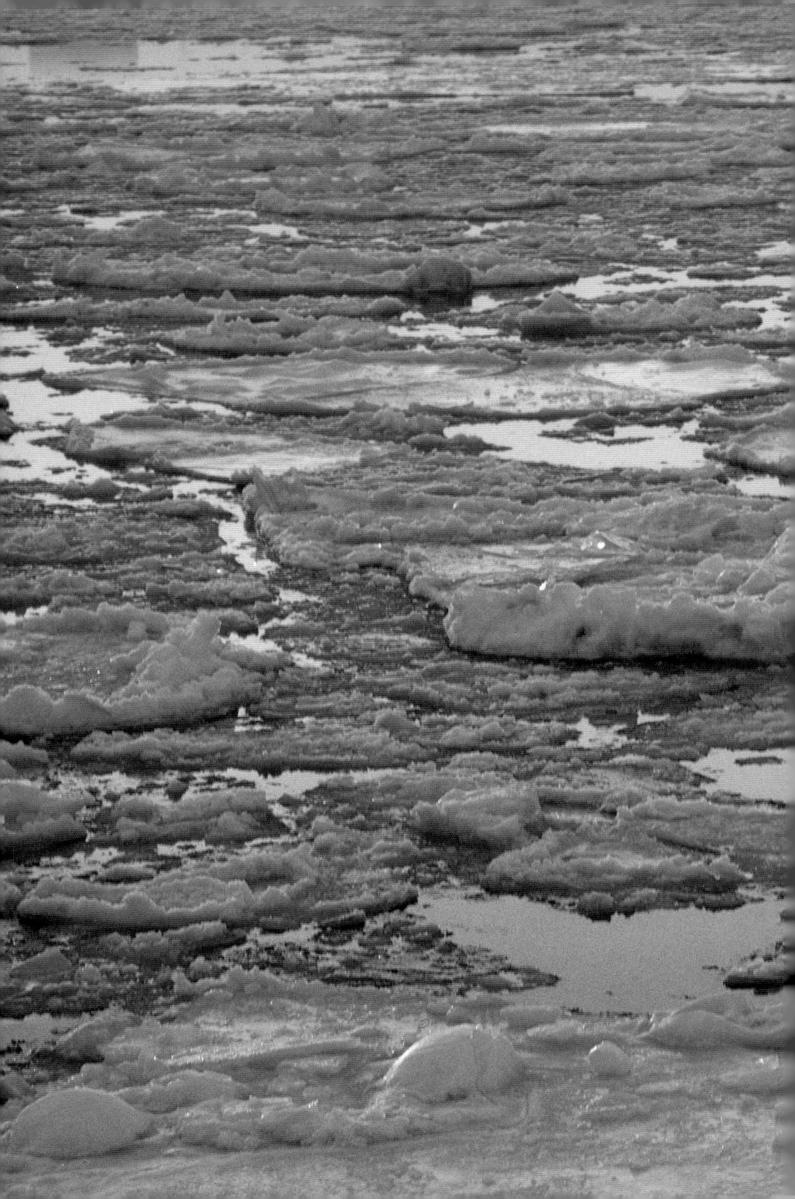

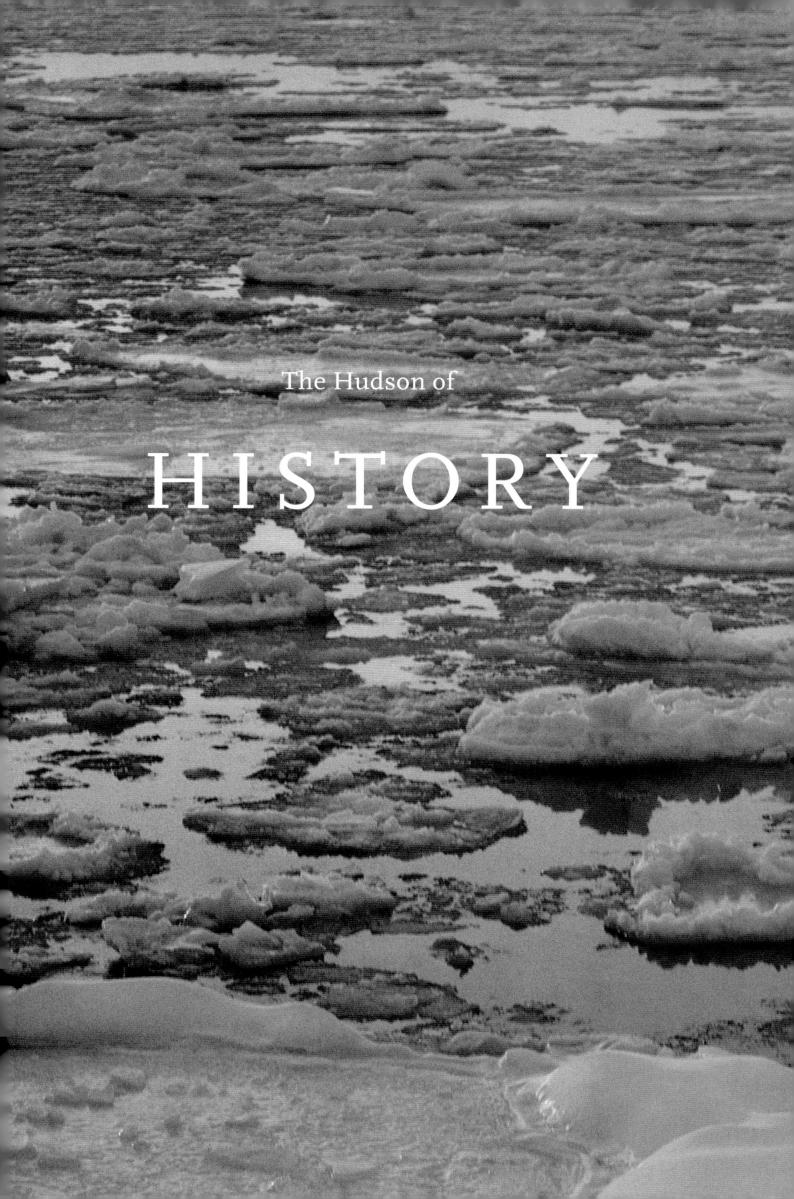

AS A BOND OF UNION BETWEEN THE ATLANTIC AND WESTERN STATES,

it may prevent the dismemberment of the American Empire. As an organ of communication between the Hudson, the Mississippi, the St. Lawrence, the Great Lakes of the north and west and their tributary rivers, it will create the greatest inland trade ever witnessed. The most fertile and extensive regions of America will avail themselves of its facilities for a market.

GOVERNOR DEWITT CLINTON

Above and opposite: Erie Canal, Waterford.

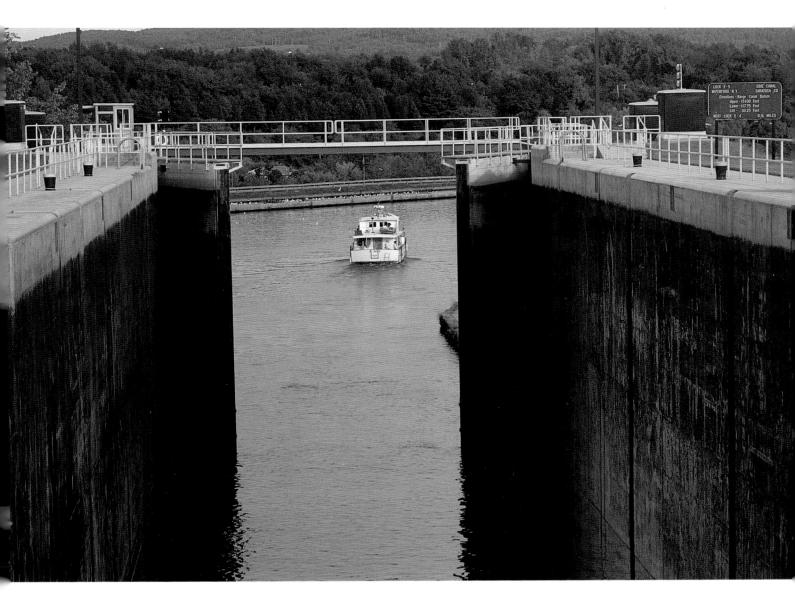

Troy.

THE STORY OF THE RIVER'S NATURAL ASPECTS IS WRITTEN ALONG ITS banks in a language without words. The diversity of its water stretches, its tumbling banks sweeping up to miniature mountains, the changing lights of sunshine and cloud-shadow, the inexplicable variety of color in calm or storm, on field or forest or peak, all unroll a scroll written in that wordless language which is obvious to every eye. They give themselves direct, without benefit or need of interpreter. They convey the diversions of pleasure or awe with undeviating, inescapable directness ...

The Hudson of our interest is the navigable Hudson. Our race first came to this part of its shore; and over a subsequent period of more than three hundred years, here etched a record of peculiar significance in those three hundred years of American drama. Scenically, historically and humanistically, in its tangibles and intangibles, its cumulative interest is scarcely exceeded, if indeed, it is even matched by any other of our rivers.

The tangibles of the Hudson are all one sees in sailing the length of its waters. Its intangibles are all the great or amusing characters who have passed or paused on its shores; all the alluring myths attaching to it ...

The names of the great characters of the river include by association, if not by birth, a large percentage of all who have contributed to the military, political and cultural phases of our national life. Perhaps more intimately identified as sons of the river were the Van Rensselaers, the Van Cortlandts, the Beekmans, the Schuylers, the Livingstons, the Clintons, Alexander Hamilton, Martin Van Buren, and Washington Irving. But equally a part of its story are the piratical operations of Captain Kidd and Fulton's successful application of steam to water navigation; and in the shadow of the Palisades, Aaron Burr fired the bullet which snuffed the life out of his own great political career as surely as it snuffed the life out of the body of Alexander Hamilton.

The mention of Washington Irving reminds that one of the most unique features of the Hudson is that almost alone of all American rivers is it endowed with its own lore, its own mythology. It is a river of mystery as well as of history. There are tales and fictitious characters associated with the river, which have become so vivid to the American consciousness that they seem as real as the facts and personages of its real story. Who thinks of the Catskills without thinking of Rip Van Winkle? Who hears the thunder-peals reverberating across the water from mountain to mountain and does not recall that the men of Hudson's ghostly crew are again at their game of ninepins? The mere mention of Sleepy Hollow envisions Ichabod Crane in flight before the Headless Horseman. Just so we think of the burghers of New Amsterdam as Knickerbockers, though the name Knickerbocker existed only rarely and somewhat obscurely except in Irving's roguish fancy. There is a spice of irony in the fact that the descendants have since accepted the claim of being "one of the old Knickerbocker families" as a title of aristocracy.

Myths, too, account for the names of hills, creeks, points and other natural formations; a tale is, as it were, in every stone; a book, as it were, in every running brook.

PAUL WILSTACH

Hudson River Landings, 1933

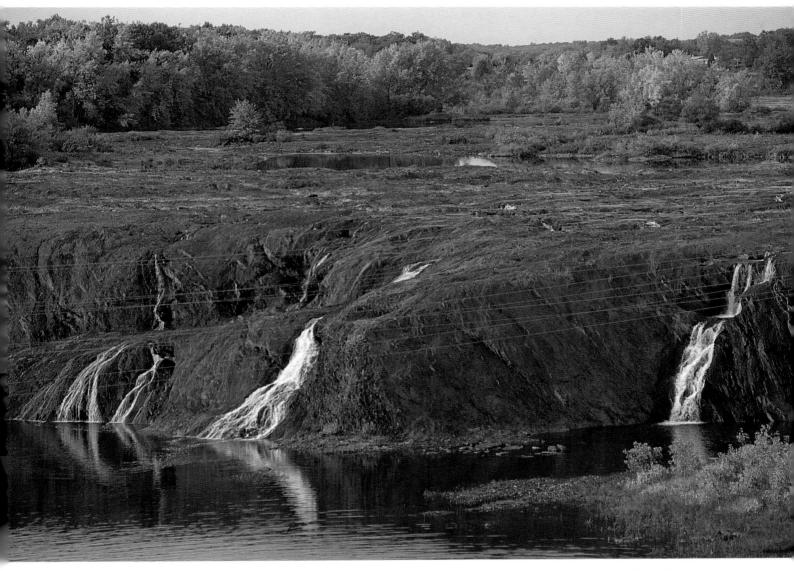

Cohoes Falls.

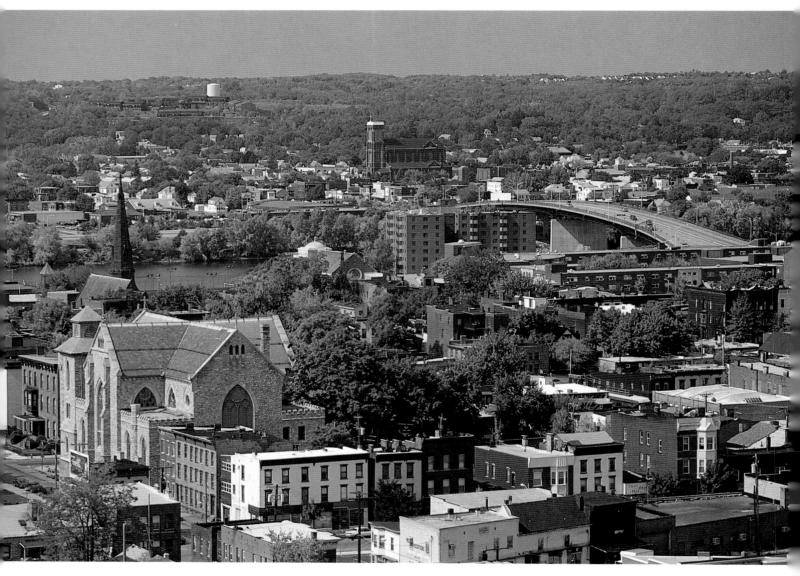

Troy.

TROY, THE CAPITAL OF RENSSELAER COUNTY, IS SIX MILES ABOVE ALBANY, and the head of tide-water, one hundred and fifty-one miles from the city of New York. It is a port of entry, and its commerce is very extensive for an inland town. It is seated upon a plain between the foot of Mount Ida and the river. It has crept up that hill in some places, but very cautiously, because the earth is unstable, and serious avalanches have from time to time occurred. Its site was originally known as Ferry Hook, then Ashley's Ferry, and finally Vanderheyden, the name of the first proprietor of the soil on which Troy stands, after it was conveyed in fee from the Patroon of Rensslaerwyck, in the year 1720. After the Revolution the spot attracted some attention as an eligible village site. Town lots were laid out there in the summer of 1787, and two year afterward the freeholders of the embryo city, at a meeting in Albany, resolved that "in future it should be called and known by the name of Troy." At the same time, with the prescience of observing men, they said – "It may not be too sanguine to expect, at no very distant period, to see Troy as famous for her trade and navigation as many of our first towns."

BENSON JOHN LOSSING

The Hudson: From the Wilderness to the Sea, 1866

MARCUS T. REYNOLDS, AN ALBANY ARCHITECT ... AND A GRANDSON OF the first president of the Albany Northern Railway, was commissioned to design the Flemish-Gothic castle-like structure that would be the new home of the D&H general offices ... The new headquarters involved a 12-story tower in line with State Street and two five-story wings, extending at an angle in each direction with a frontage of 664 feet along the Plaza ... High atop the tower a weather vane in the form of a bronze replica of Henry Hudson's ship, the *Half Moon*, stands almost directly over the spot Hudson reputedly dropped anchor on his voyage in 1609.

JIM SHAUGHNESSY

Delaware & Hudson, 1967

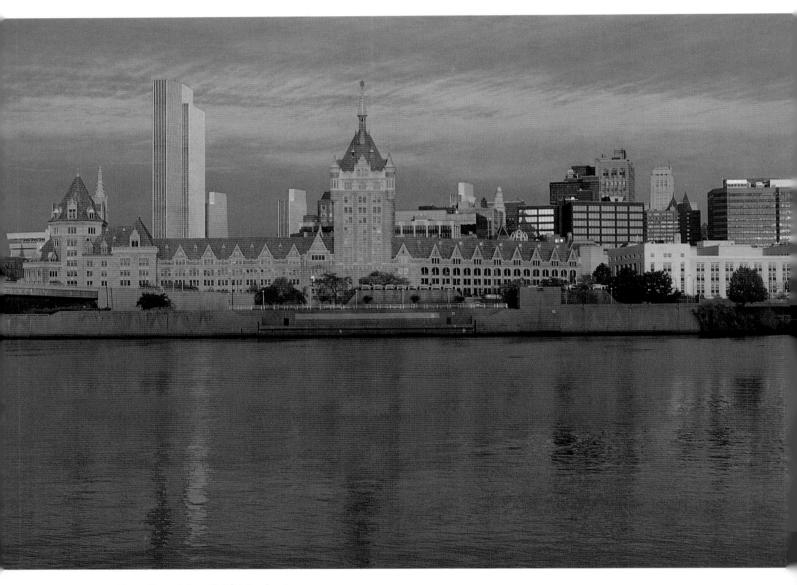

Above: Albany skyline with D & H Headquarters.

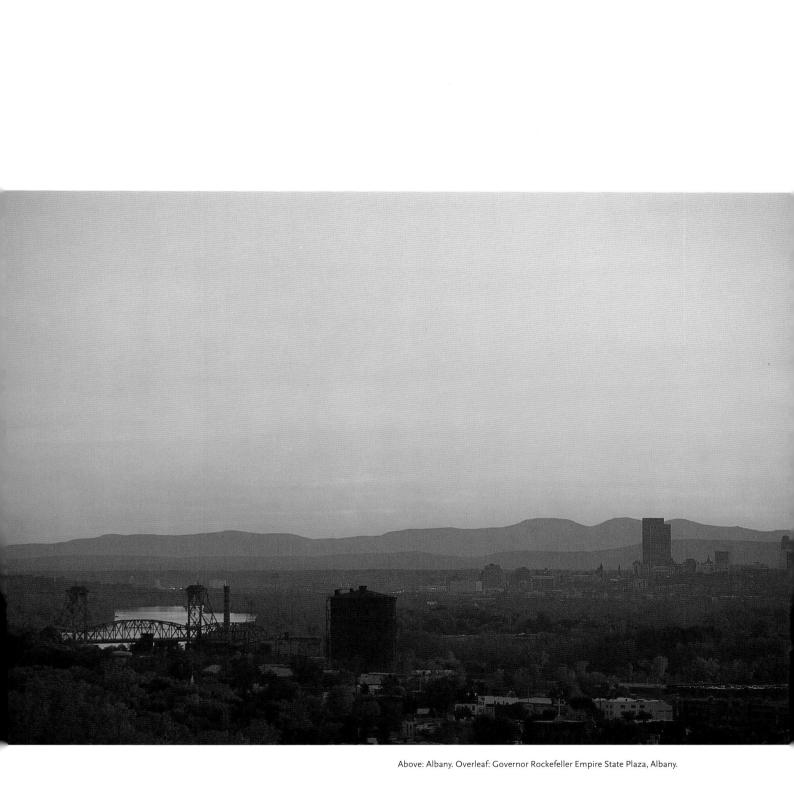

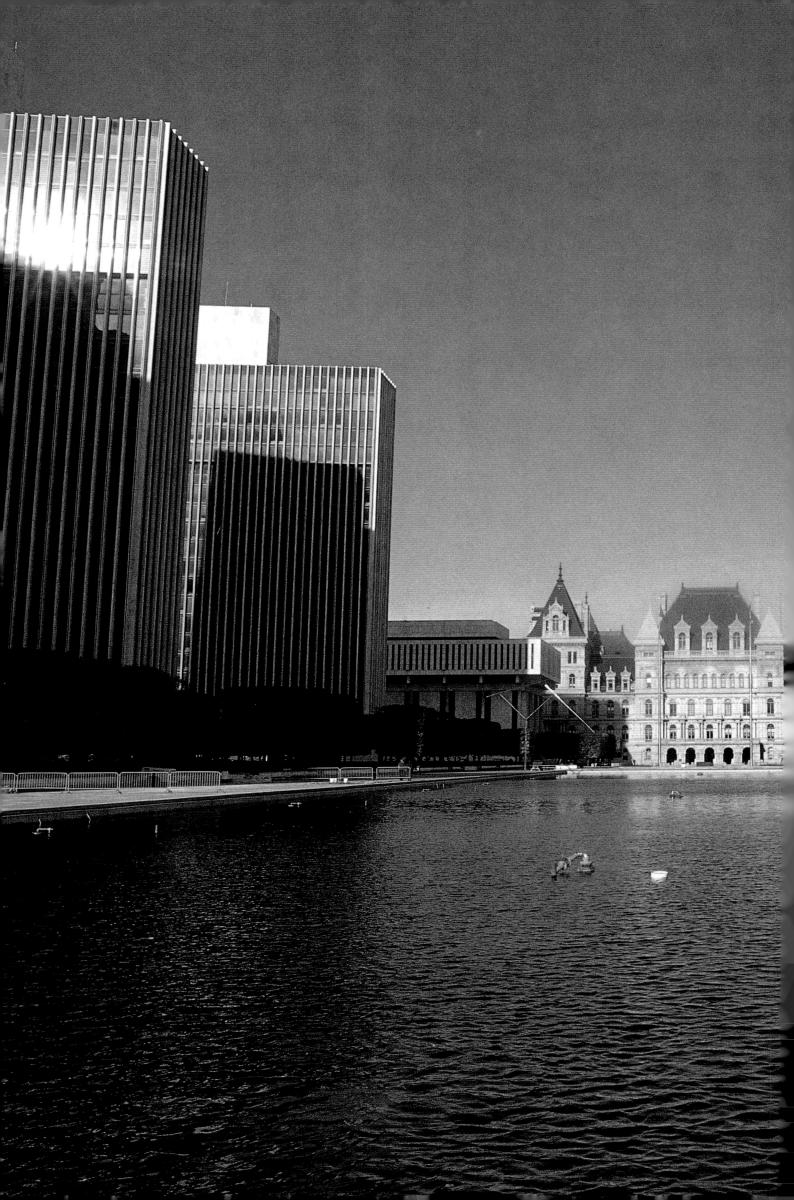

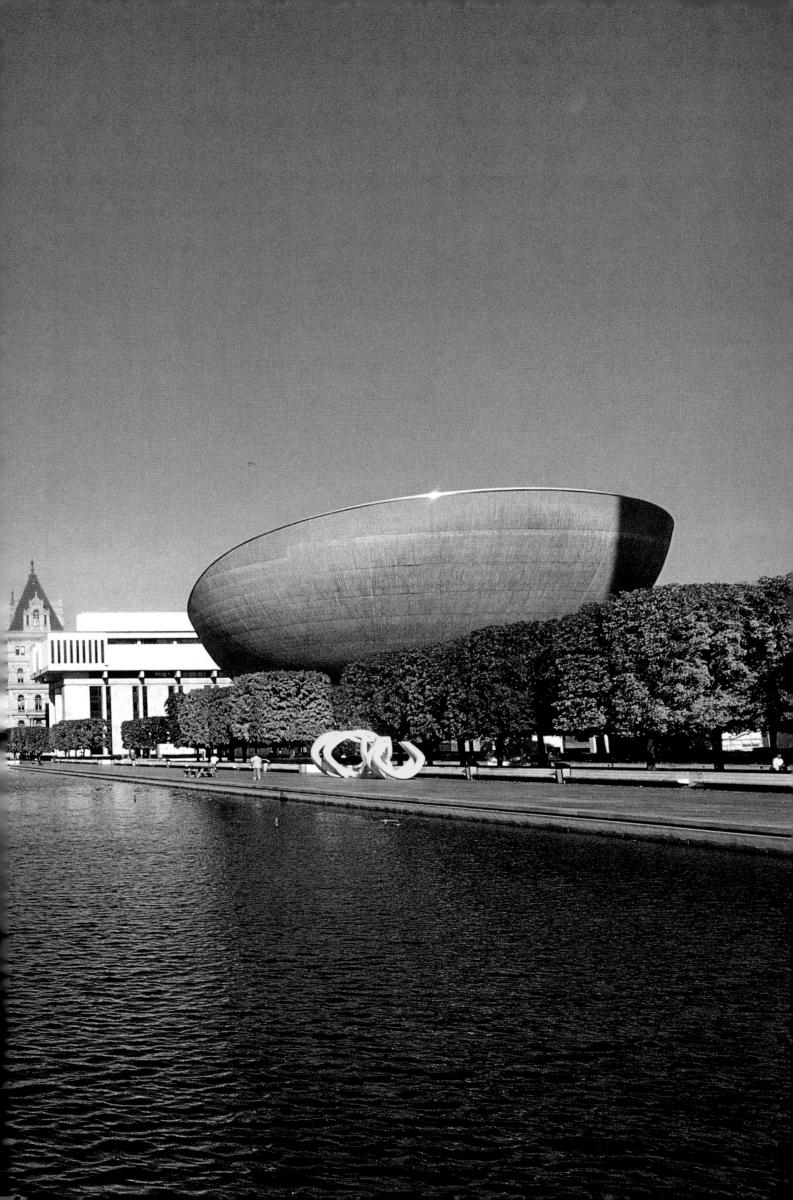

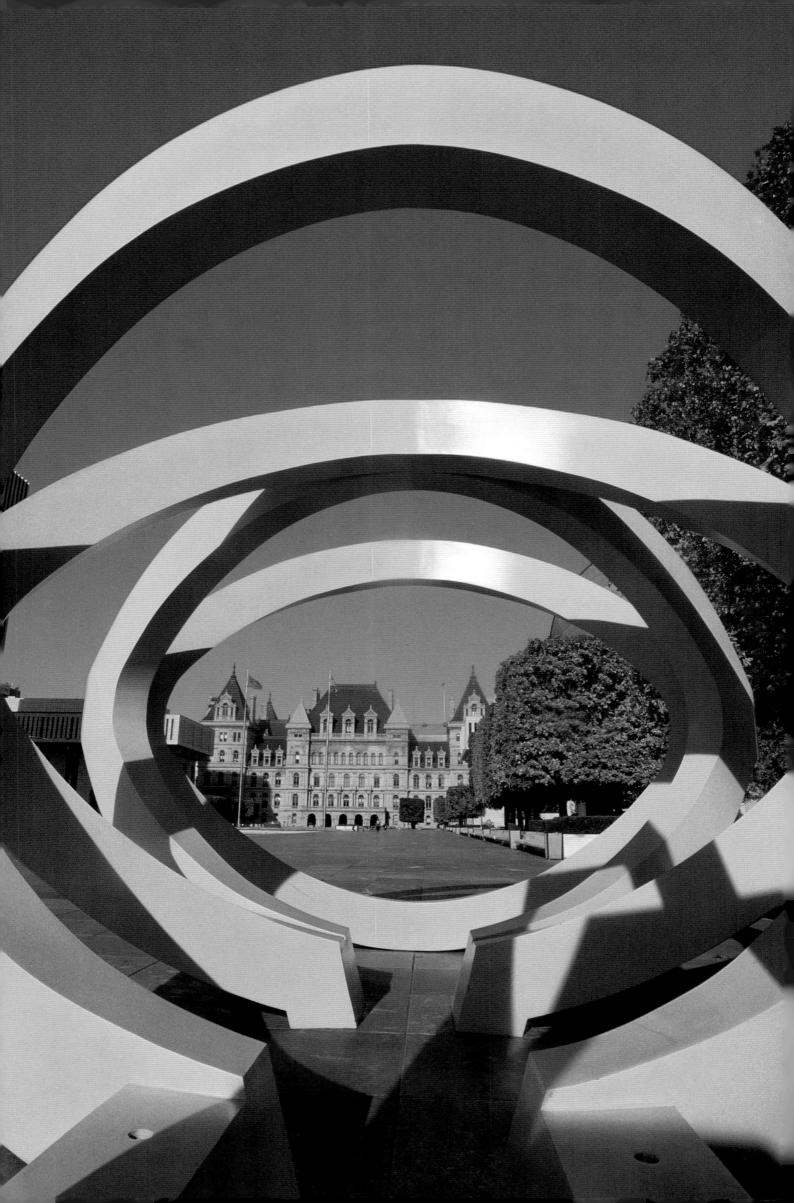

THE HISTORY OF ALBANY IS NOT VERY DEFINITE, TOUCHING ITS FIRST settlement. The probability seems, that, in 1614, the Dutch erected a fort and trading-house on an island just below the city; and also, in nine years after, a fort, which they called Fort Orange, on the present site. It would appear to have been canonically christened, and has been called at different periods Auralia, Beverwyck, and Williamstadt. "All this time," says the historian, "it was known also by the name of 'The Fuyck.'" The Indian appellation in which it rejoiced was Schaunaugh-ta-da, or Once the pine plains.

Albany is the residence of several of the oldest and wealthiest families in the State; but except this, it is a mere centre of transit – the channel through which passes the vast tide of commerce and travel to the north and west. The Erie and Champlain canals here meet the Hudson; and that which is passed up by this long arm from the sea, is handed over to the great lakes by the other two, – as if old Enceladus had been turned into a "wordy," and stood with his long arms between salt water and fresh.

NATHANIEL PARKER WILLIS American Scenery, 1836

State Capitol.

THE NEW CAPITOL HAD BEEN BEGUN IN 1868 WITH THE UNDERSTANDING that it was not to cost more than four million dollars. When the Legislature met in 1875 it had cost five millions, and was very far from complete even up to the floor of the third story – the highest point to which the walls had been carried. At least seven millions more were declared needful to complete it in accordance with the designs of the architect in charge, and it was apparent to the most superficial observer that these designs were proving unsatisfactory in almost every practical respect. The Legislature therefore appointed a new Commission with Lieutenant-Governor Dorsheimer as its chairman to inquire into the prospects of the work, and resolved to grant no more money except upon its recommendation. This commission appointed Messrs. [Leopold] Eidlitz, [Henry Hobson] Richardson, and [Frederick Law] Olmsted as its Advisory Board of Architects. Early in 1878 a detailed report based upon a careful examination of the building itself and of the architect's drawings was submitted by the Board to the Commission and by the Commission to the Senate ... By order of the Commission work upon the Capitol was resumed in accordance with the new design proposed by Messrs. Eidlitz and Richardson.

MARIANA GRISWOLD VAN RENSSELAER

Henry Hobson Richardson and His Works, 1888

State Capitol.

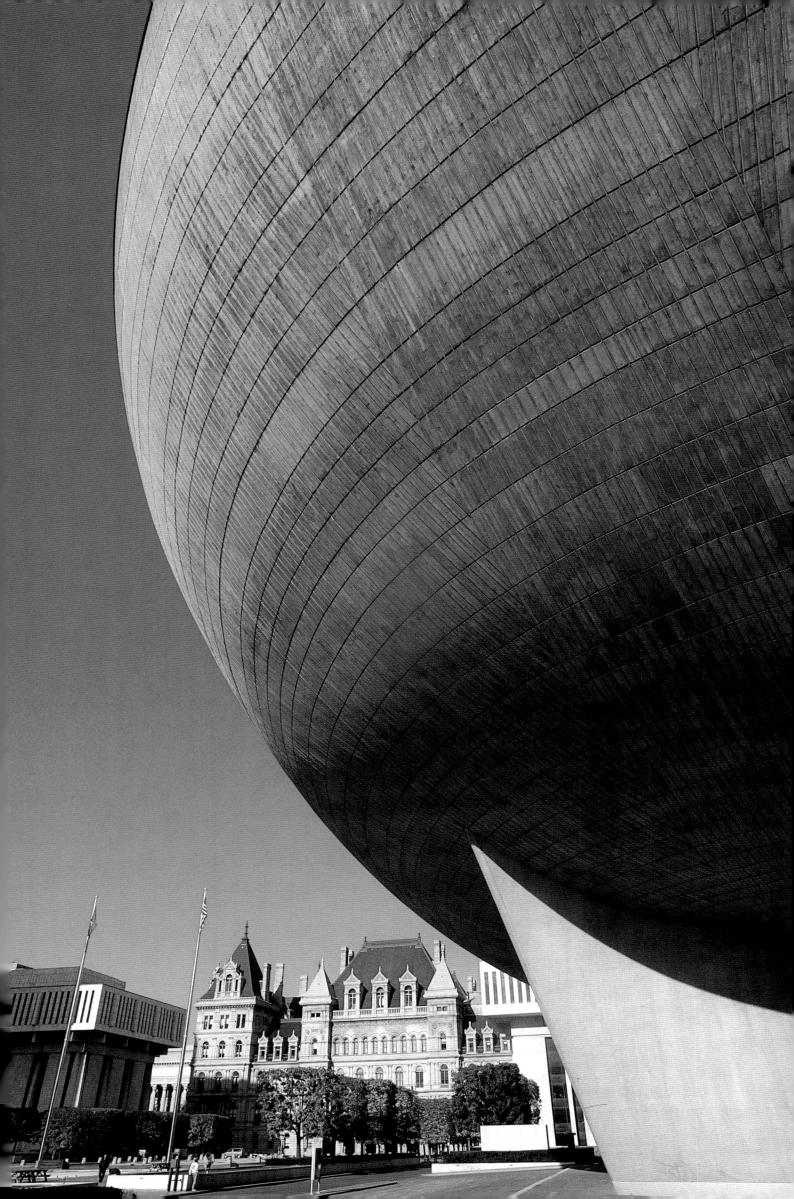

Above and opposite: Old Chatham.

WHOEVER HAS MADE A VOYAGE UP THE HUDSON MUST REMEMBER THE Kaatskill Mountains. They are a dismembered branch of the great Appalachian family, and are seen away to the west of the river, swelling up to a noble height, and lording it over the surrounding country. Every change of season, every change of weather, indeed, every hour of the day, produces some change in the magical hues and shapes of these mountains, and they are regarded by all the good wives, far and near, as perfect barometers. When the weather is fair and settled, they are clothed in blue and purple, and print their bold outlines on the clear evening sky; but, sometimes, when the rest of the landscape is cloudless, they will gather a hood of gray vapors about their summits, which, in the last rays of the setting sun, will glow and light up like a crown of glory.

WASHINGTON IRVING

Autobiography, 1909

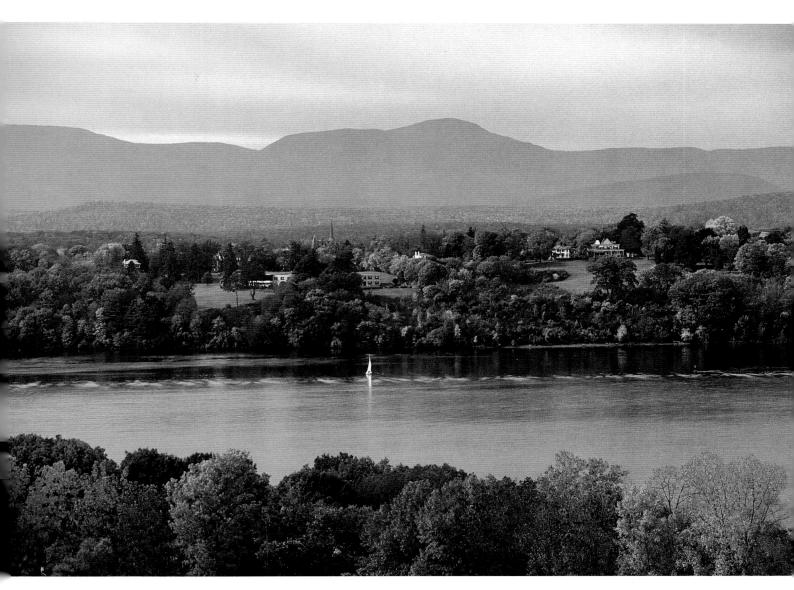

The Catskills from Hudson.

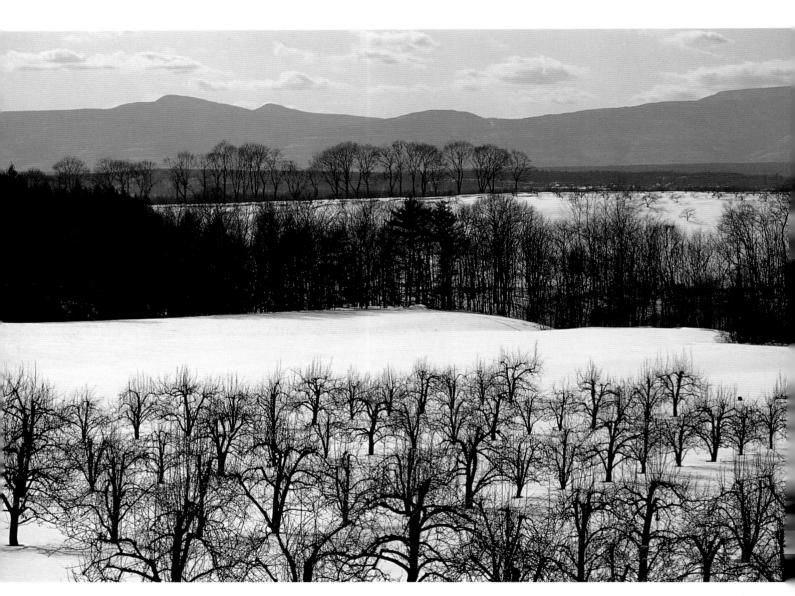

Above and opposite: Apple orchards in Hudson.

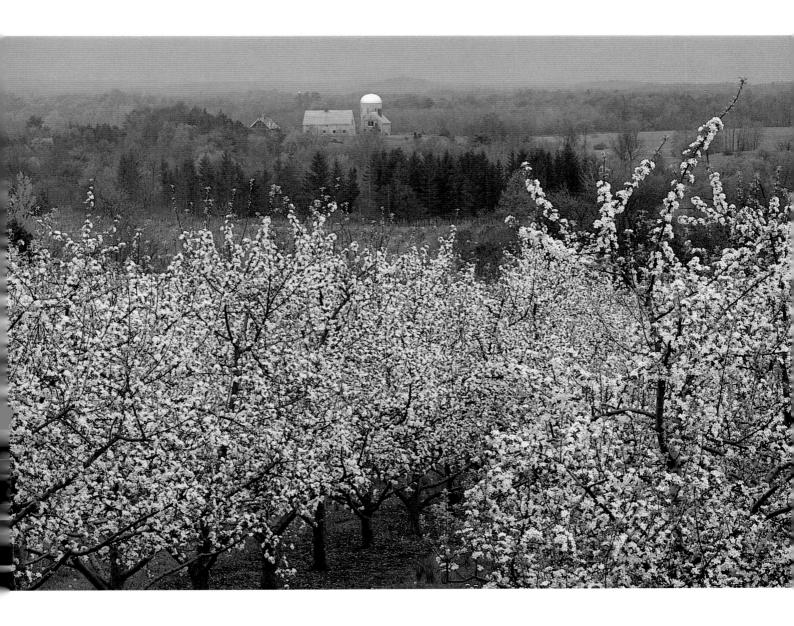

HUDSON (115 MILES FROM NEW YORK; POPULATION 9,633), WAS FOUNDED in the year 1784, by thirty persons from Providence, R. I., and incorporated as a city in 1785. The city is situated on a sloping promontory, bounded by the North and South Bays. Its main streets, Warren, Union and Allen, run east and west a little more than a mile in length, crossed by Front Street, First, Second, Third, etc. Main Street reaches from Promenade Park to Prospect Hill. The Park is on the bluff just above the steamboat landing; we believe this city is the only one on the Hudson that has a promenade ground overlooking the river. It commands a fine view of the Catskill Mountains, Mount Merino, and miles of river scenery...

Hudson grew more rapidly than any other town in America except Baltimore. Standing at the head of ship navigation it would naturally have become a great port had it not been for the steam engine and the steamboat.

There was also a good sprinkling of Nantucket blood, and visitors from that quaint old town recognize in portico, stoop, and window a familiar architecture. Columbia Springs, an old-fashioned resort with pleasant grove and white sulphur water, lies four miles northeast of Hudson. Claverack, three and a half miles east of Hudson is a restful old-fashioned village. It is situated at the crossing of the old Post Road and the Columbia Turnpike and was county seat of Columbia in Knickerbocker days.

WALLACE BRUCE

The Hudson,1901

Opposite: Warren Street, Hudson. Overleaf: Olana State Historic Site, Hudson.

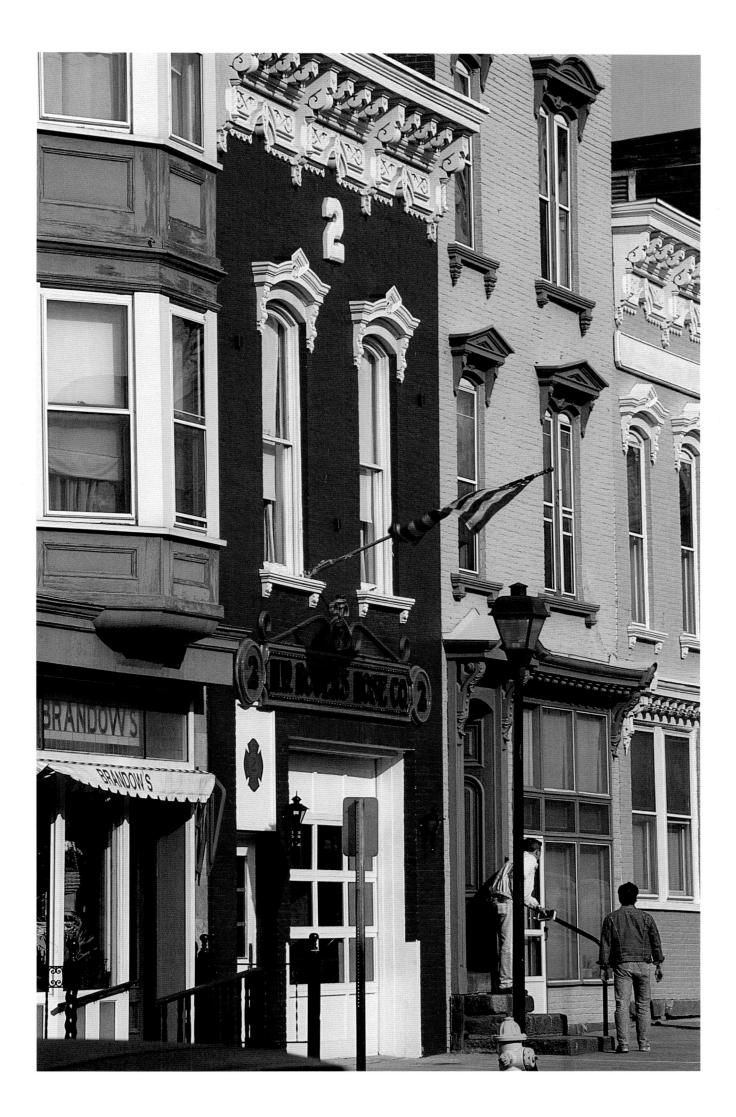

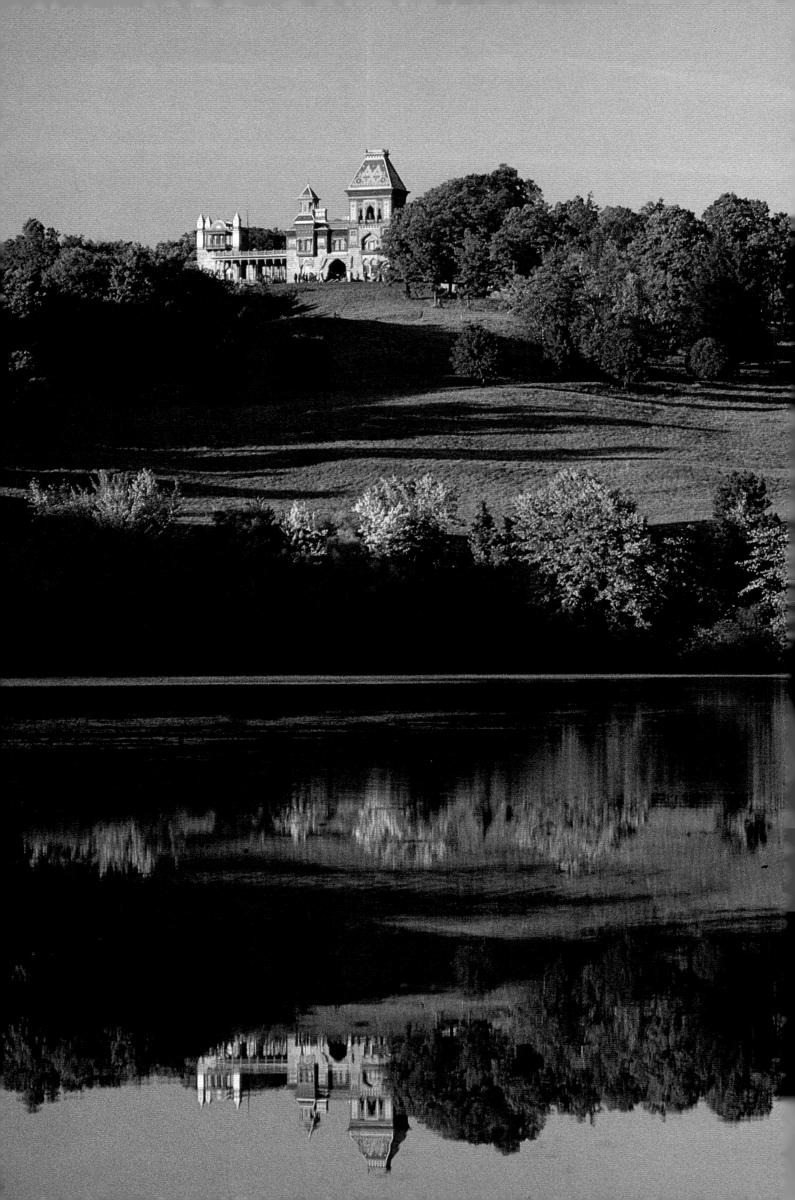

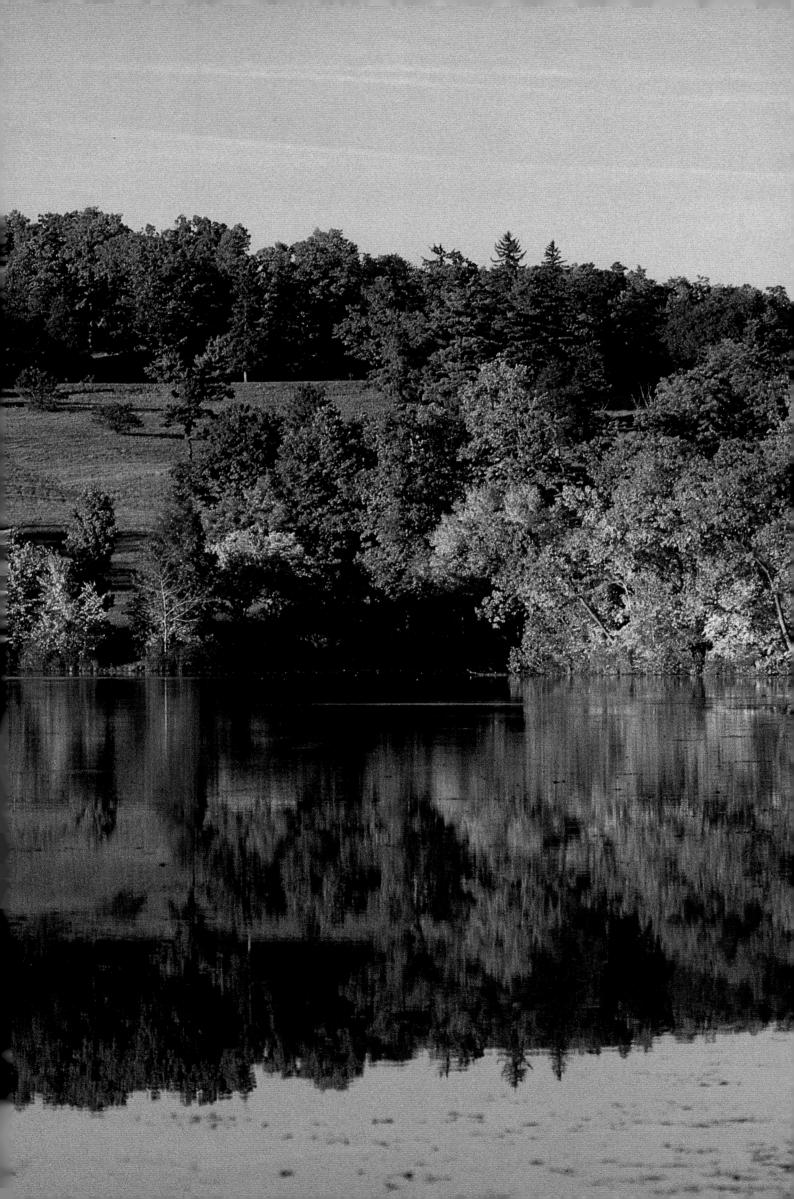

FREDERIC EDWIN CHURCH, BORN AT HARTFORD, CONNECTICUT, WAS THE son of a wealthy man whose considerable assets provided the youth with the means to develop his early interest in art. By the age of sixteen, he was studying drawing and painting; two years later, Daniel Wadsworth, son-in-law of John Trumbull and, like Trumbull, a patron of Thomas Cole's, prevailed upon Cole to take Church as his pupil. Church's precociousness displayed itself quickly...

In 1860 Church bought farmland at Hudson, NewYork, and married Isabel Carnes, whom he met during the exhibition of his Heart of the Andes. His marriage to both – his wife and his farm – became the joint center of his life, in later years tending to divert his attentions from painting major canvases. Church's happiness was blasted in March of 1865, when his son and his daughter died of diphtheria, but with the birth of Frederic junior in 1866, Church and his wife began a new family that was eventually to number four children. In late 1867, the Churches launched on an eighteen-month trip to Europe, North Africa, the Near East, and Greece that was the genesis of several important pictures. Church, however, began to devote his creative energies increasingly to gentleman farming and to the designing and redesigning of Olana, his hilltop fantasy of a Persian villa at Hudson, NewYork, a seemingly endless undertaking begun in 1869 in consultation with the architect Calvert Vaux. From the 1870s until his death afflicted with painful rheumatism of the right arm, which interrupted or prevented work on major pictures, Church still managed to produce in his later years a few large retrospective canvases. His final artistic legacy was a multitude of breathtaking small oil sketches, mostly of Olana ...

ЈОНИ К. НОШАТ

American Paradise: The World of the Hudson River School, 1987

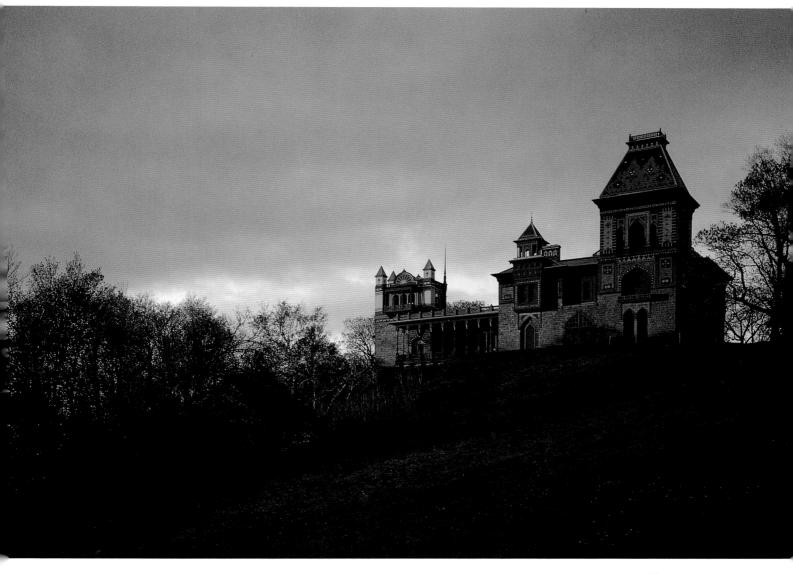

Olana.

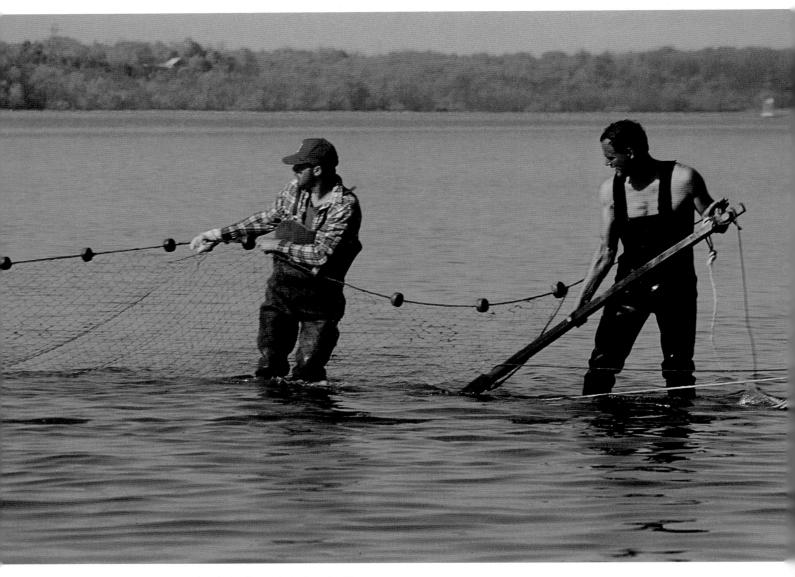

Above, opposite, and overleaf: Fishing in the Hudson, Catskill.

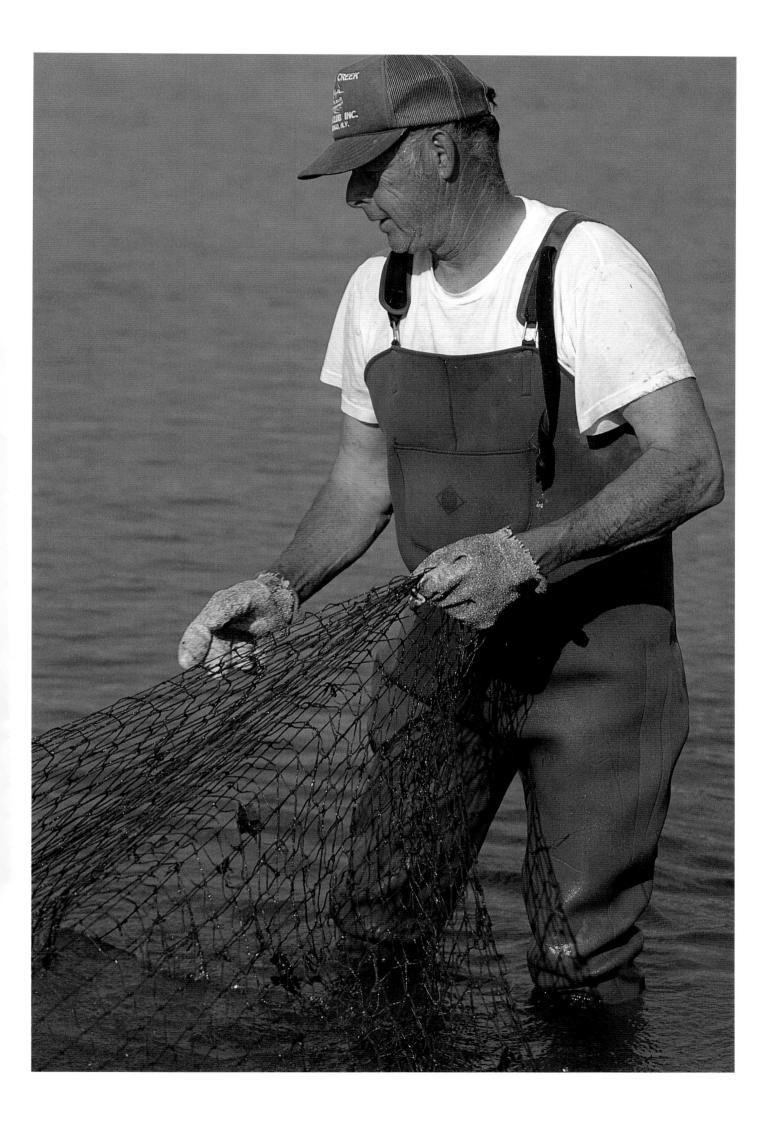

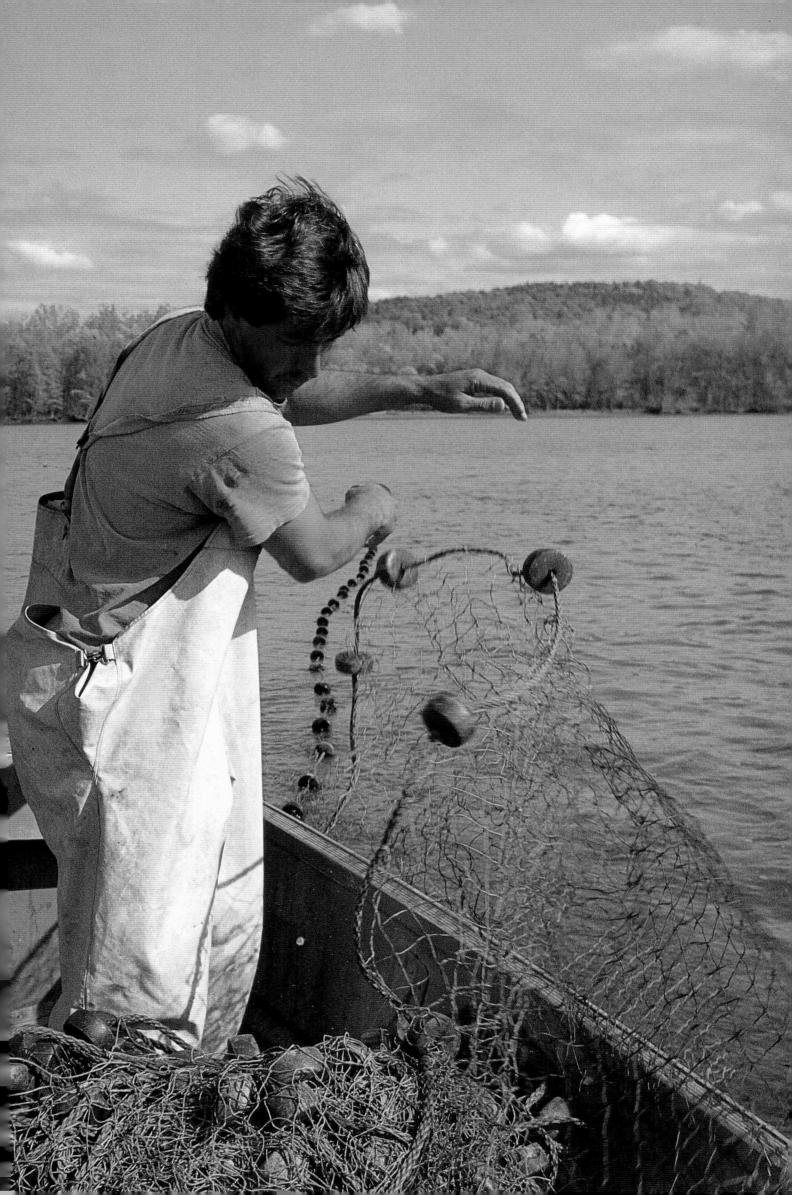

Clermont State Historic Site, Germantown.

CLERMONT, THE MANSION LIVINGSTON HAD BUILT FOR HIMSELF IN 1793, stood high on a natural terrace looking across the broad Hudson RiverValley to the timeworn Catskill Mountains, their rounded peaks silvery at that season with encrustations of ice and snow. The design of the house was highly personal. Extending from the two-story central section were four one-story pavilions – in plan like an H with the 104-foot-long sides squarely facing the river and the mountains beyond. Built of brick and local stone and covered with stucco, the most striking feature was the great multi-paned windows, which gave the exterior the airy elegance of a small French chateau and admitted to the interior abundant light. Much of the furniture and wallpaper was imported from France. The library, of which Livingston was justly proud, contained over four thousand volumes. The greenhouse, with adjoining bathing rooms and offices that he had just added to the south wing, was innovative and pleasant.

CYNTHIA OWEN PHILIP

Robert Fulton: A Biography, 1985

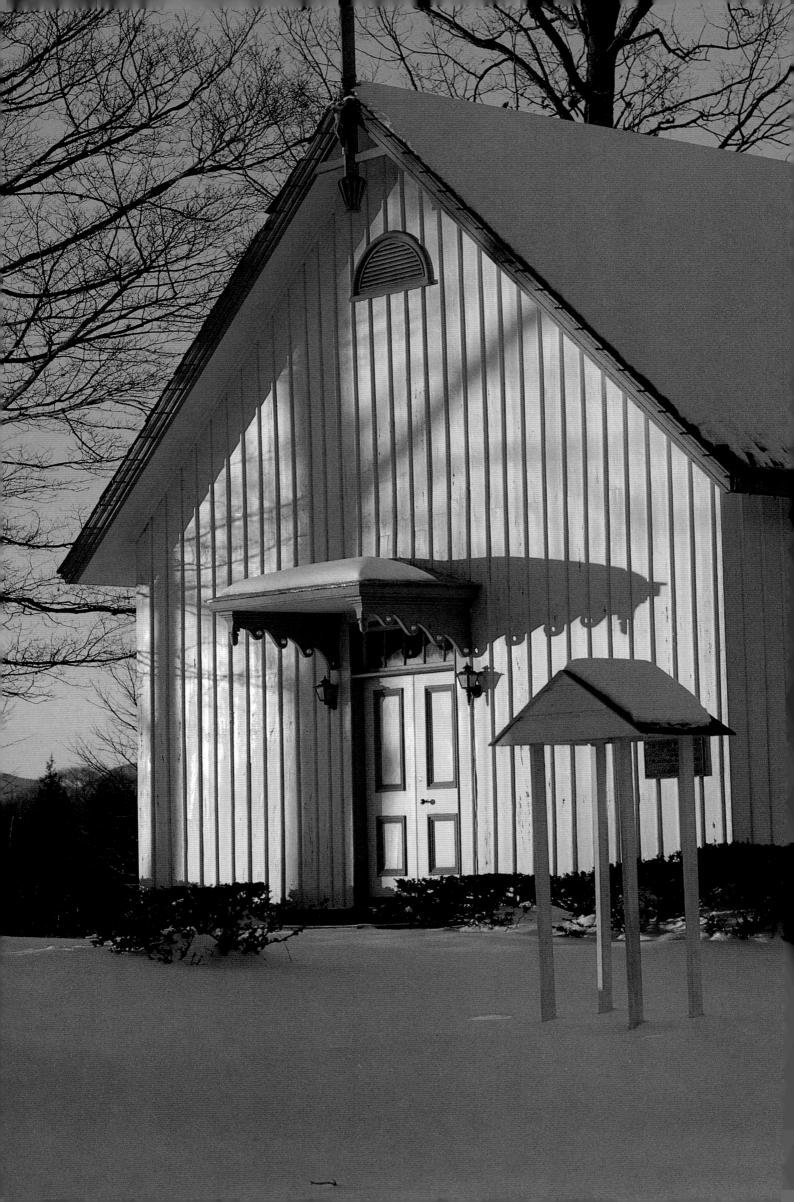

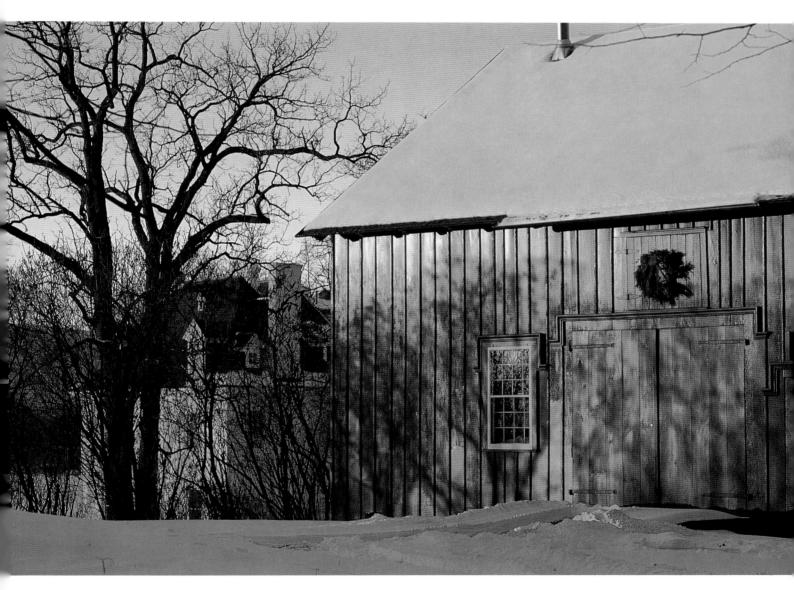

Above and opposite: Clermont.

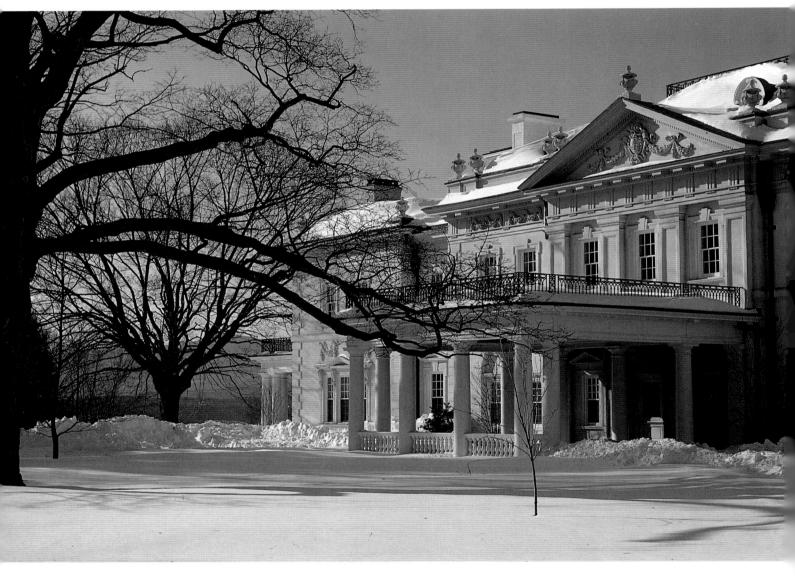

Above and opposite: Blithewood, Bard College, Annandale.

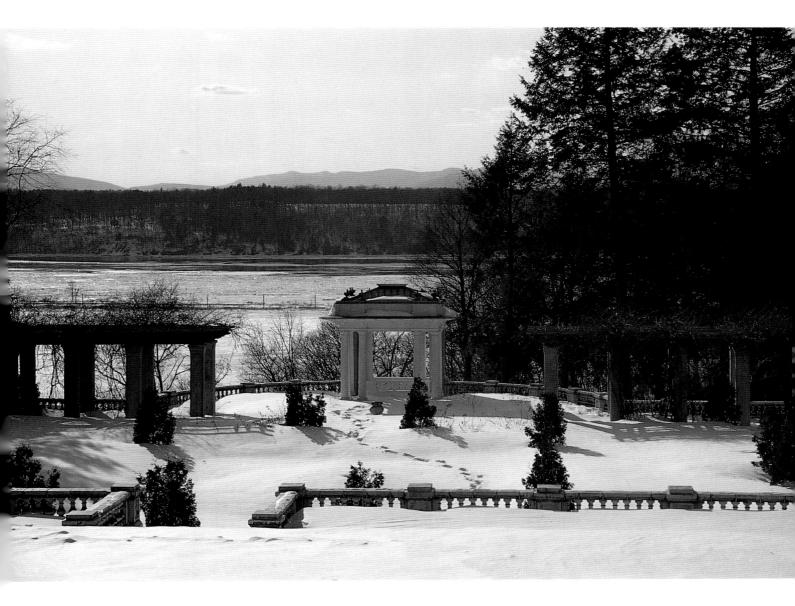

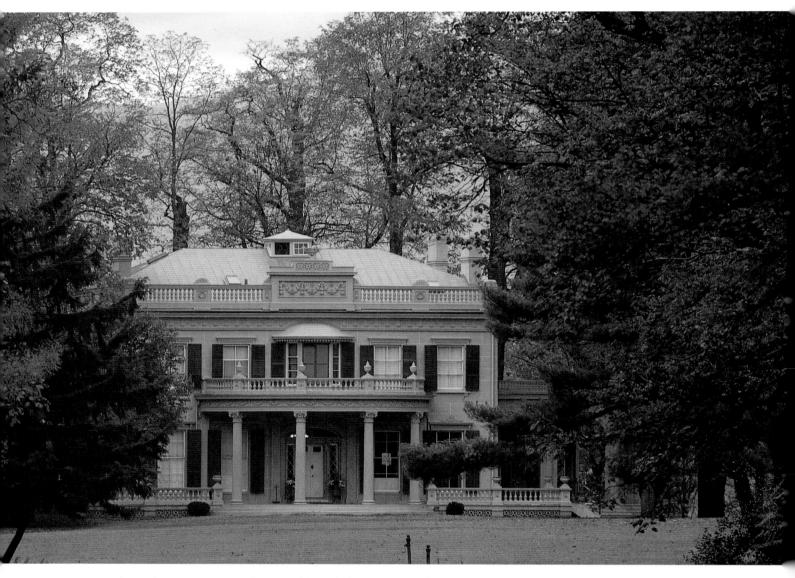

Above and opposite: Montgomery Place, Annandale. Overleaf and second overleaf: Hudson River Valley from Escarpment Trail.

IN 1818 THE LEGISLATURE OF NEW YORK – DEWITT CLINTON, GOVERNOR – ordered the remains of General Montgomery to be removed from Canada to NewYork. Governor Clinton had informed Mrs. Montgomery of the hour when the steamer Richmond, conveying the body, would pass her home. At her own request she stood alone on the portico. It was forty years since she had parted from her husband, to whom she had been wedded but two years when he fell on the heights of Quebec; yet she had remained faithful to the memory of "her soldier," as she always called him. The steamboat halted before the mansion; the band played the "Dead March," and a salute was fired; and the ashes of the venerated hero, and the departed husband, passed on.

WILLIAM LEETE STONE

History of New York City, 1901

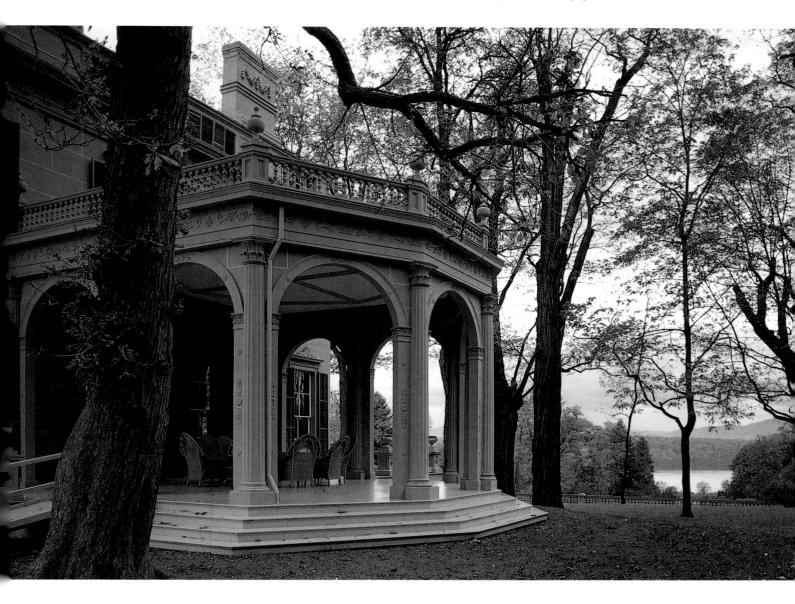

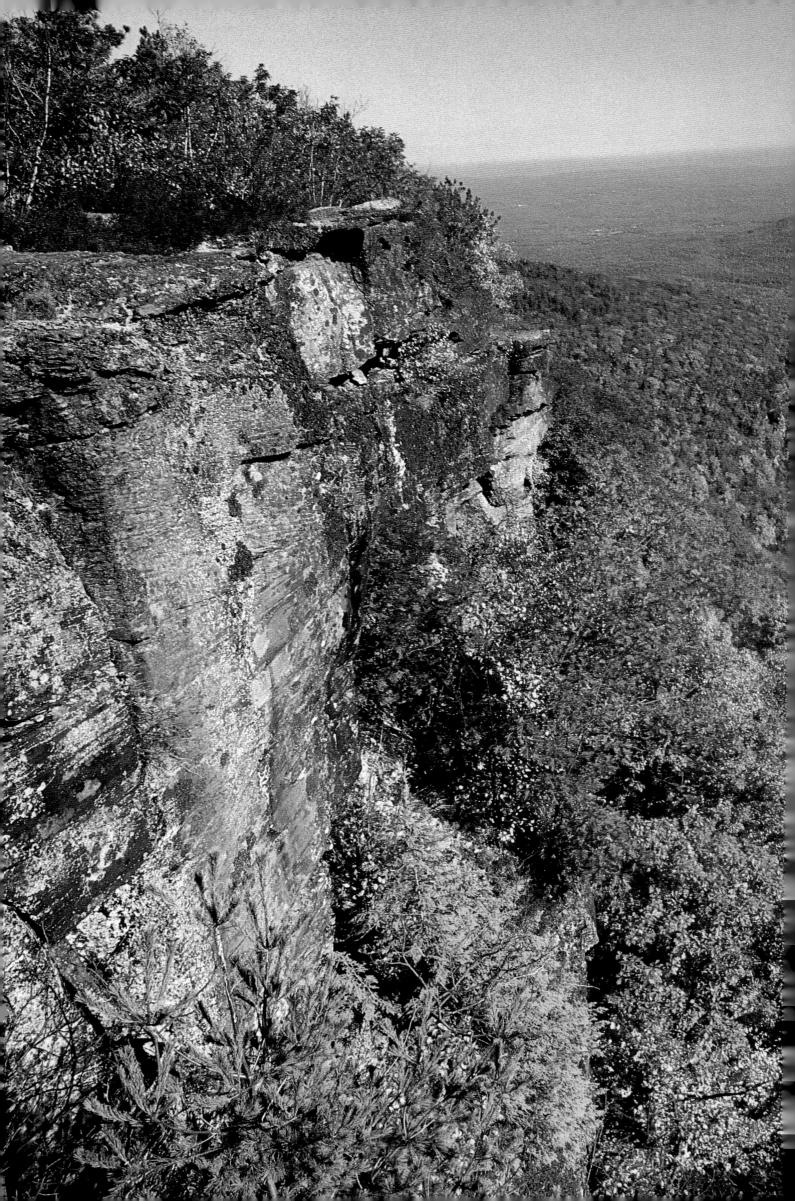

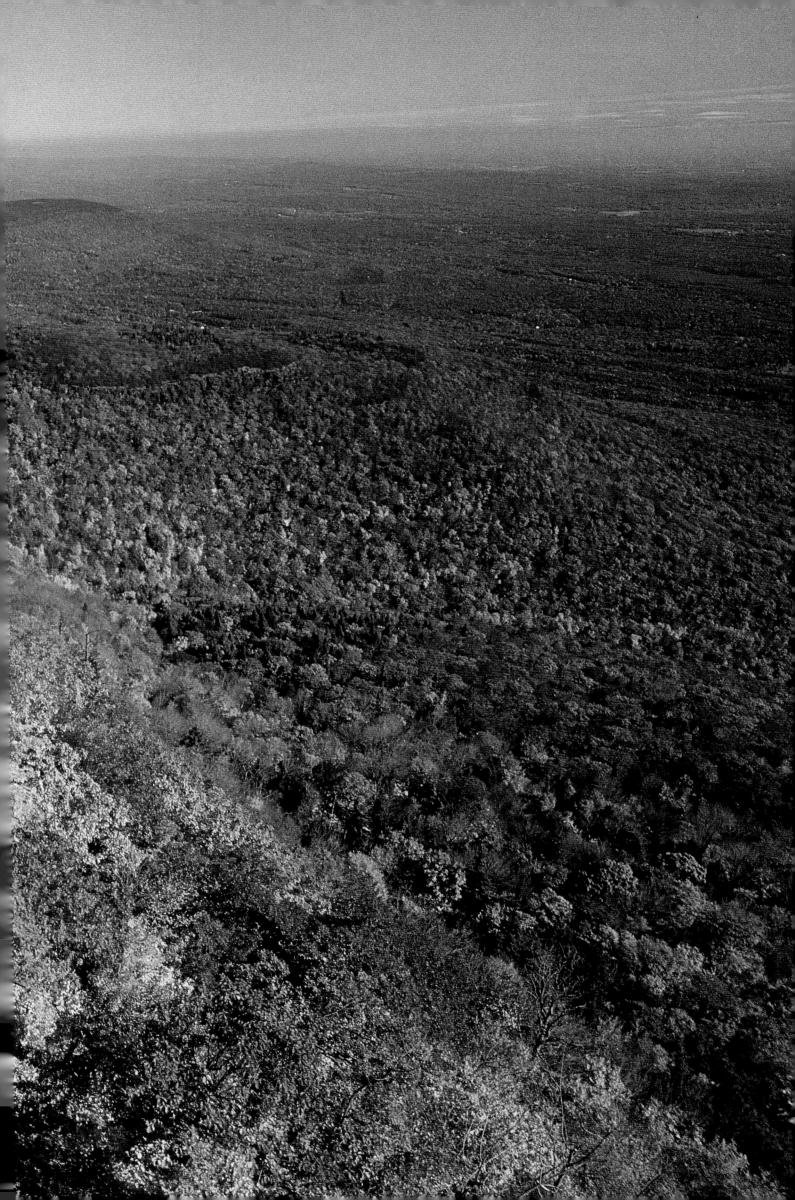

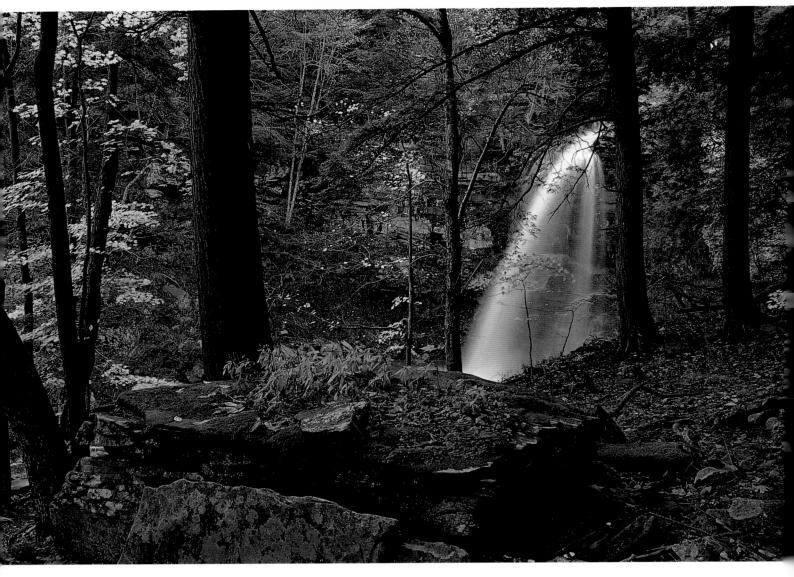

Above and opposite: Platte Cove Waterfall, Catskill Park.

"WHY, THERE'S A FALL IN THE HILLS WHERE THE WATER OF THE TWO LITTLE ponds, that lie near each other, breaks out of their bounds and runs over the rocks into the valley ... The water comes crooking and winding among the rocks; first so slow that a trout could swim in it, and then starting and running like a creatur' that wanted to make a far spring, till it gets to where the mountain divides, like the cleft hoof of a deer, leaving a deep hollow for the brook to tumble into... The stream gathers itself together again for a new start, and maybe flutters over fifty feet of flat rock before it falls another hundred, when it jumps about from shelf to shelf, first turning thisaway and then turning thataway, striving to get out of the hollow, till it finally comes to the plain."

JAMES FENIMORE COOPER

Natty Bumpo in The Pioneers, 1823

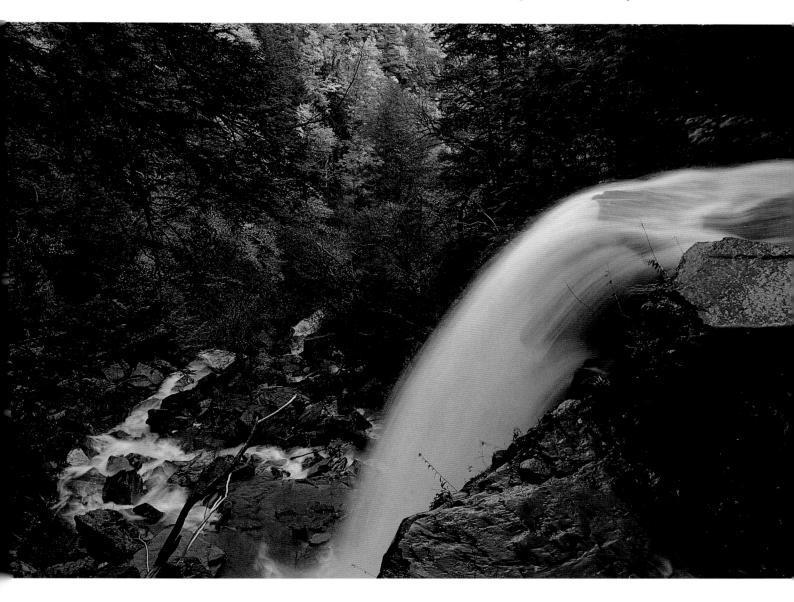

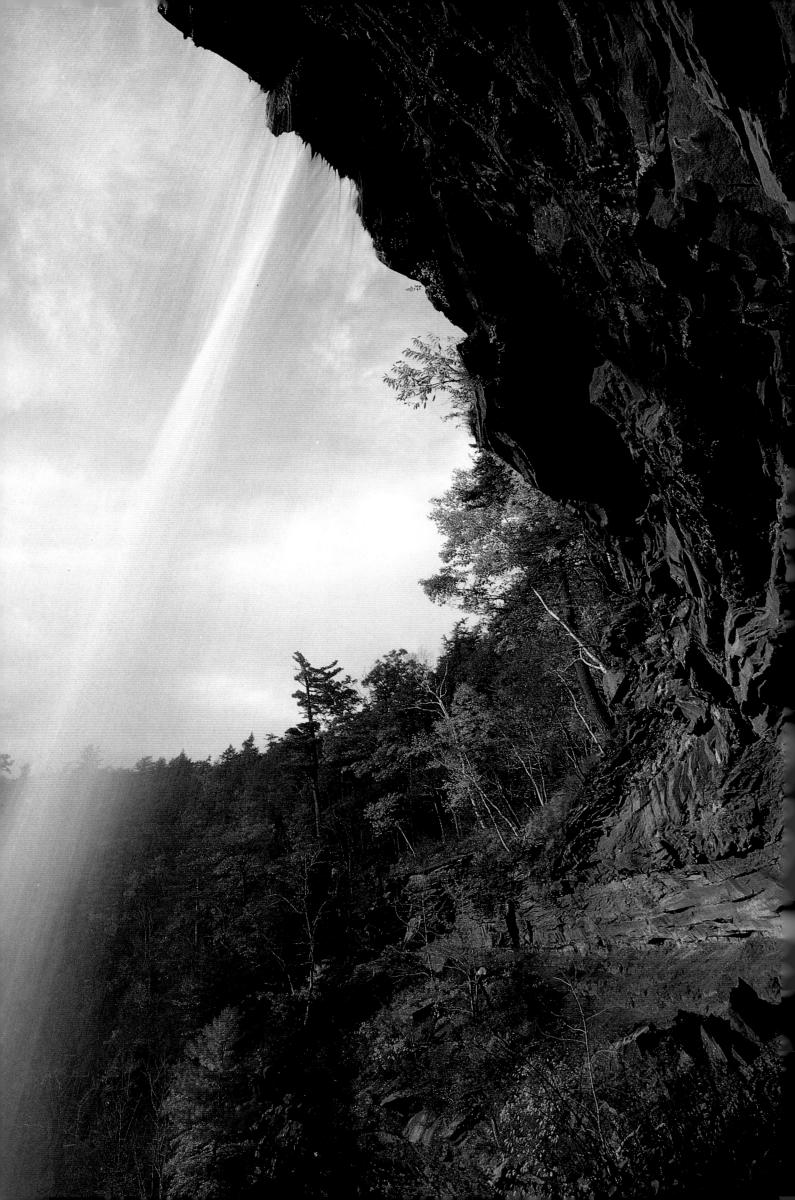

AN EARLY COMMENT ON THE VEGETATION OF THE AREA IS FOUND IN HENRY Hudson's Journal in an entry made in 1609 at a point twelve days sail up the Hudson River, "We rode still and went on land to walke of the west side of the River, and found goode grounde for corn and other garden herbs, with great store of goodly oakes and walnut-trees and Chestnut trees, ewe trees and trees of sweetwood in great abundance."

ROBERT P. MCINTOSH

The Forest Cover of the Catskill Mountain Region, New York, As Indicated by Land Survey Records, 1962

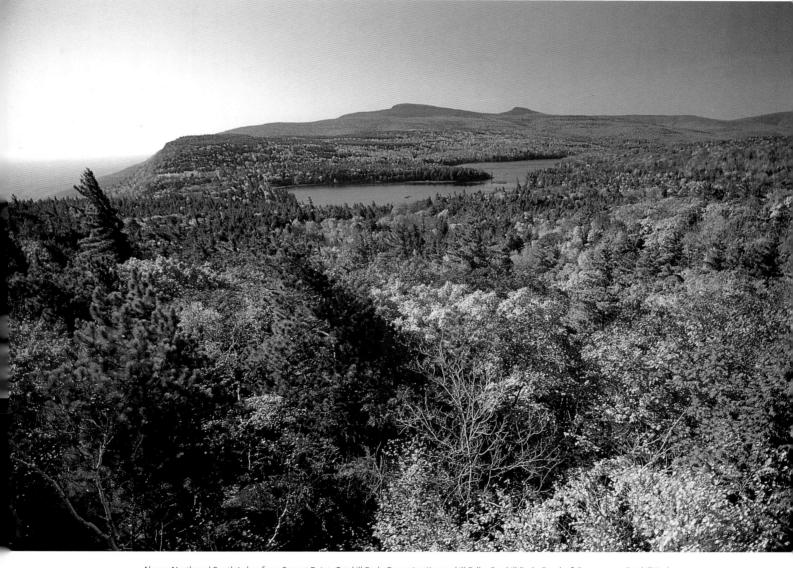

Above: North and South Lakes from Sunset Point, Catskill Park. Opposite: Kaaterskill Falls, Catskill Park. Overleaf: Snowgeese, Catskill Park.

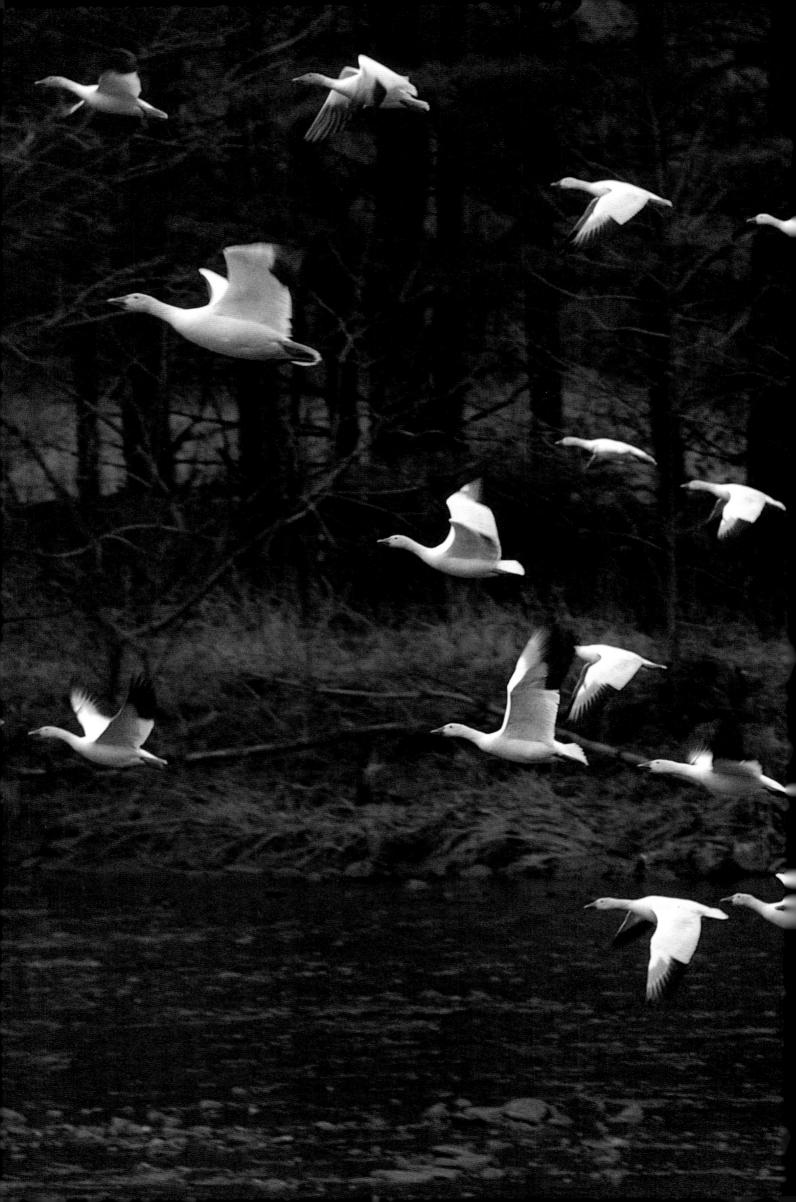

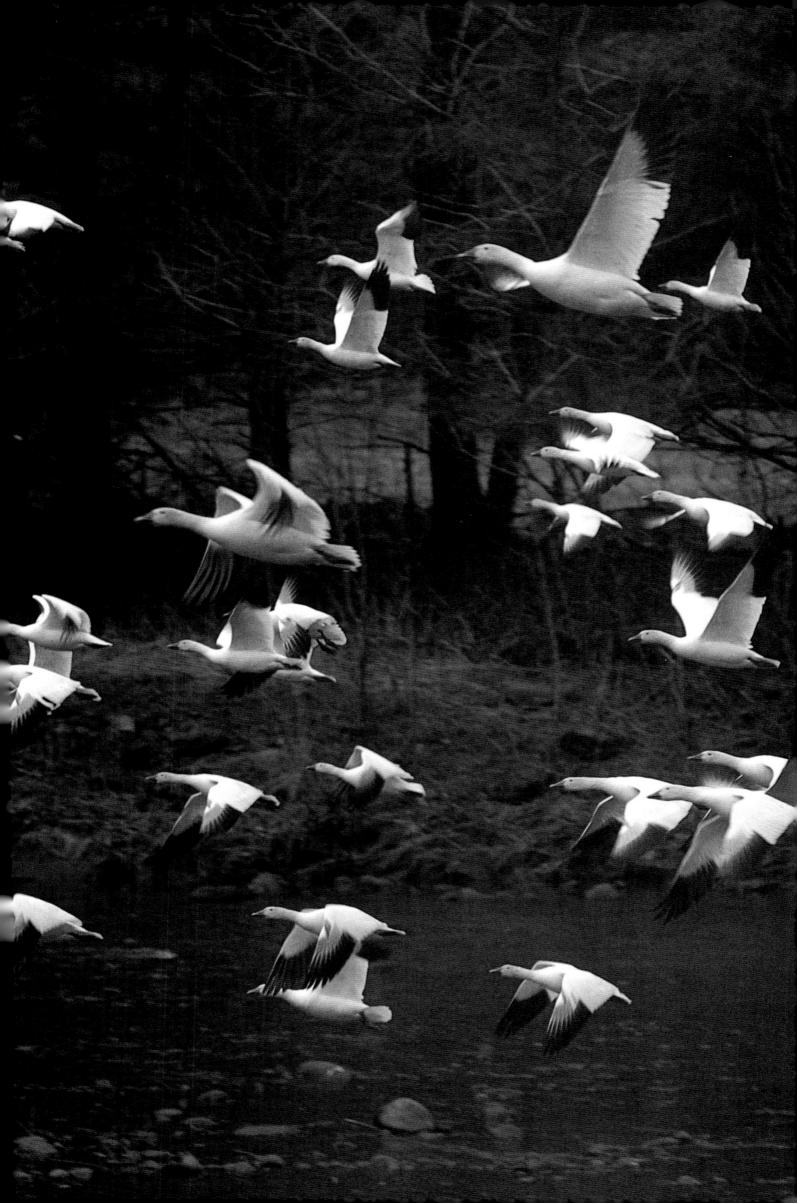

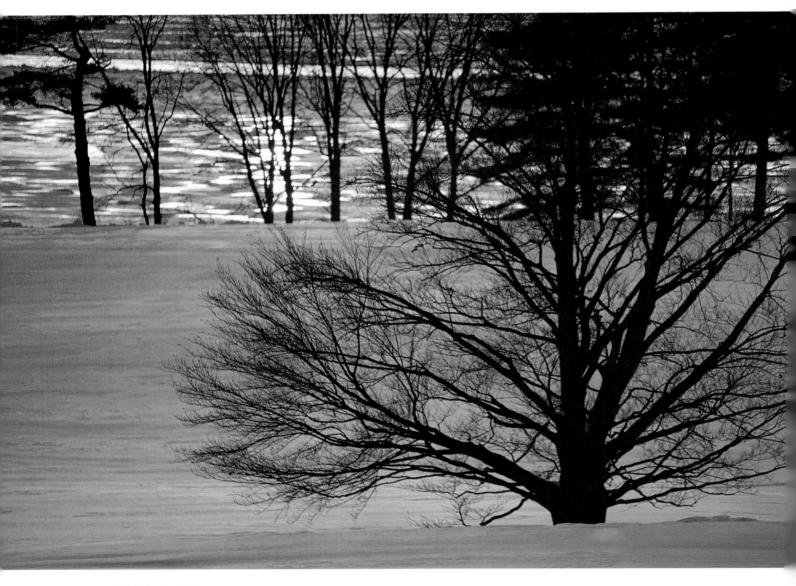

The Hudson in winter.

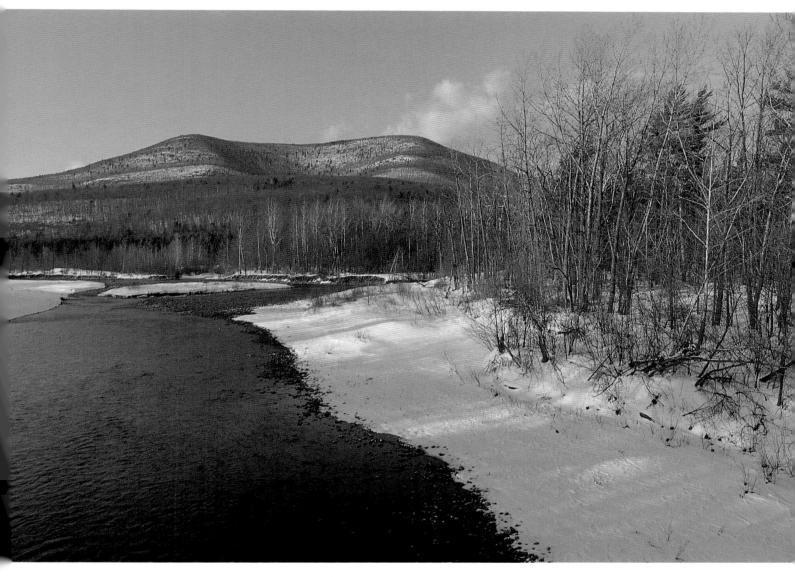

Above: Esopus Creek and Mount Tremper, Catskill Park. Overleaf: Esopus Creek, Catskill Park.

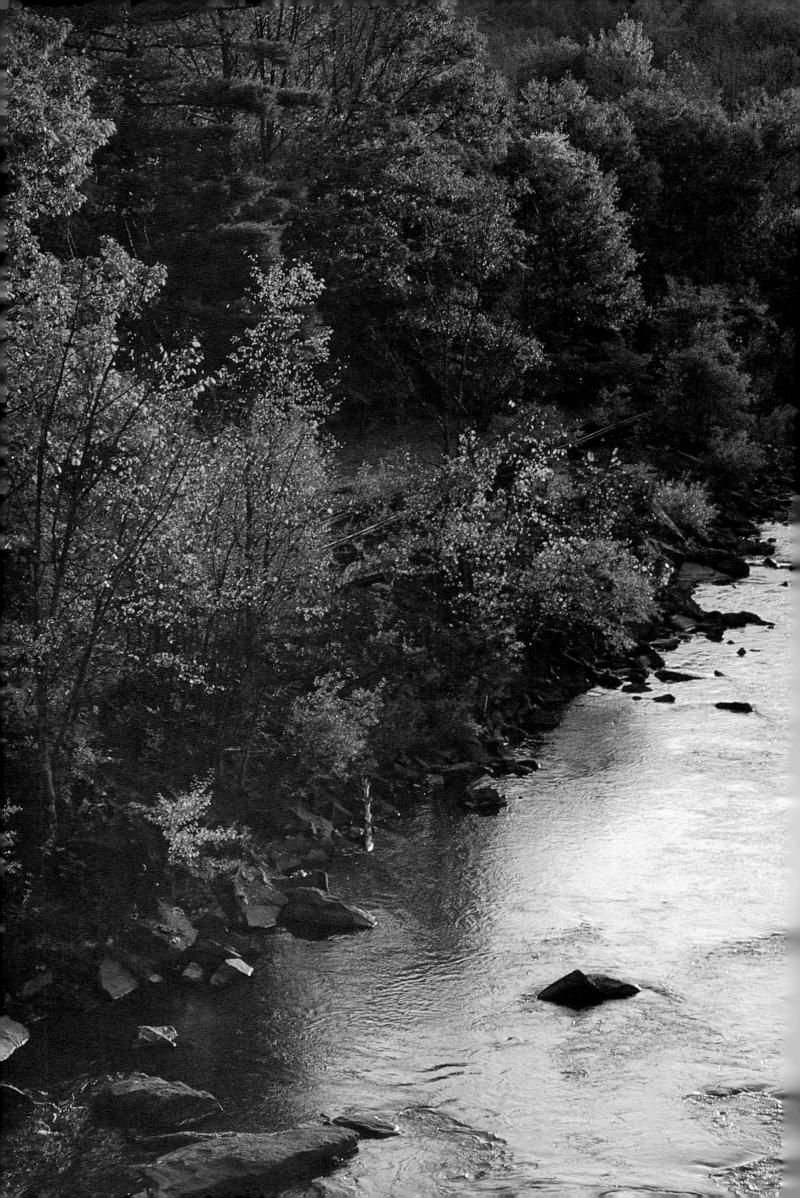

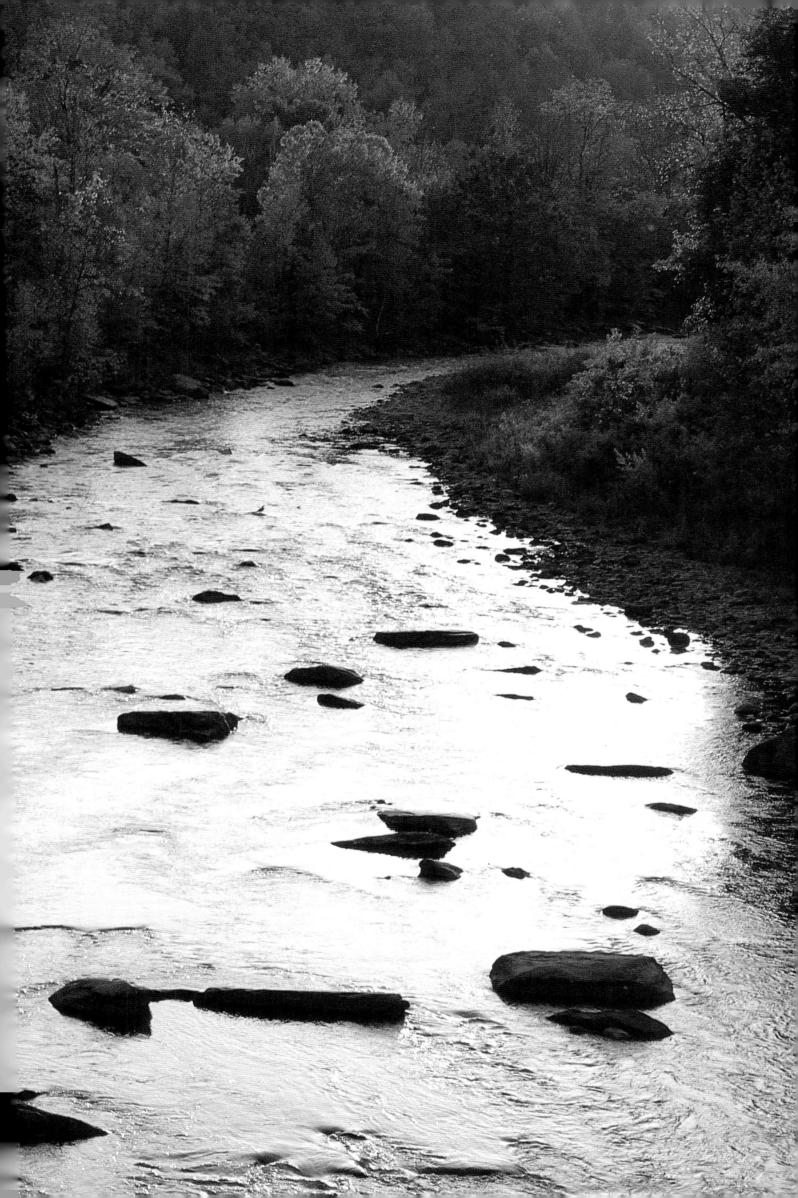

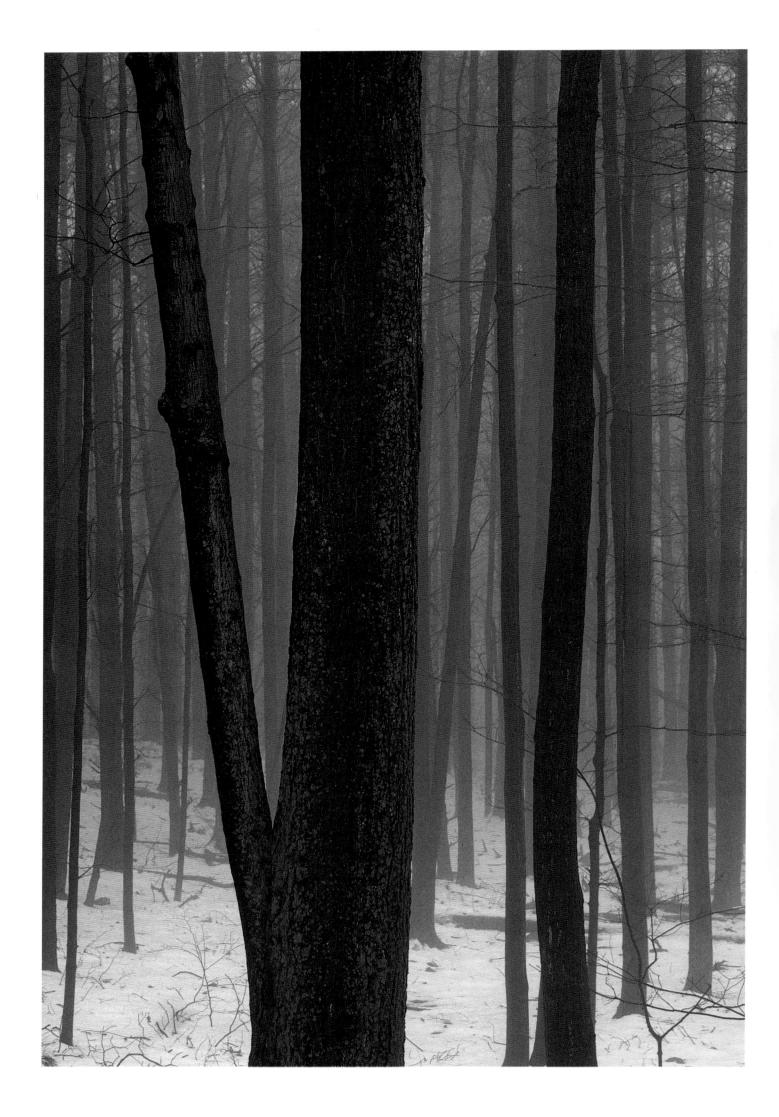

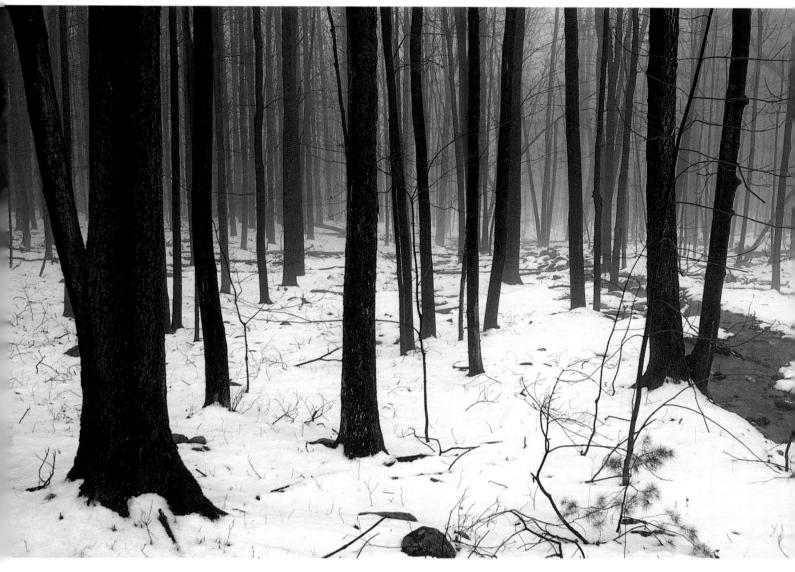

Above and opposite: Trees around Ashokan Reservoir, Catskill Park. Overleaf: Road to Mount Tremper, Catskill Park. Second overleaf: Kingston.

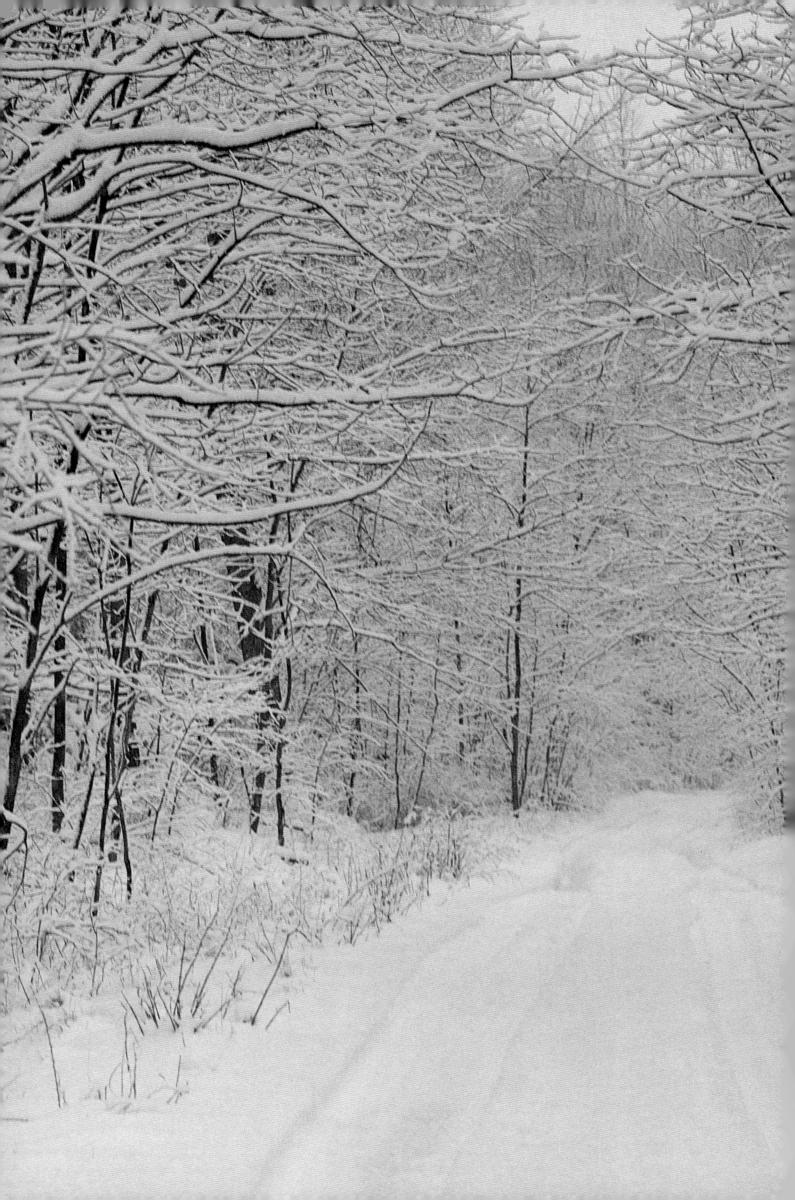

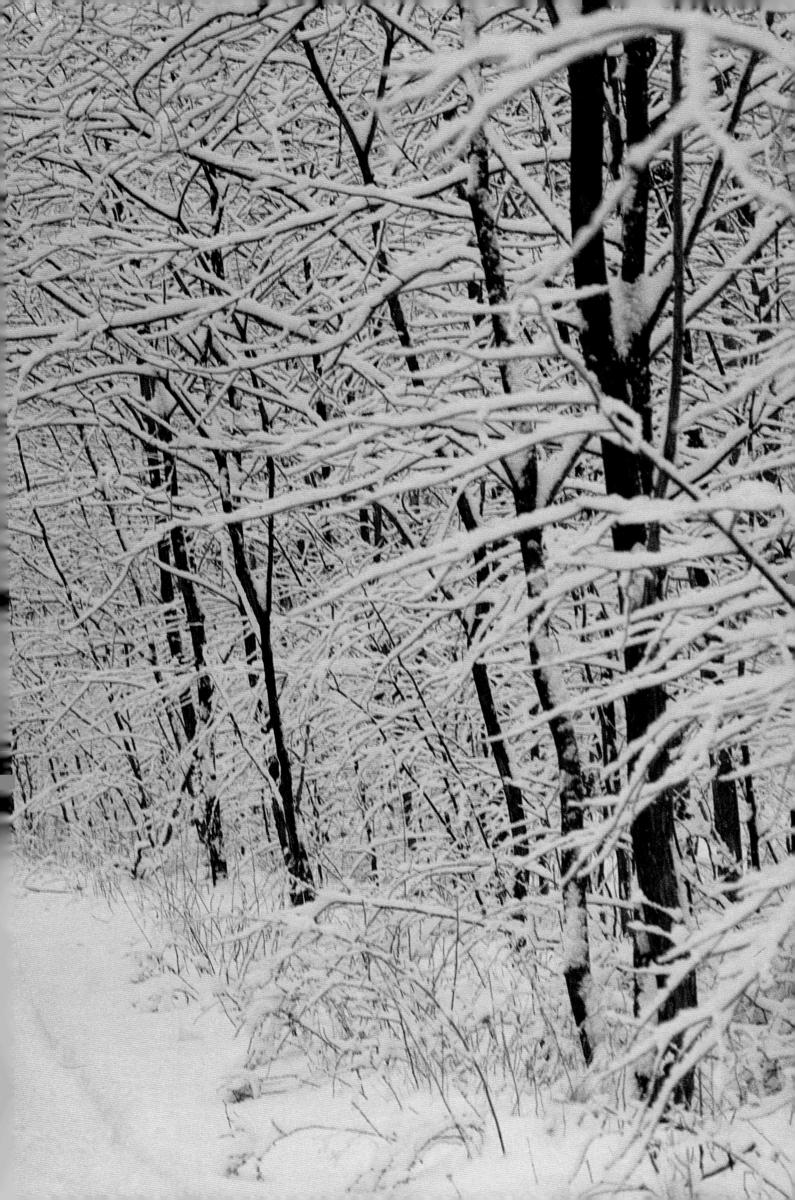

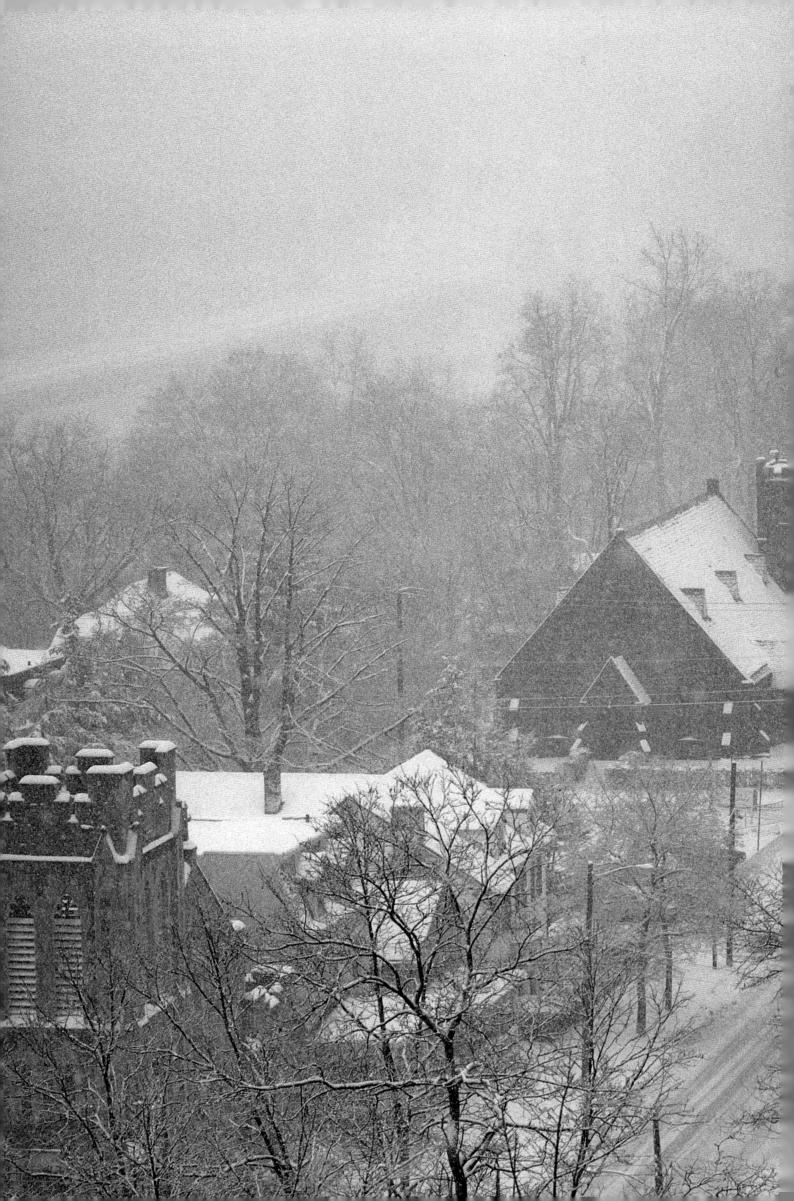

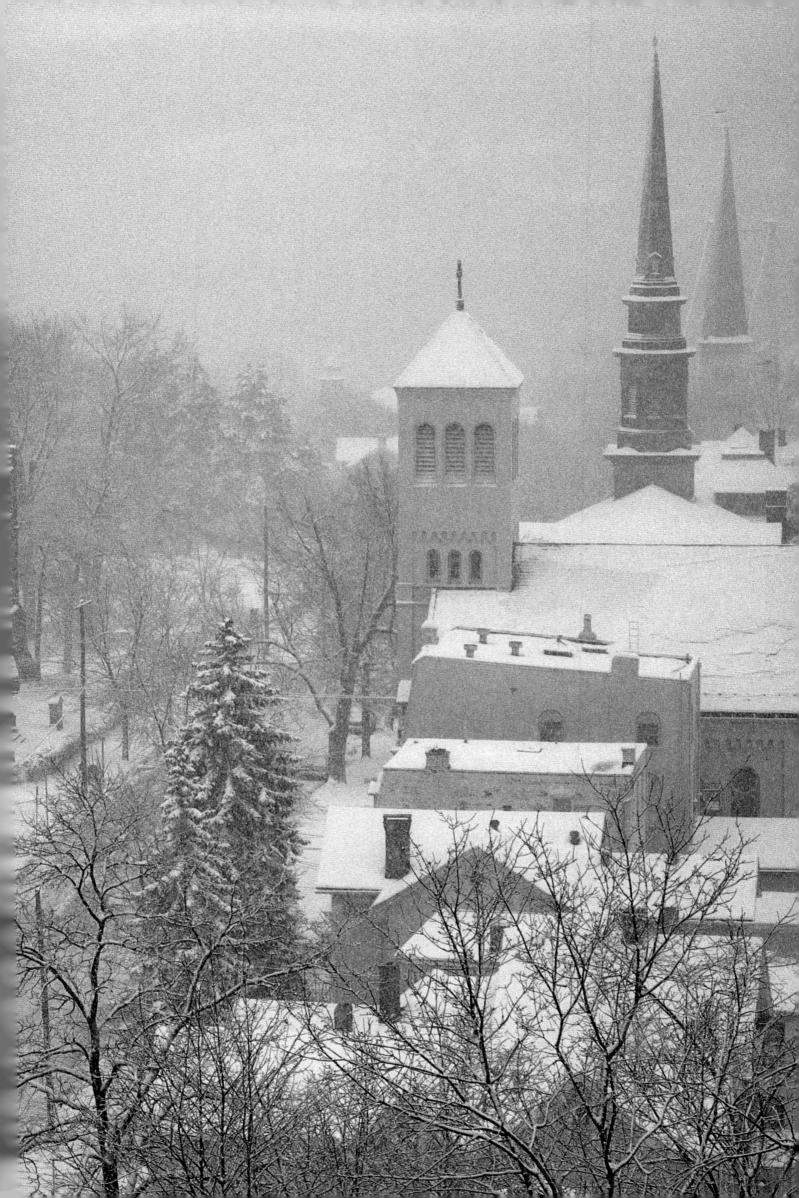

LOOK UP AT THE MIRACLE OF THE FALLING SNOW, – THE AIR A DIZZY maze of whirling, eddying flakes, noiselessly transforming the world, the exquisite crystals dropping in ditch and gutter, and disguising in the same suit of spotless livery all objects upon which they fall. How novel and fine the first drifts! The old dilapidated fence is suddenly set off with the most fantastic ruffles, scalloped and fluted after an unheard-of fashion! Looking down a long line of decrepit stone wall, in the trimming of which the wind had fairly run riot, I saw, as for the first time, what a severe yet master artist old Winter is. Ah, a severe artist! How stern the woods look, dark and cold and as rigid against the horizon as iron!

JOHN BURROUGHS

"The Snow Walkers," In the Catskills

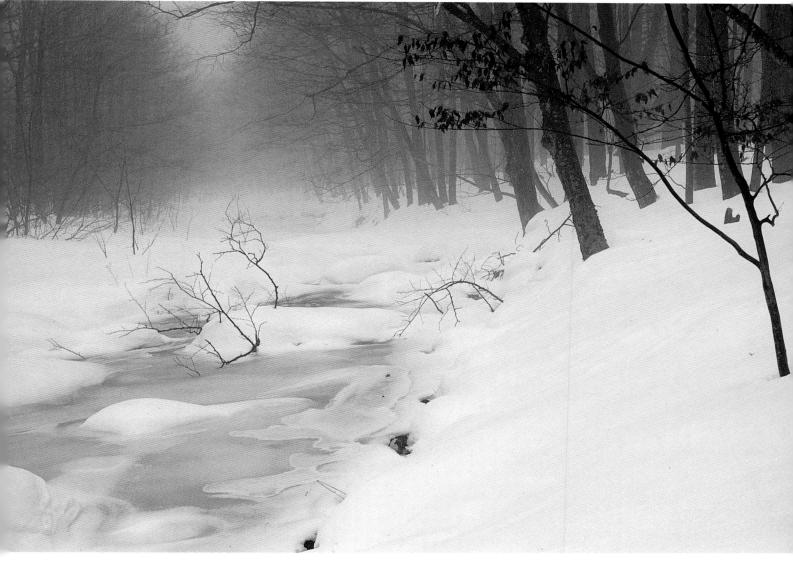

Esopus Creek, Catskill Park.

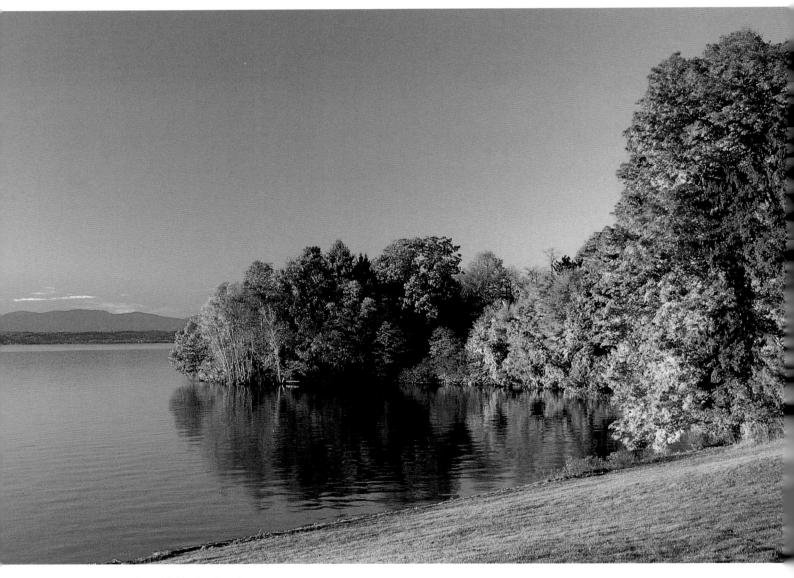

View from Mills Mansion, Staatsburg.

WHEN THE ORIGINAL MANSION BURNED IN 1832, MORGAN LEWIS AND HIS wife immediately had it rebuilt in the popular Greek Revival style of their day. At the end of the 19th Century, the home was in the possession of Ruth Livingston Mills, great-granddaughter of the original builder and wife of Ogden Mills, a wealthy financier and philanthropist. At this time the old Greek Revival building was heavily remodeled in accordance with designs prepared by the prestigious architectural firm of McKim, Mead and White. Two large wings were added to the existing central core and the exterior was embellished with balustrades, pilasters and swags. The interior, decorated in the style of Louis XV and Louis XVI, remains rich with marble fireplaces, oak paneling, and gilded ceiling and wall decorations installed at that time.

Mills Mansion State Historic Site brochure

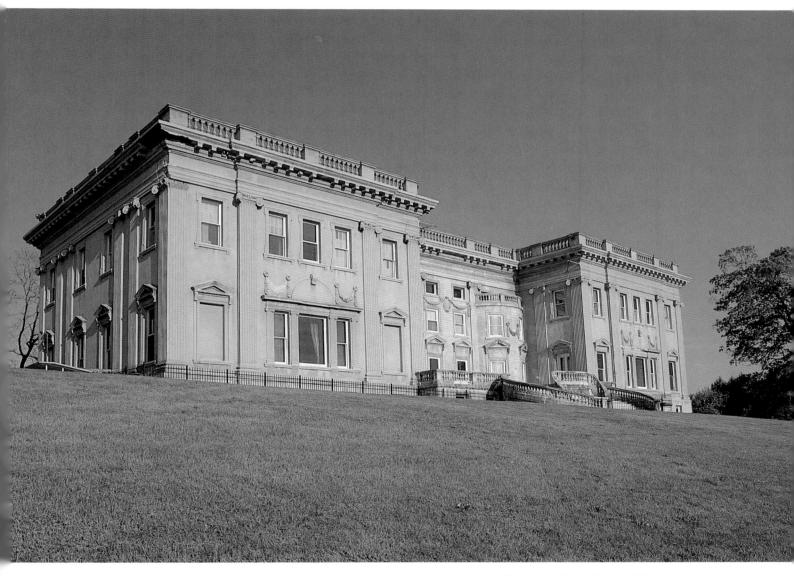

Mills Mansion. Overleaf: Kingston Lighthouse.

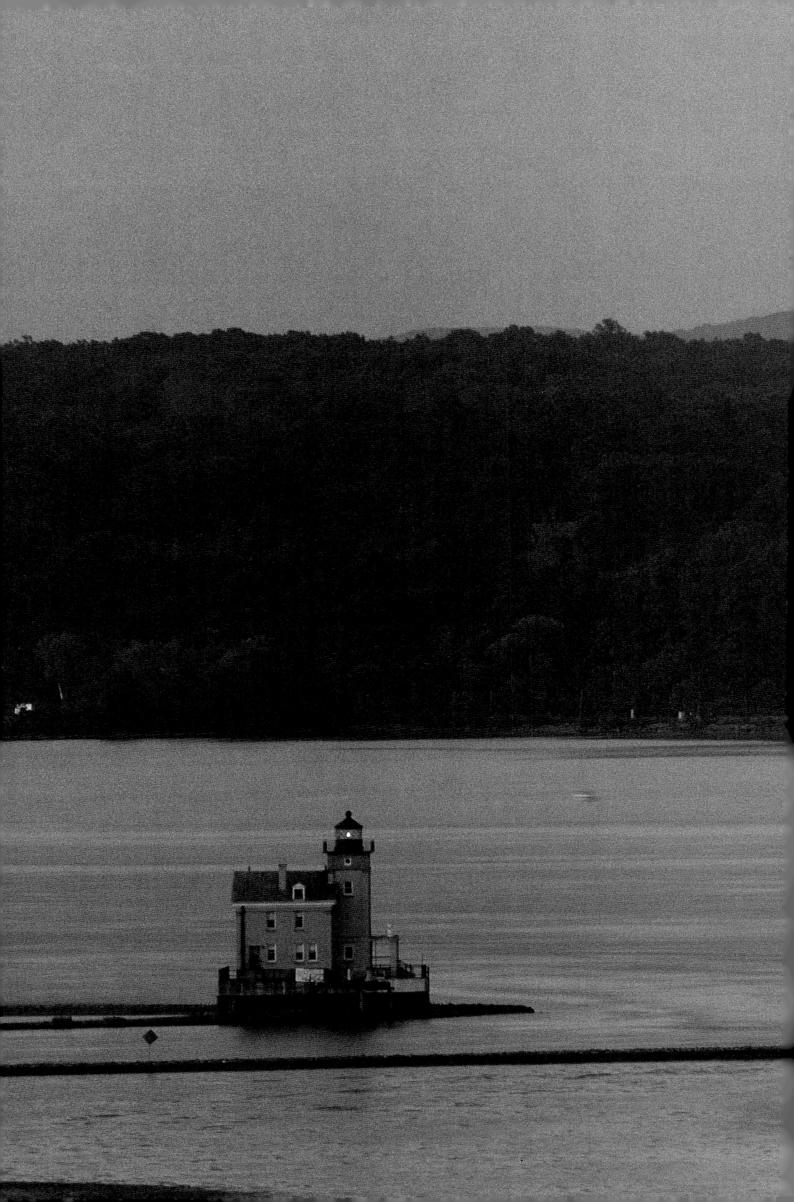

The Hudson of

LITERATURE

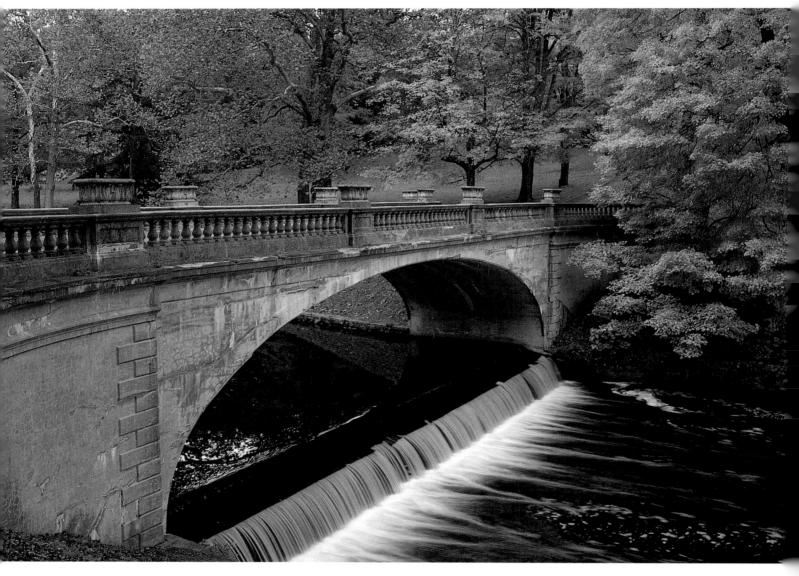

Vanderbilt Mansion National Historic Site, Hyde Park.

THE AMERICAN METROPOLIS HAS BEEN PICTURED AS A DREARY PLACE, where even the rich live in caves cut into the faces of the canons named streets and lighted by glazed apertures called windows. But New York's pillars of Hercules, happily, do not stand on the banks of the Harlem. The boundaries of the city are really set far beyond Poughkeepsie, so many of the modern Knickerbockers have country seats on the heights on either side of the Hudson River. A trip along the stream which the Dutch navigator discovered is like a journey through a garden of the gods ... The Hudson helps to keep youth and vitality in the veins of old NewYork ...

Beautiful country seats stretch in almost unbroken line from Yonkers to Hyde Park, and beyond. The little railroad stations, the names of which appear on the time table, are really so many porters' lodges. Dobbs Ferry, Irvington, Tarrytown, and the rest, are in summer time points of assembly for the carriages, surreys, traps, and dog carts which are driven from the heights every morning and evening. The trains are filled at this season of the year, and they will be until the late fall, with Gothamites and their guests, who are hurrying away from the City of Awful Din to the Land of Delectable Summer. Every Saturday afternoon there goes up from Manhattan Island a throng of commuters so happy that they even forget to play whist. Their minds are intent as their eyes, upon the beautiful Hudson along which they are being rapidly carried ...

Many of the estates along the stream are ancestral. The old Knickerbockers loved this land which the captain of the Half Moon saw and pronounced very good. The patroons had country homes along the Hudson centuries ago, and the settlements still ring with the names of Livingston, De Peyster, and Roosevelt ... Estates which were falling into decay have been purchased by citizens of Manhattan. The landscape gardener, under the supervision of the new owner, has brought out the old lines anew, and has laid out roads and graded the lawns on other levels. With the assistance of city architects, additions have been placed upon country houses, and the electrician, the plumber, and a host of other artisans have made the old dwellings homes of luxury. Acres of farming land have been transferred to city owners, and the original sons of the glebe have been driven steadily back from the banks of the Hudson. The farm house has given place to the modern castle, and the dingy barn to the breeding stable of the gentleman farmer.

It is in midsummer that the NewYorker who affects the Hudson thinks only of his place on the river. He hurries to the earliest possible train in the afternoon, and gladly plunges through the roaring, soot filled tunnel. The thoughts of a drive along smooth roads, of a game of golf, of a walk over the springy turf, make him feel at peace with all mankind ...

He who has a country seat along the Hudson may wield the putter on his own golf links, drive on his own roads, hunt in his own preserves, or go aboard his yacht from his own pier. His table is supplied from the richness of his own land. He is surrounded by a small army of retainers, to whom his every wish is law. Except for the drawbridge and the dungeon keep, his house is as much of a castle as any pile of stone erected by feudal barons on the crags above the river Rhine...

The principal amusements of the Knickerbocker at his Hudson home are golf, yachting, and driving. He takes delight in being in the open air and in drinking in the prospect of the waving forests and the ever changing river. Often he comes up from the city on his own yacht, and reaches a club station or his own pier in the twilight. He finds pleasure in driving the white rubber ball, and in raising a thirst for oatmeal water, and perhaps for Scotch whisky, as he tramps over the links. Whatever he does, this Hudson River country makes him a happier and a freer man.

JOHN W. HARRINGTON

Summer Homes on the Hudson River, 1899

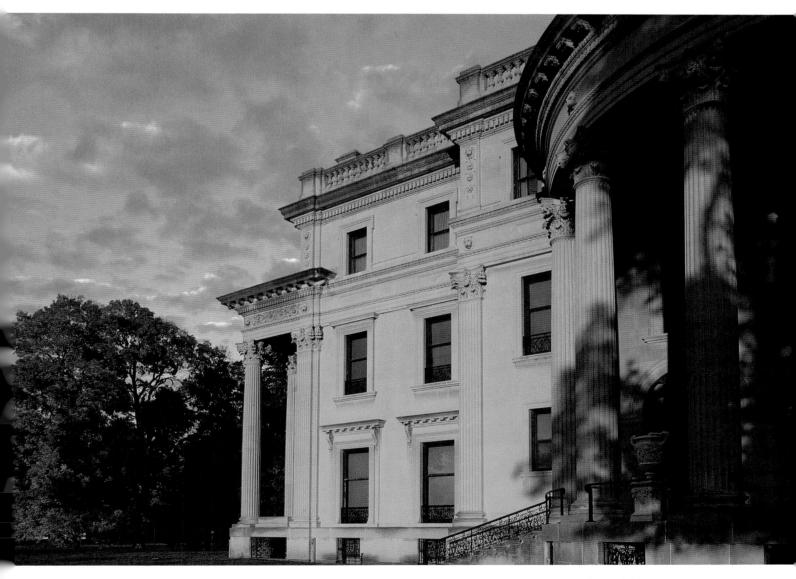

Above: Vanderbilt Mansion. Overleaf: View from Vanderbilt Mansion.

UNIQUE AMONG THE GREAT COUNTRY HOUSES OF AMERICA, THE

Vanderbilt Mansion has well been called "A Monument to an Era." It is a magnificent example of the great estates developed by financial and industrial leaders in the era following the Civil War. It was the country home of Frederick William Vanderbilt, a grandson of "the Commodore" Cornelius Vanderbilt who founded the family fortune in steamboating and railroading. *Vanderbilt Mansion National Historic Site brochure*

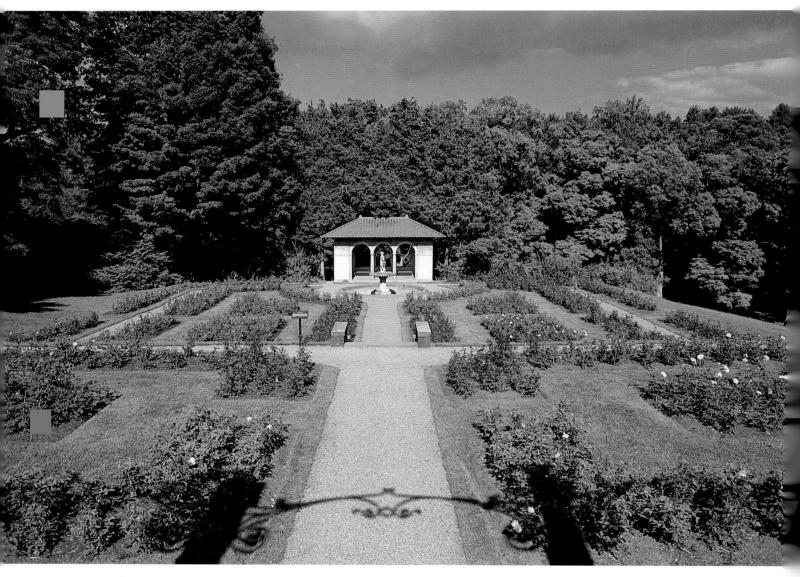

Above and opposite: Vanderbilt Mansion gardens.

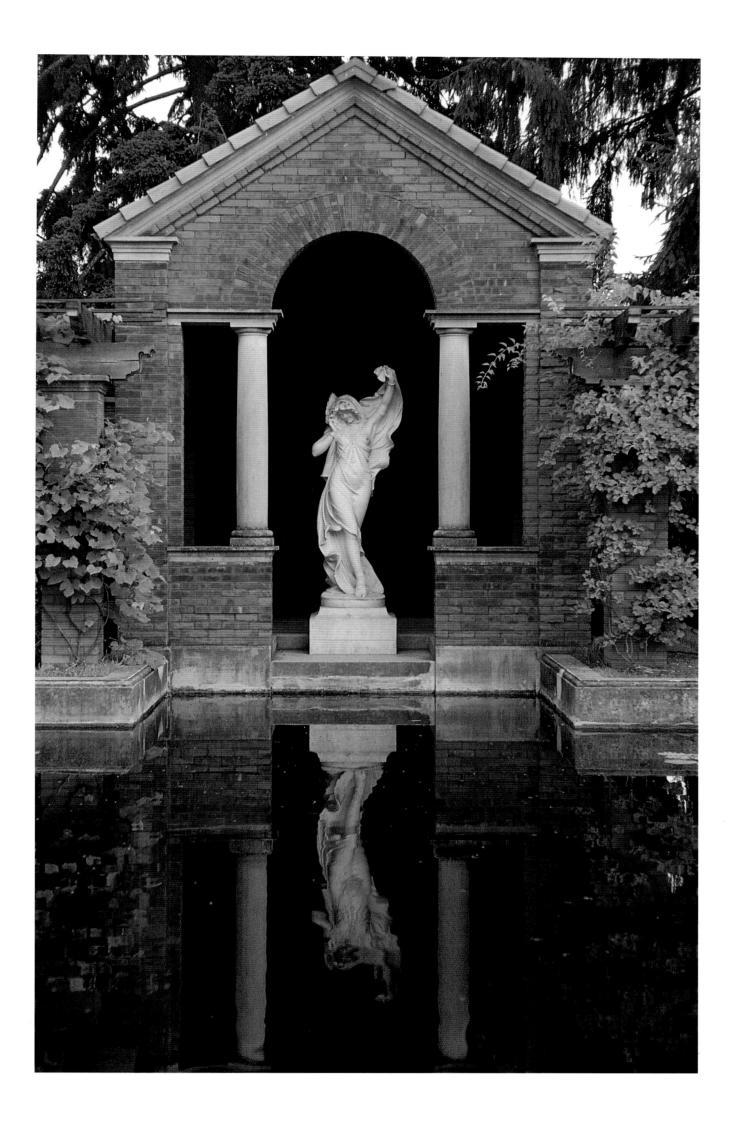

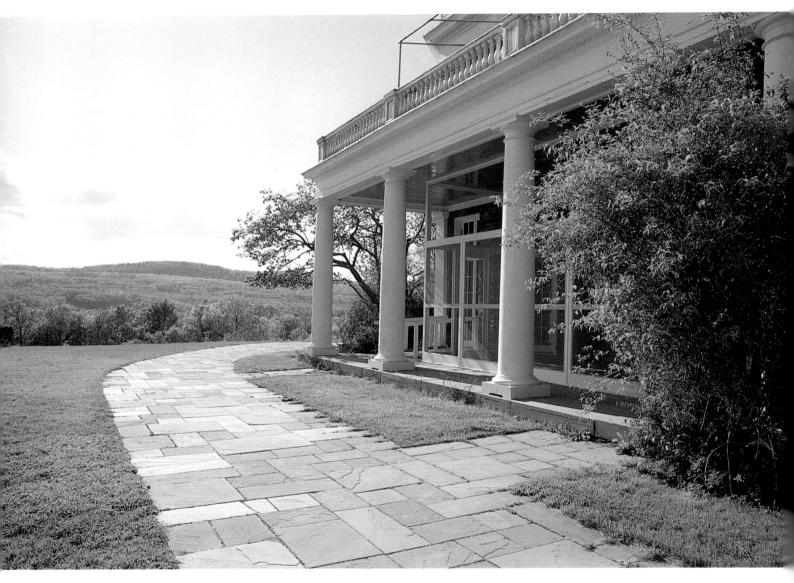

Above and opposite: Franklin D. Roosevelt National Historic Site, Hyde Park. Overleaf: Mohonk Mountain House, near New Paltz.

THE ASPECT OF HYDE PARK FROM THE RIVER HAD DISAPPOINTED ME, after all I had heard of it. It looks little more than a white house upon a ridge. I was therefore doubly delighted when I found what this ridge really was. It is a natural terrace, overhanging one of the sweetest reaches of the river; and though broad and straight at the top, not square and formal like an artificial embankment, but undulating, sloping, and sweeping between the ridge and the river, and dropped with trees; the whole carpeted with turf, tempting grown people, who happen to have the spirits of children, to run up and down the slopes and play hide-and-seek in the hollows.

HARRIET MARTINEAU

Retrospect of Western Travel, 1838

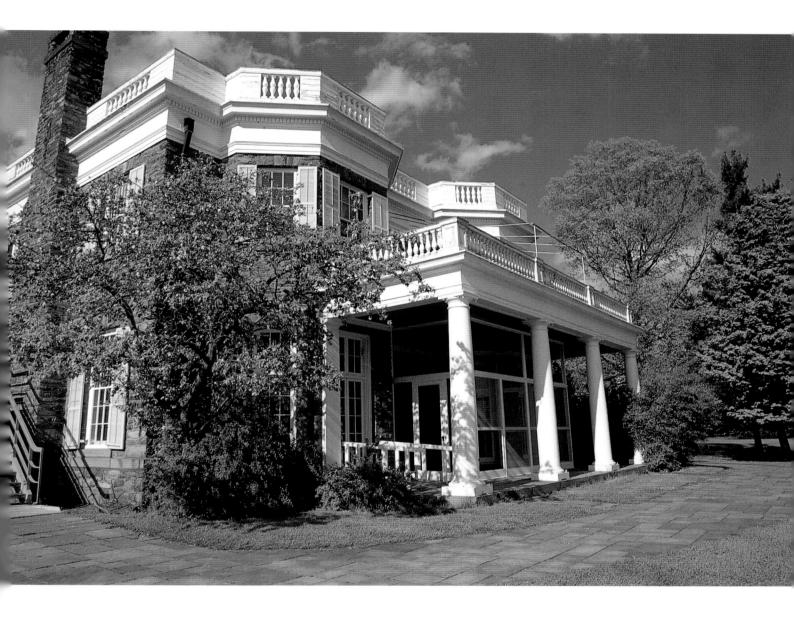

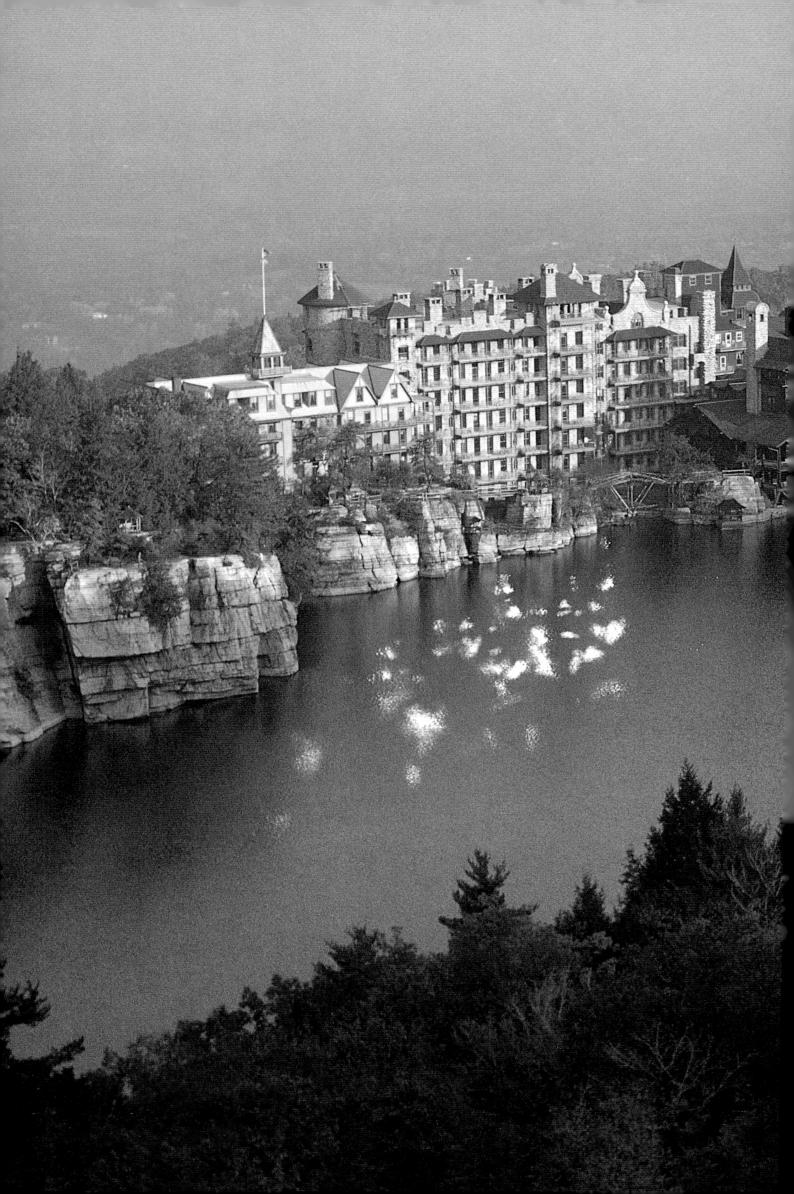

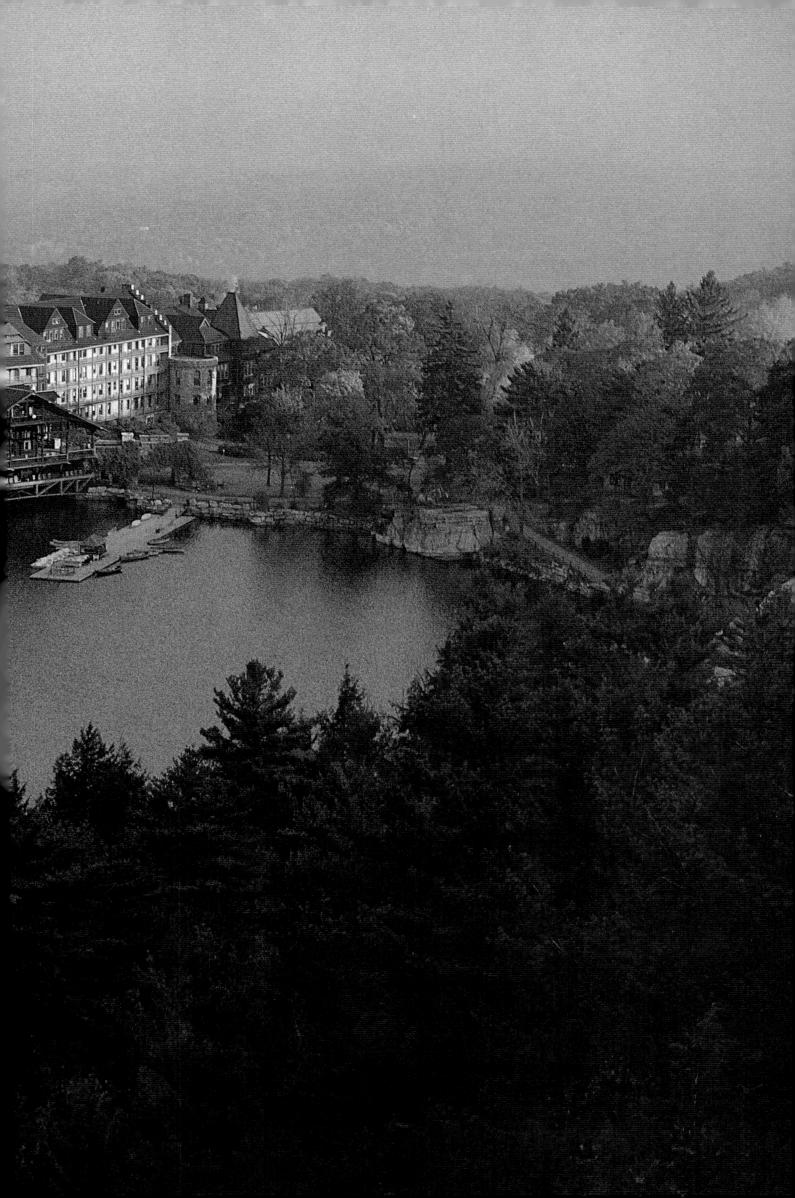

TRADITION ATTRIBUTES THE SETTLEMENT AT NEW PALTZ TO ONE OF THE incidents connected with the Indian massacre at Esopus in June 1663. Catherine Blanshan, the wife of Louis DuBois, was one of the captives carried away into the wilderness. DuBois with a band of the settlers started in pursuit, and, in following the stream which was afterwards called the Wallkill, they noticed the rich lands in the vicinity of the present village of New Paltz. The search was successful, the prisoners were rescued from captivity, and in the more leisurely return to Esopus, Louis DuBois and his companions examined carefully the land which, by its beauty and apparent fertility, had before attracted their attention. Some years afterwards (May 1677), he and his associates purchased from the Indians the large tract of land, estimated to contain some 36,000 acres, including part of the present townships of New Paltz, Rosendale, and Esopus, and the whole of Lloyd, - bounded on the west by the Shawangunk Mountains and on the east by the Hudson River. For this valuable grant the Indians received "40 kettles, 40 axes, 4 adzes, 40 shirts, 400 strings of white beads (wampum), 300 strings of black beads, 50 pairs of stockings, 100 bars of lead, 1 keg of powder, 100 knives, 4 quarter-casks of wine, 40 jars, 60 splitting or cleaving knives, 60 blankets, 100 needles, 100 awls, and 1 clean pipe"... All were Huguenots, who fleeing from kingly and church persecution in France, had found an asylum in the Lower Palatinate at Mannheim, and had probably spent some time in Holland also, whence they had come with the Dutch to Esopus. In memory of their German home on the banks of the Rhine and adjacent to the forest region of the Odenwald, they named their new home on the Hudson, New Paltz, or the New Palatinate, and here established, to a considerable degree, the local government and peculiar customs of the German village community.

IRVING ELTING

Dutch Village Communities on the Hudson River, 1886

Huguenot House, New Paltz.

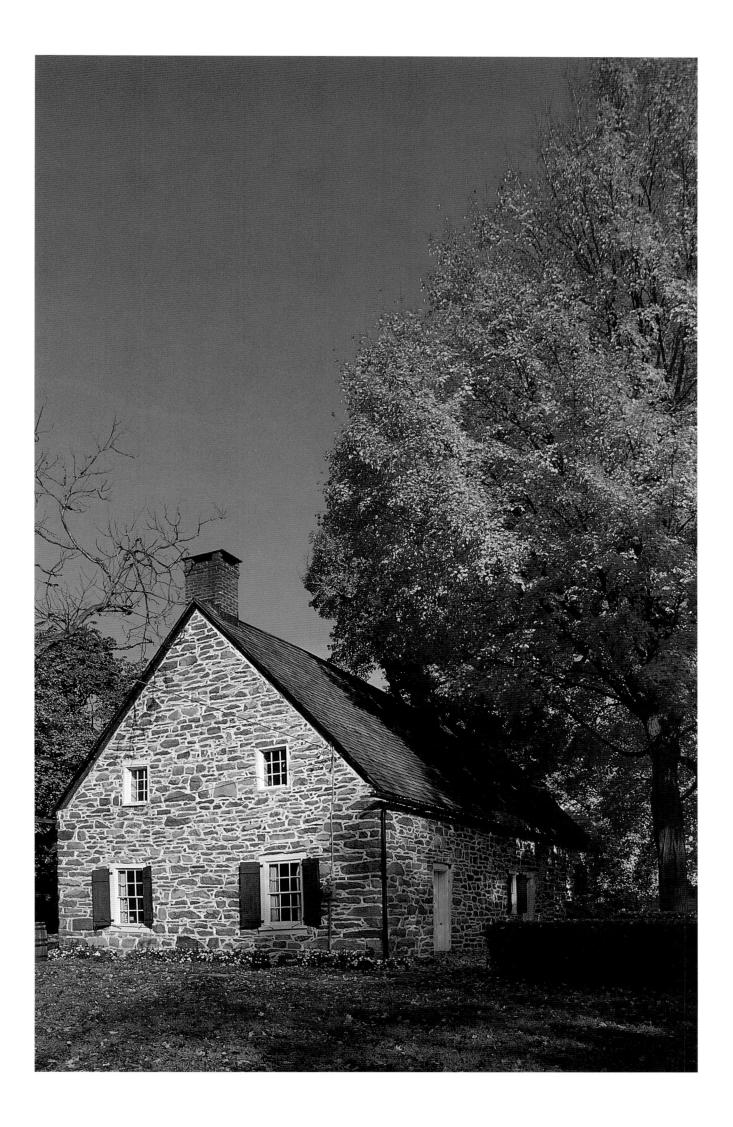

IT HAS BEEN SAID THAT HISTORY AND TRADITION HAVE LENT AN ADDED CHARM to the natural beauties of Shawangunk and this may account for the growth of population over the last decade. Or it might just be the lure of the rocky sides of the old Shawangunks themselves, which legend has it "have more than once been reddened by the glare of burning homes; whose precipices have echoed back the dying groans of early settlers, and whose night winds have borne along its rugged crest the shrieks of women and children mingled with the war whoops of savages."

CAROLE DECKER

Ulster County Tercentennial 1683–1983, 1983

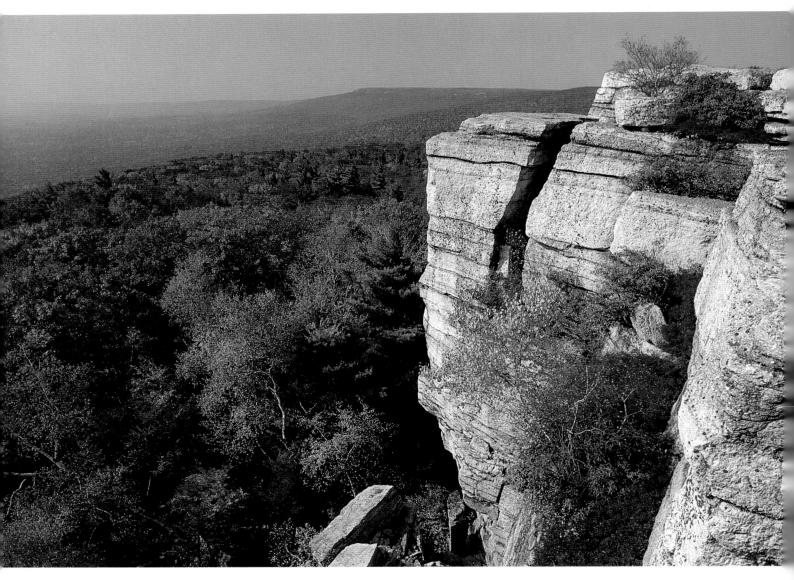

Gertrude's Nose, Shawangunk Mountains, Minnewaska State Park.

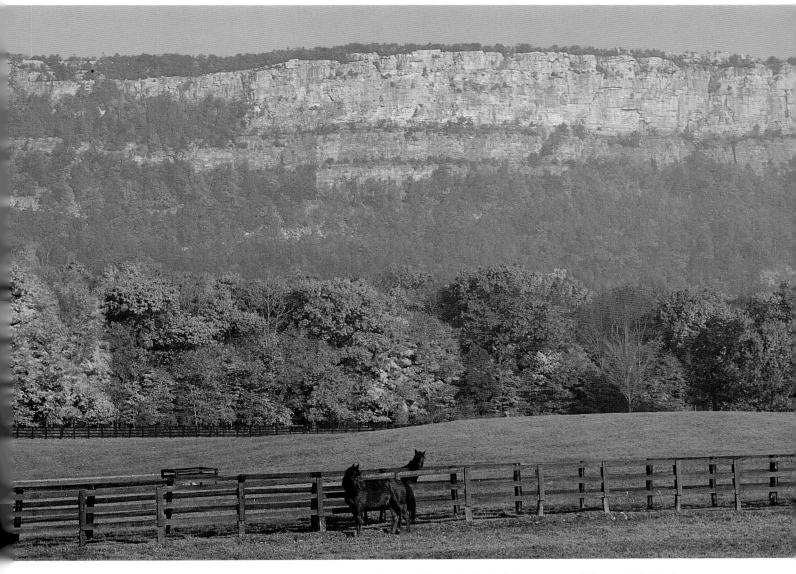

Above: Shawangunk Mountains. Overleaf and second overleaf: Minnewaska State Park.

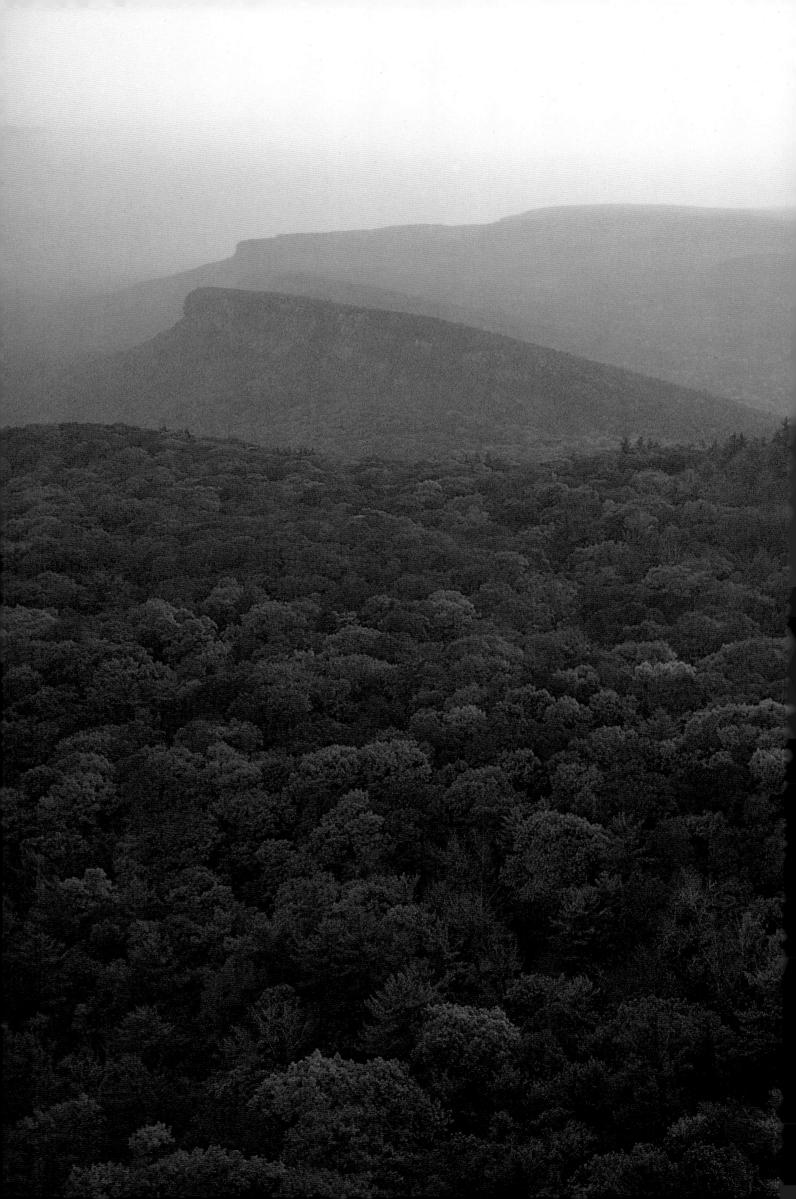

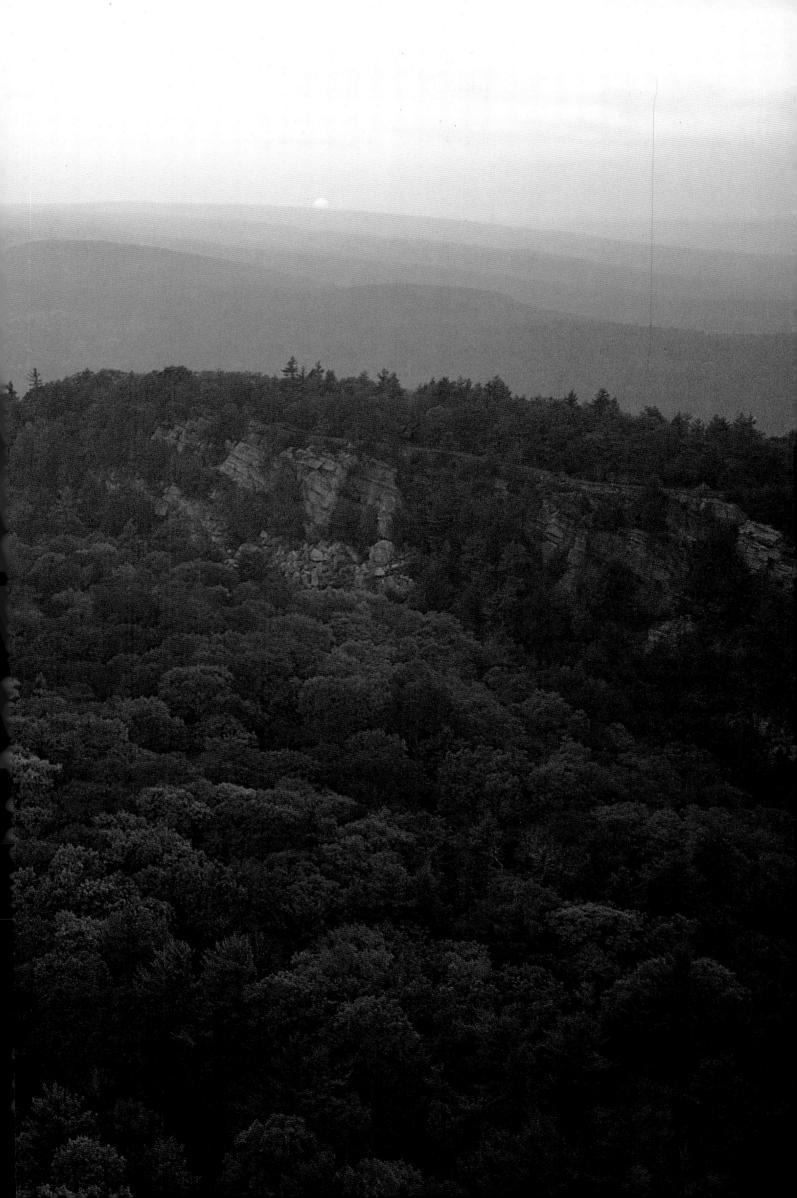

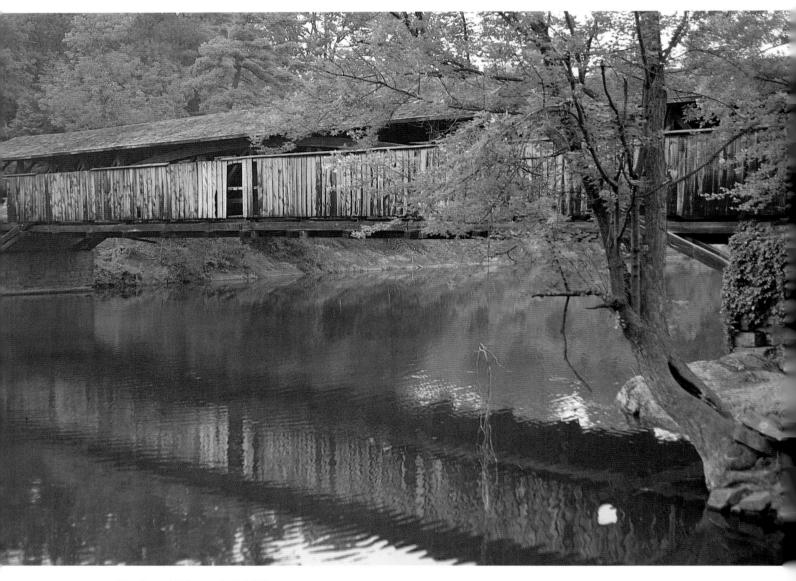

Rifton Covered Bridge over the Walkill River.

Wildflowers.

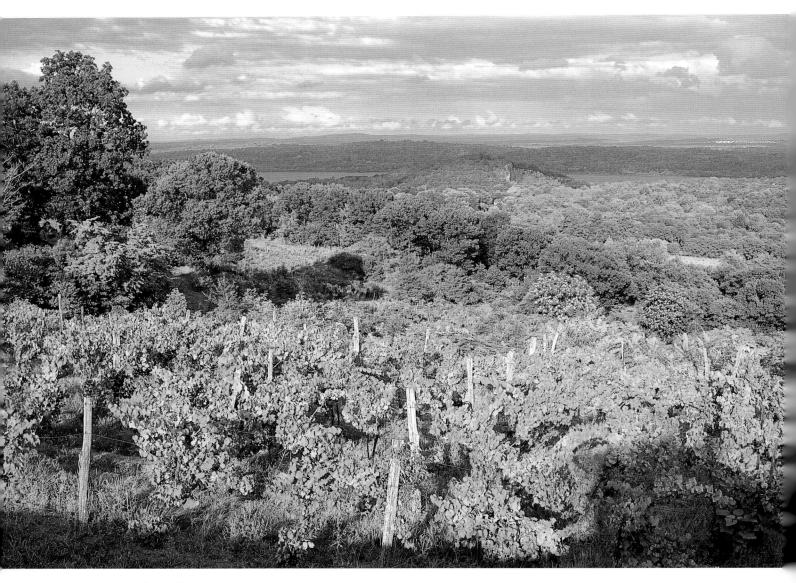

Vineyards in Marlboro.

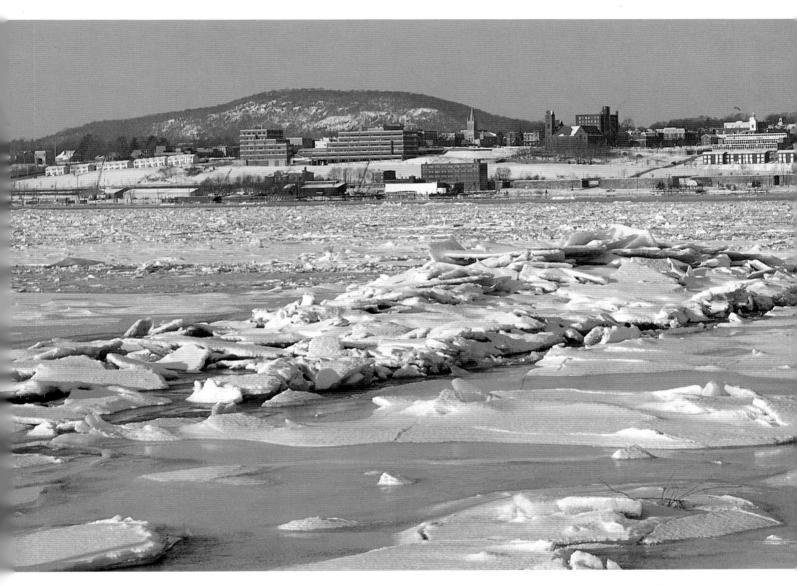

Above: Newburgh. Overleaf: Newburgh Bridge.

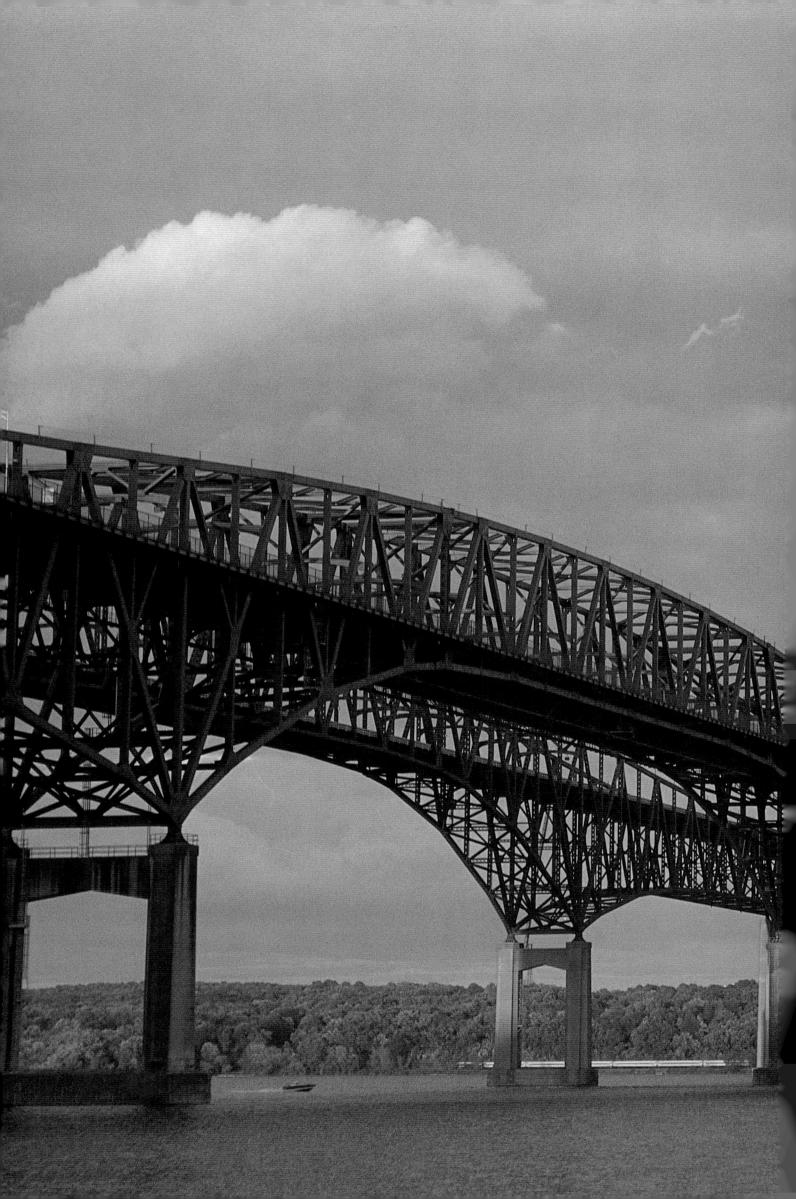

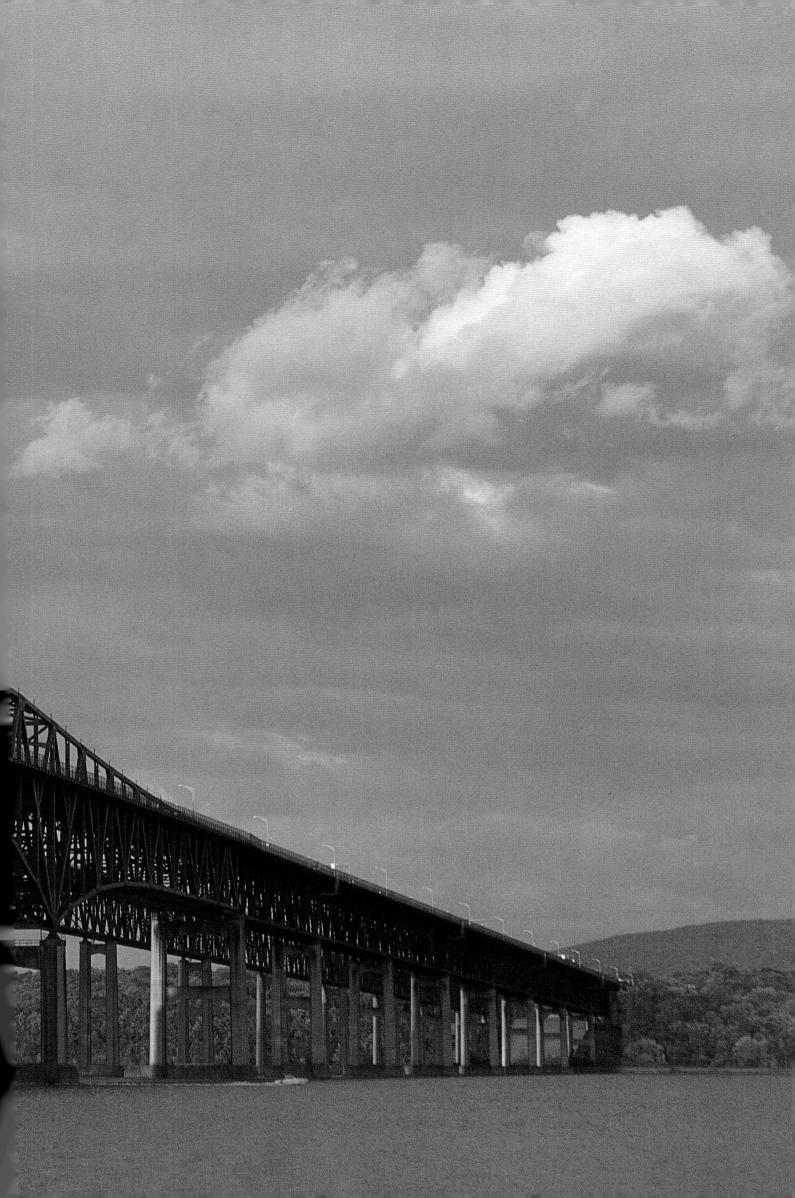

Above and opposite: Newburgh.

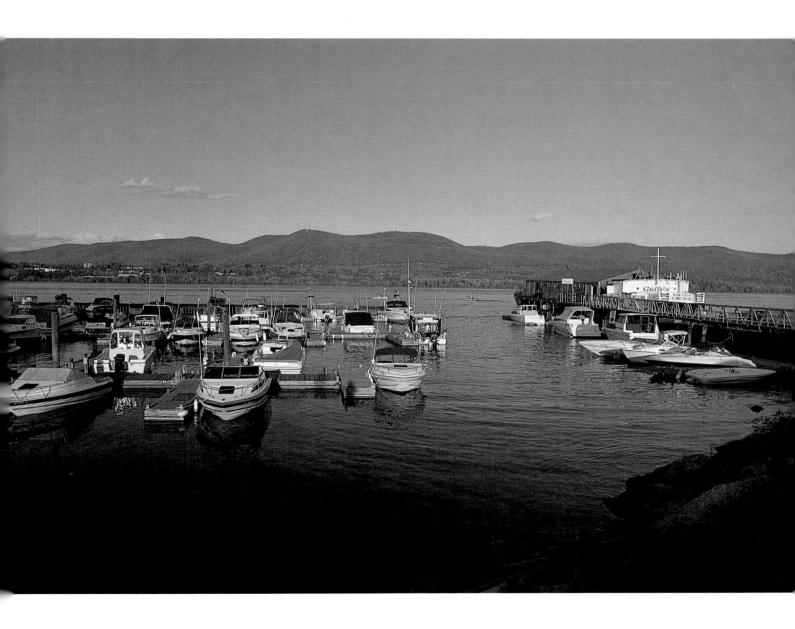

THE MAN WHOSE IMAGINATION AND ENERGY ARE SOLELY RESPONSIBLE for the building of the castle, the towers, the portcullis and everything on the Island was Frank BannermanVI. He was born in Dundee, Scotland, in 1851 and came to this country when he was three years old. The family settled in Brooklyn where his father established a business of selling articles acquired at Navy auctions, particularly flags, ship chandlery, and rope . . . In addition to an active interest in local and world affairs Francis Bannerman was a student of antiquities of all kinds but especially of military matters. Probably the greatest interest was collecting, on his travels to all parts of the world, unusual items for the museum which he maintained in his store in NewYork. Some of the armor was at one time exhibited in the Metropolitan Museum of Art. The building of the castle on the Island was a new field of study – the architecture of castles all over Europe, especially Scotland, including minute details of decorations. Many of his plans and ideas were never completed, although building continued uninterrupted from 1900 until he died in November 1918.

The house resembles a Scottish castle with its turrets and crenellated towers . . . Francis Bannerman continued until his death to his own designs, under his personal supervision, the No. 3 arsenal, the Tower, his personal residence, the work shop and residence apartments for the workmen, docks, turrets, walls, breakwaters, powder house, ice house, garden walks, and all their elaborate decorations. Almost all of it was done without any professional assistance from architects, engineers and contractors . . .

CHARLES S. BANNERMAN

The Story of Bannerman Island, 1962

Opposite and overleaf: Bannerman's Island. Second overleaf: View of the river from Storm King Mountain.

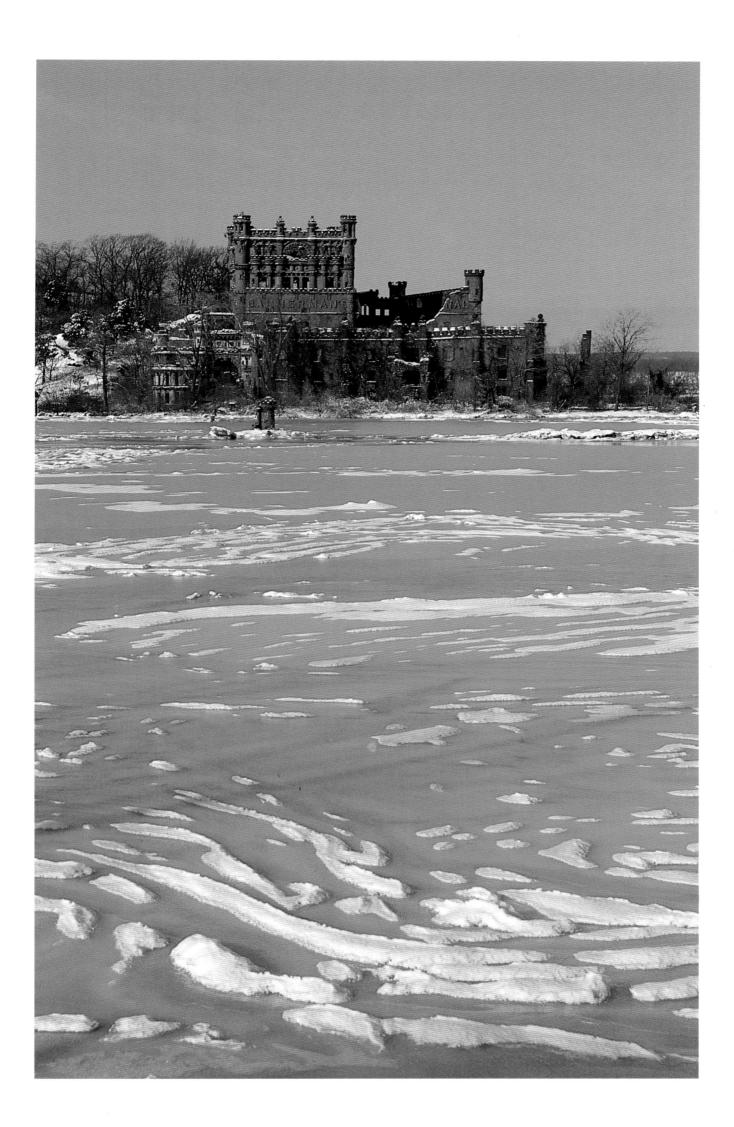

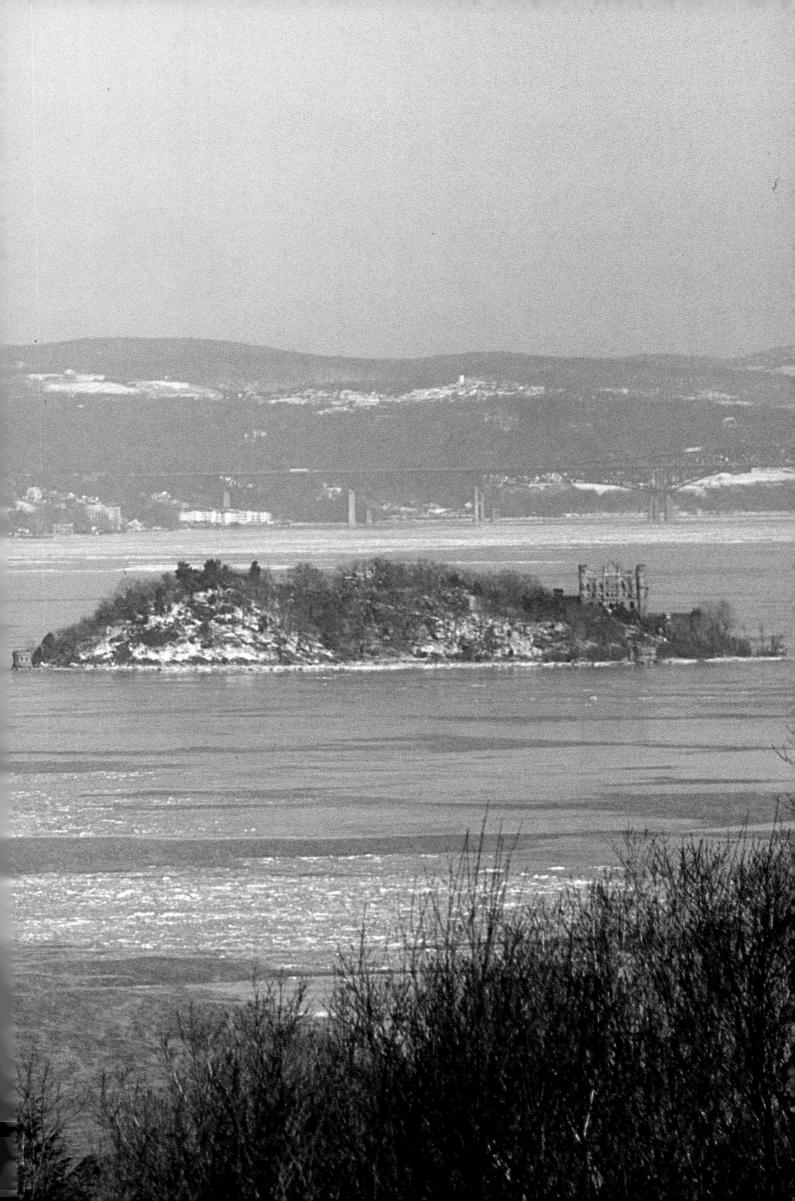

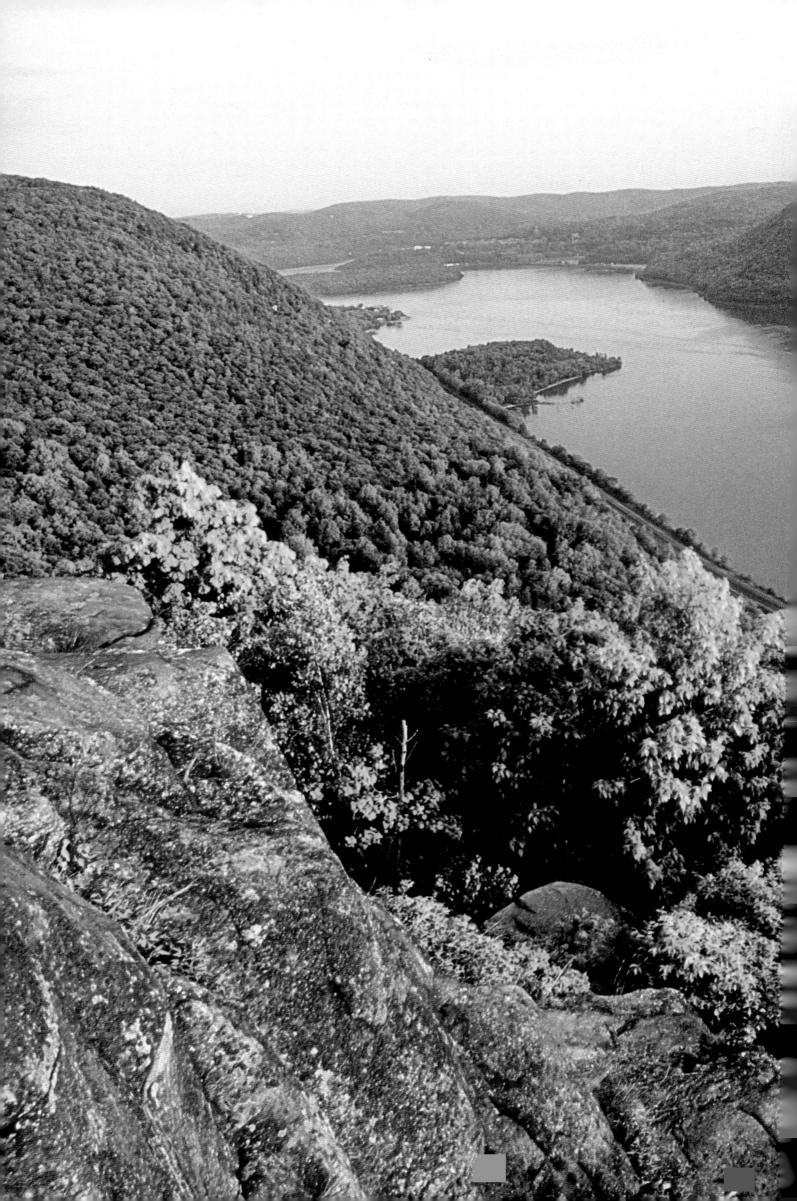

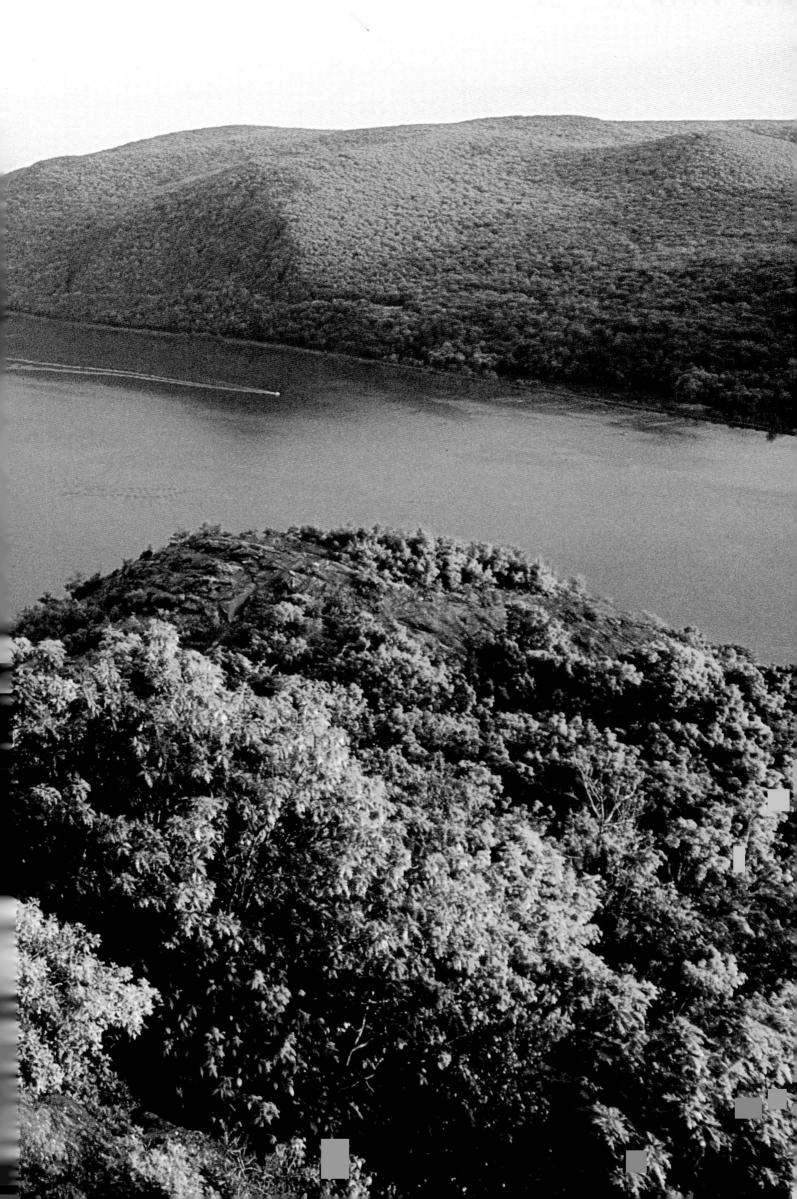

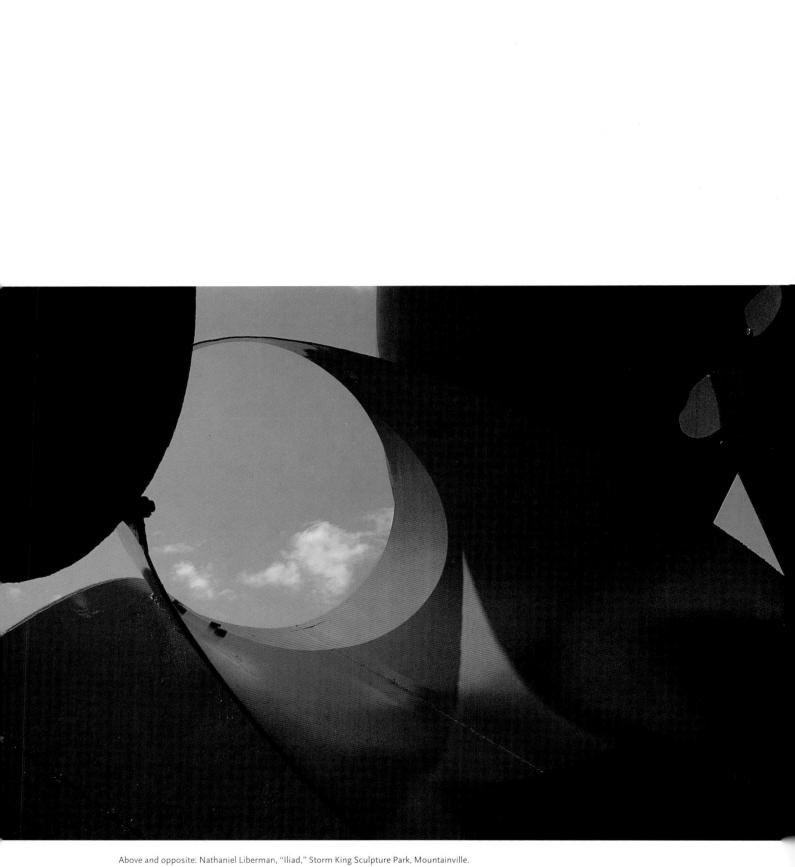

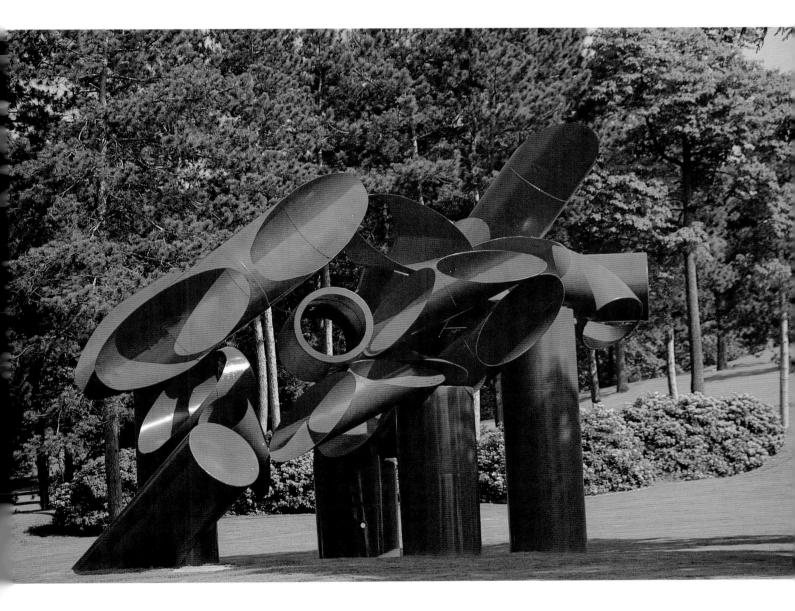

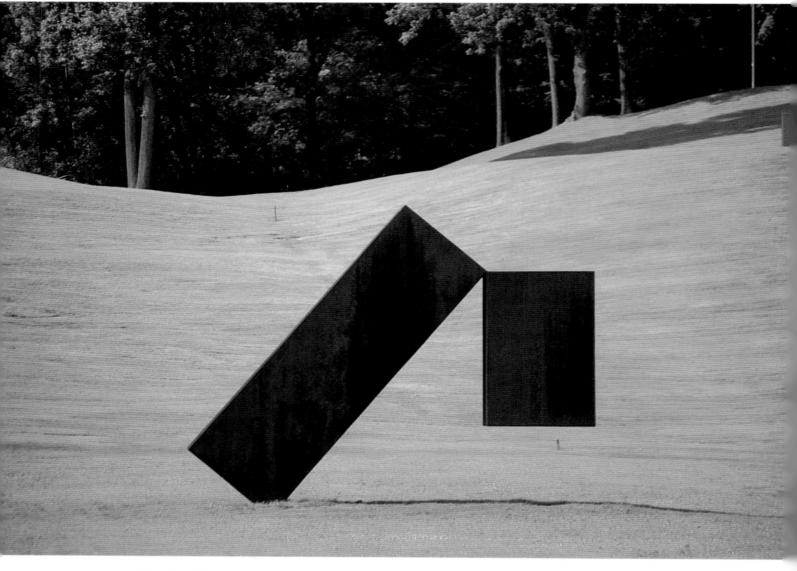

```
Menashe Kadishman, "Suspended," Storm King Sculpture Park.
```

STORM KING. TWENTY-FIVE YEARS AGO, AN ART INSTITUTION WITH initially modest ambitions was born into this evocative name. In the years since, the Storm King Art Center has come to embody all the drama and majesty of its mountain namesake. It has evolved into one of the few places in the world where one can begin to measure the exalted aspirations and achievements of postwar sculpture ...

Modern sculpture has been rendered homeless. Despite its ever-growing popularity, it is no longer appropriate in traditional contexts. In large measure, this is the outcome of modernism's deliberate goals. New materials were called upon to replace the old: first iron, then steel, then aluminum, fiberglass, neon, and even lasers were endorsed by sculptors as the proper media for our highly technological era, supplanting the venerated wood, stone, and bronze. Even more importantly, sculptors began stripping away from their art many of its conventional purposes: the depiction of recognizable images, especially the human figure; the commemoration of the past; the embellishment of architecture; and the symbolic expression of lofty ideals. Modern sculpture was expected to create its own purpose instead, to succeed or fail on its own merits as a form in space. It was to carry no content other than its own; its shape and proportions were to be self-generated. No longer the bearer of extrinsic meaning, it would stand instead as the revelation of intrinsic significance ...

Precisely why Storm King is so hospitable to modern sculpture is my ultimate subject. It results from the happy conjunction of two elements: sculpture and landscape.

JOHN BEARDSLEY

A Landscape for Modern Sculpture, 1985

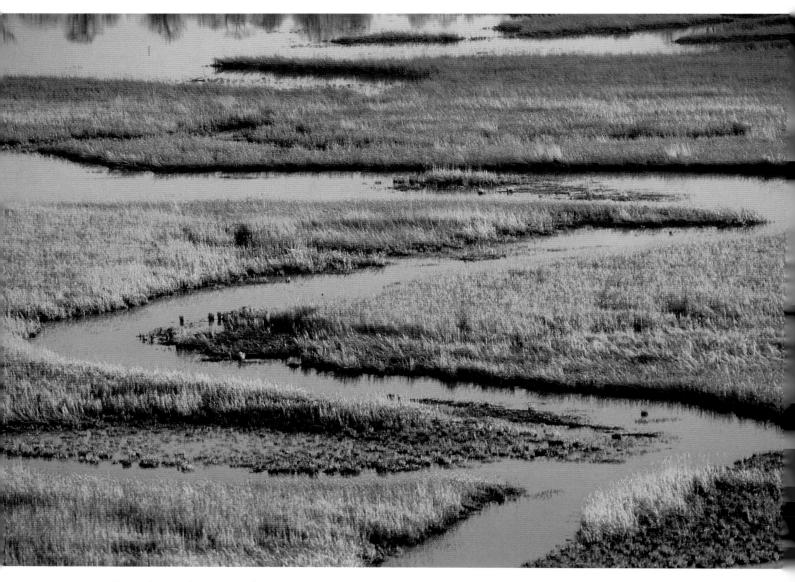

Above and opposite: Constitution Marsh, Garrison.

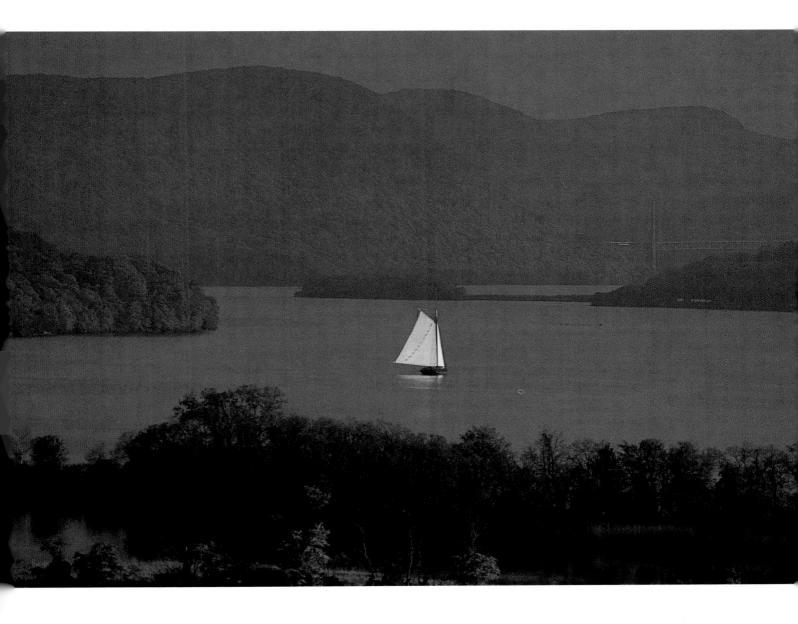

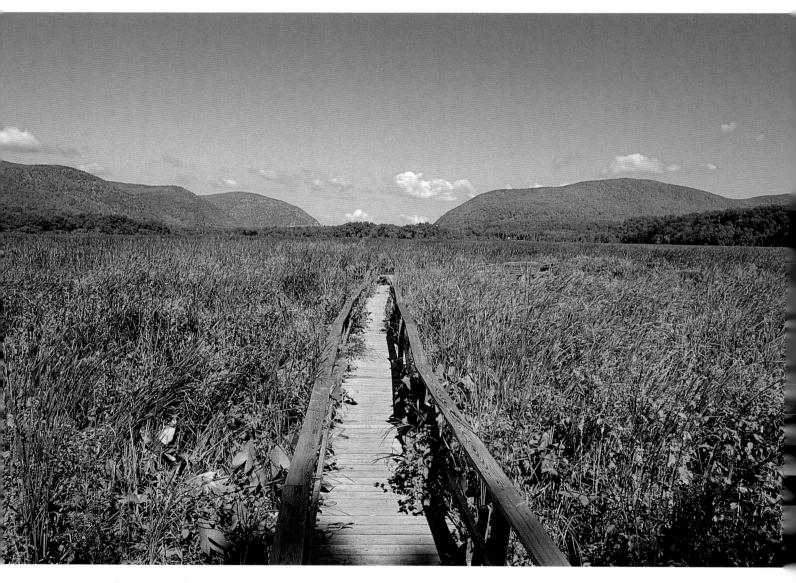

Constitution Marsh.

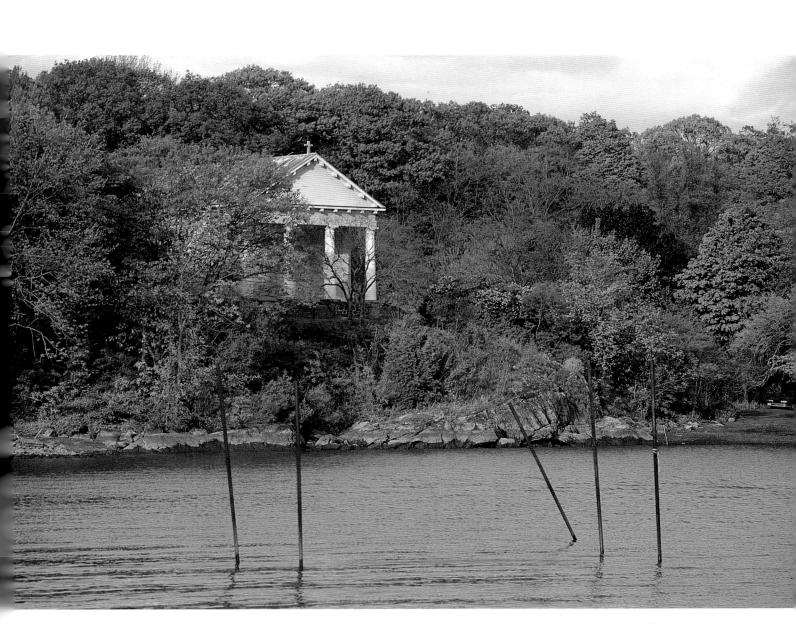

Cold Spring.

IN THIS BEAUTIFUL PLACE: THE FAIREST AMONG THE FAIR AND LOVELY Highlands of the North River: shut in by deep green heights and ruined forts, and looking down upon the distant town of Newburgh, along a glittering path of sunlit water, with here and there a skiff, whose white sail often bends on some new tack as sudden flaws of wind come down upon her from the gullies in the hills: hemmed in, besides, all round with memories of Washington, and events of the revolutionary war: is the Military School of America. It could not stand on more appropriate ground, and any ground more beautiful can hardly be.

CHARLES DICKENS

American Notes, for General Circulation, 1871

Above and opposite: Graduation Parade, U.S. Military Academy, West Point.

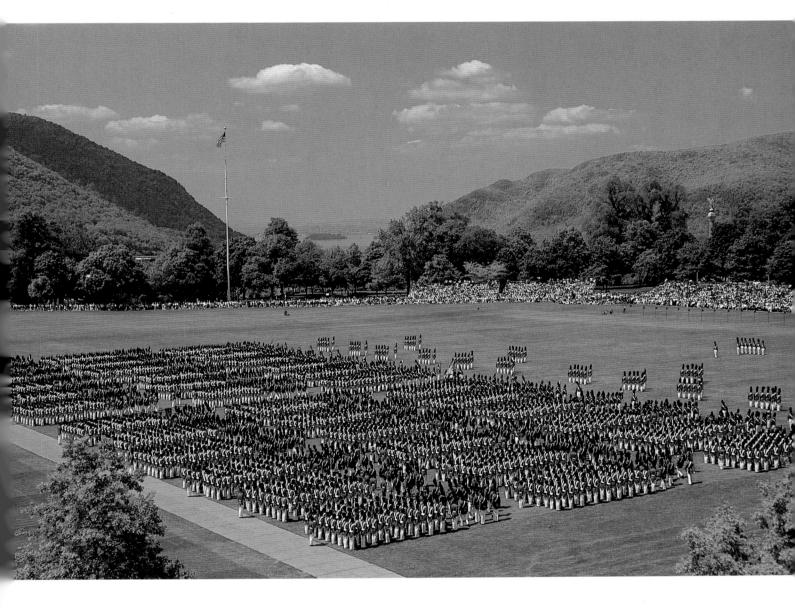

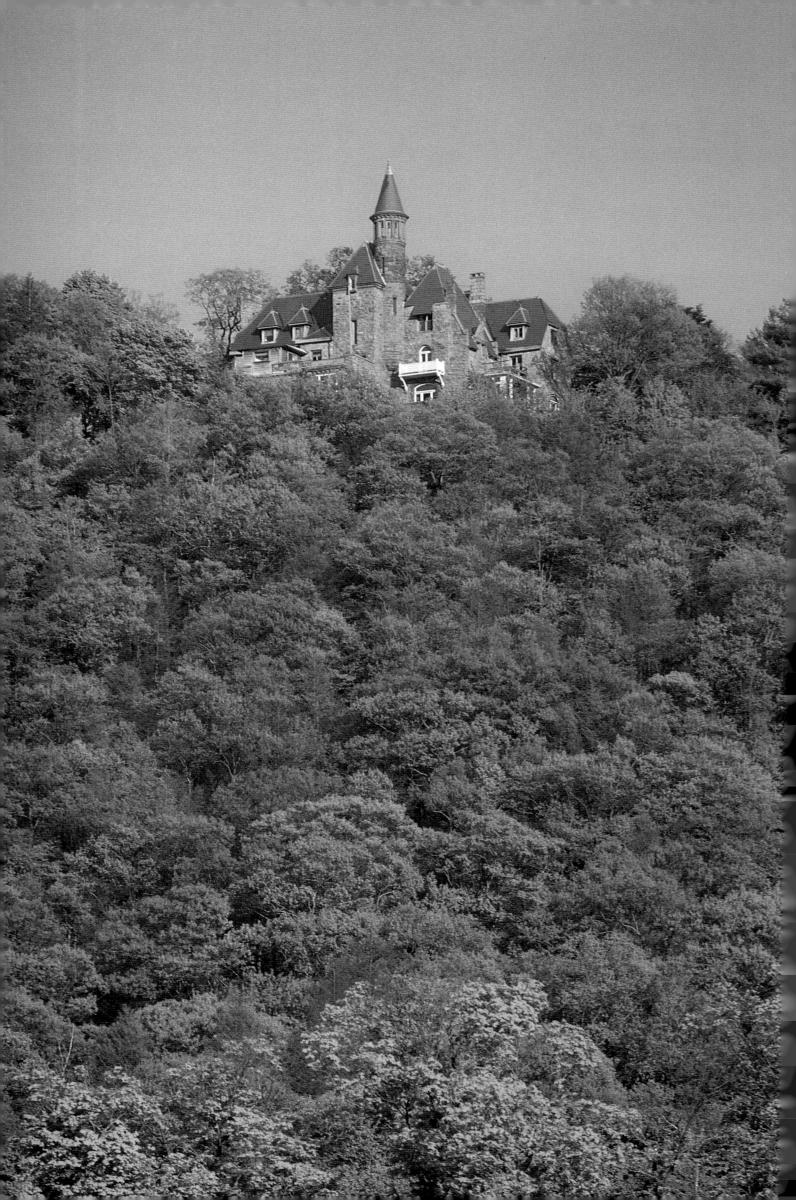

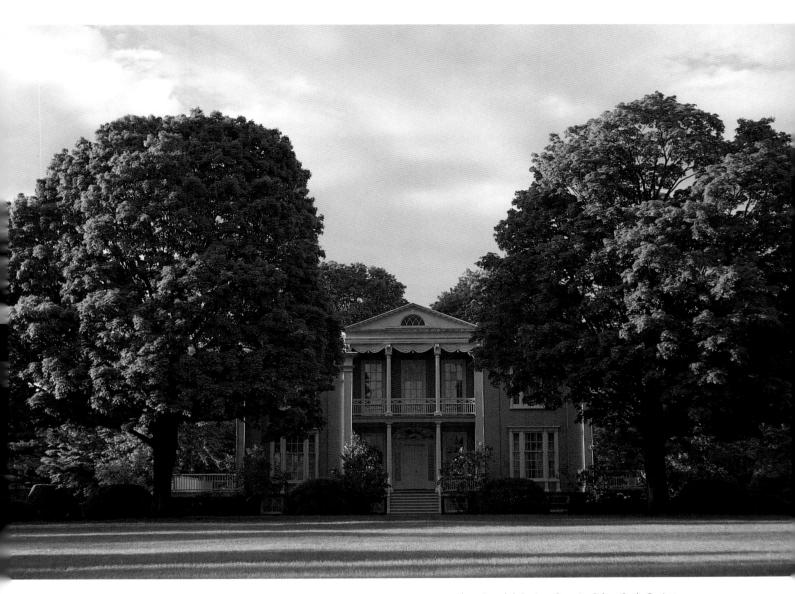

Above: Boscobel, Garrison. Opposite: Osburn Castle, Garrison.

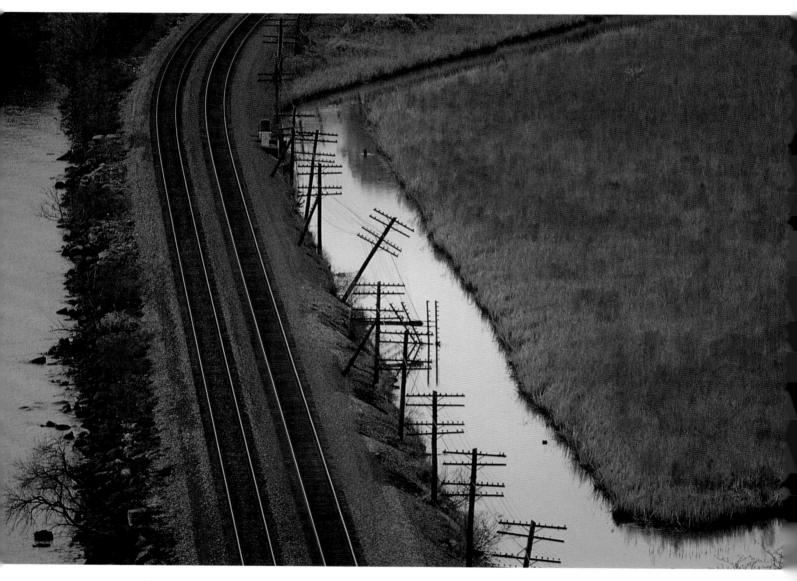

Train tracks along the Hudson.

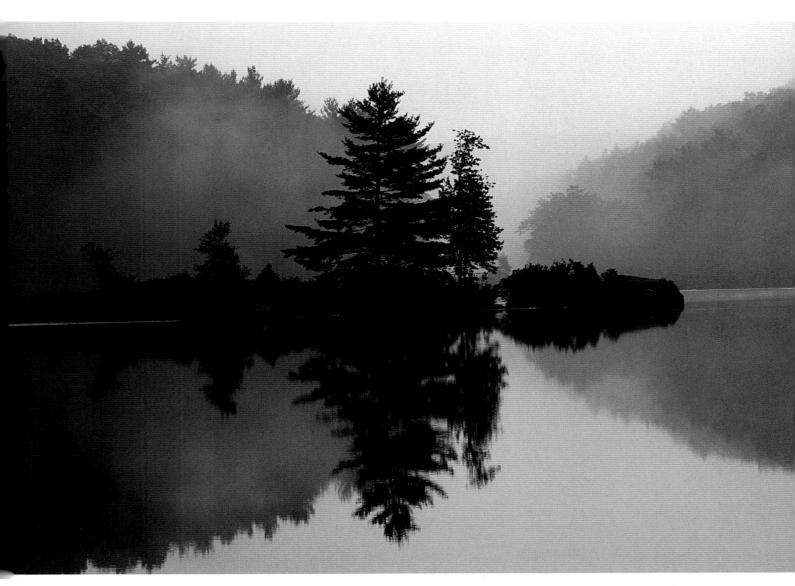

Above: Little Long Pond, Harriman State Park. Overleaf: Hudson Highlands, Harriman State Park.

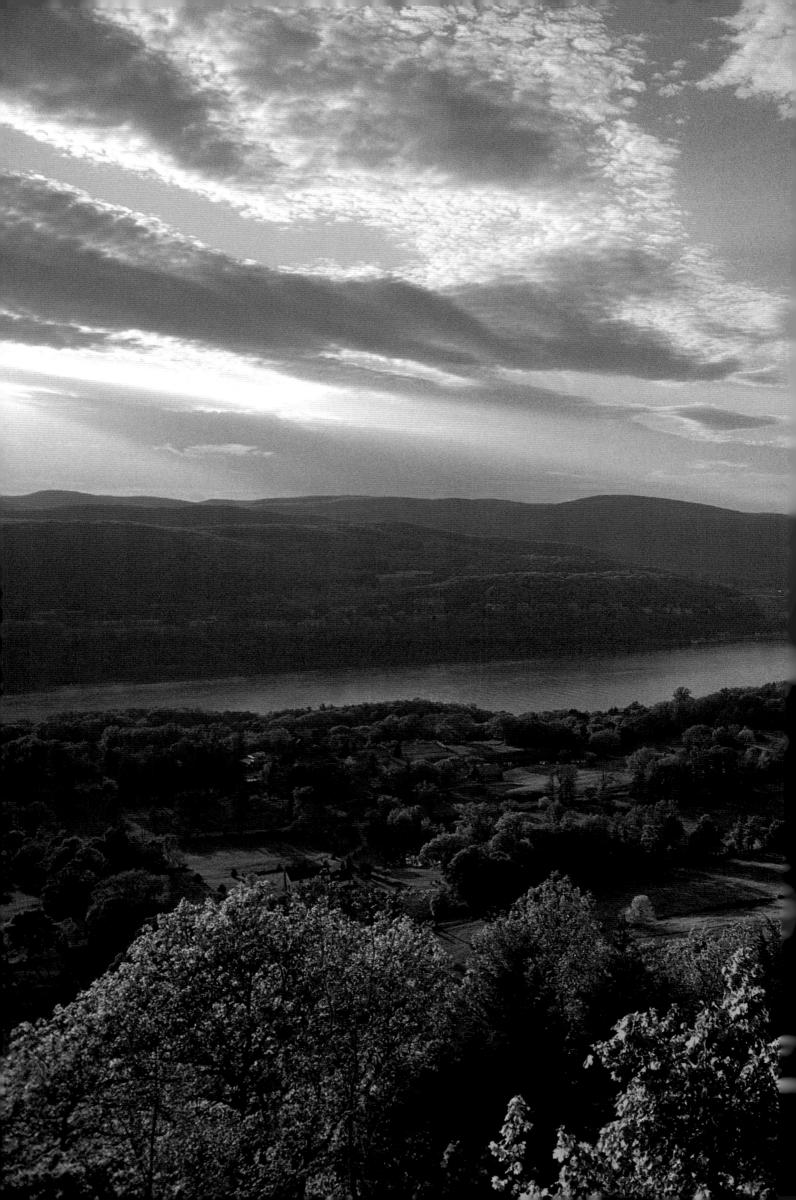

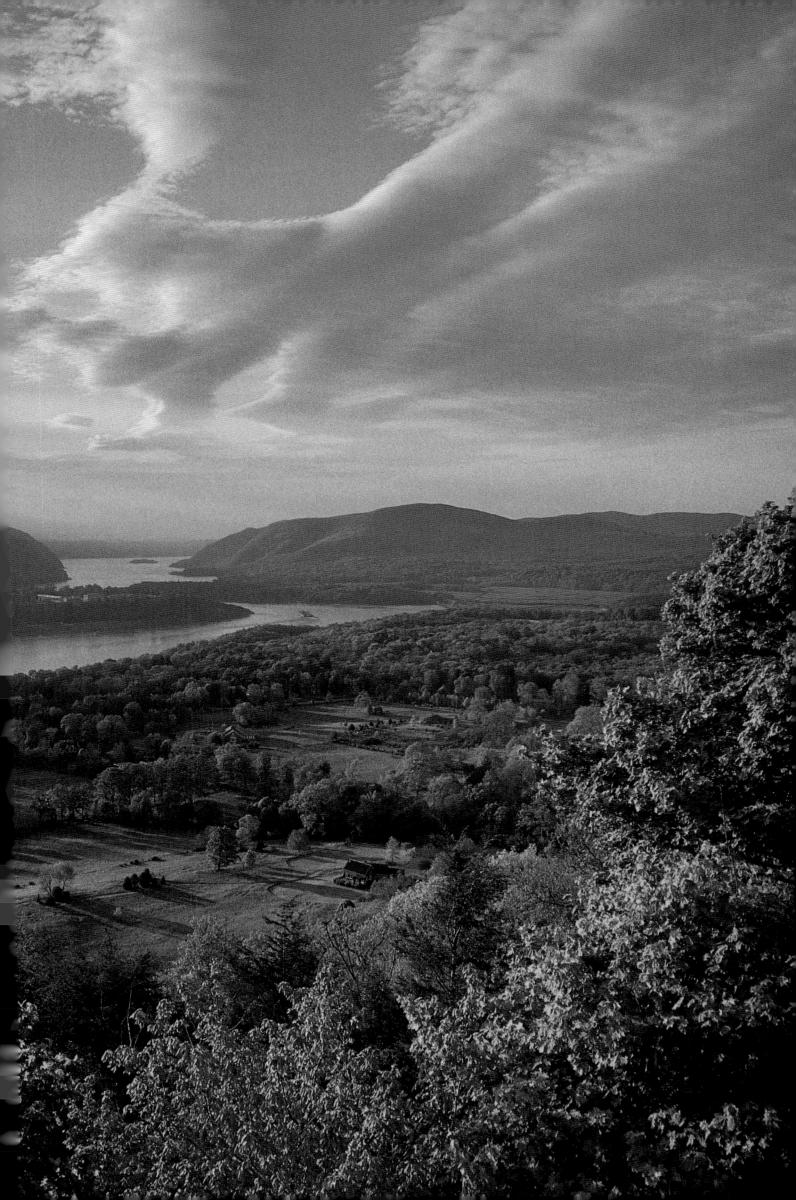

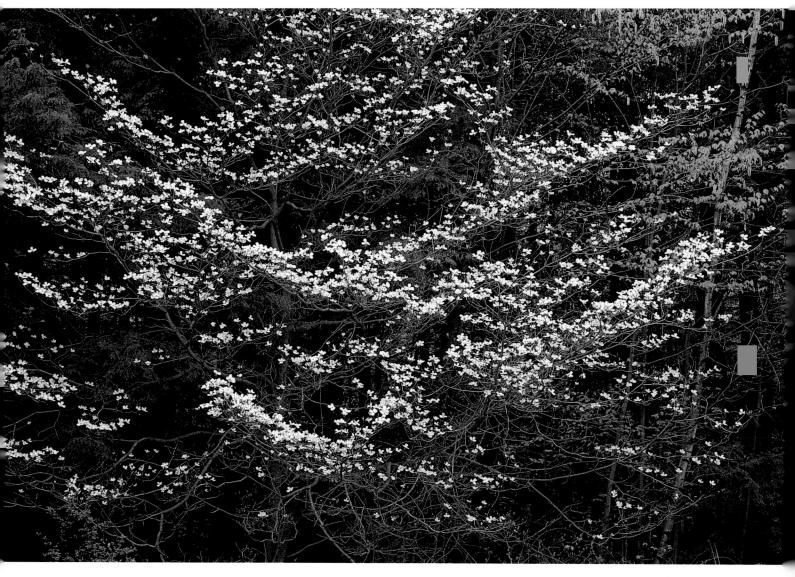

Above, opposite, and overleaf: Harriman State Park.

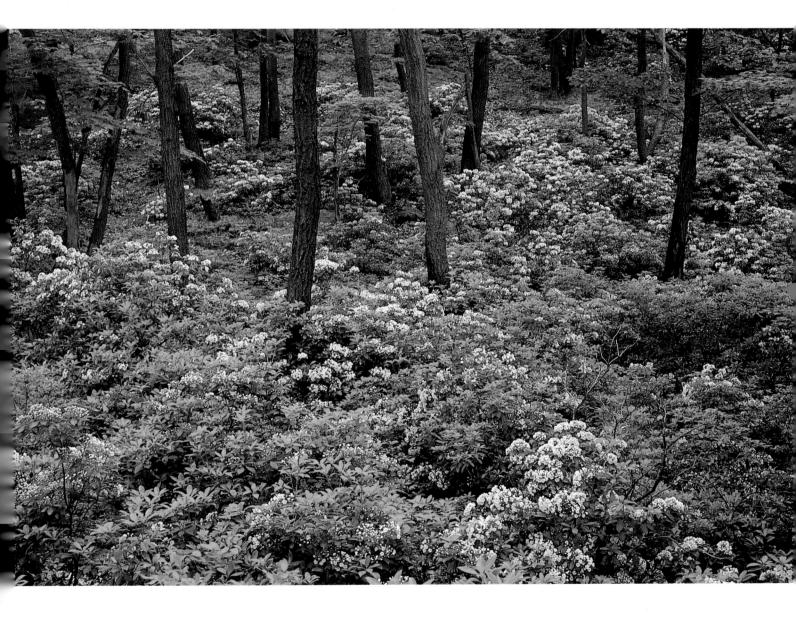

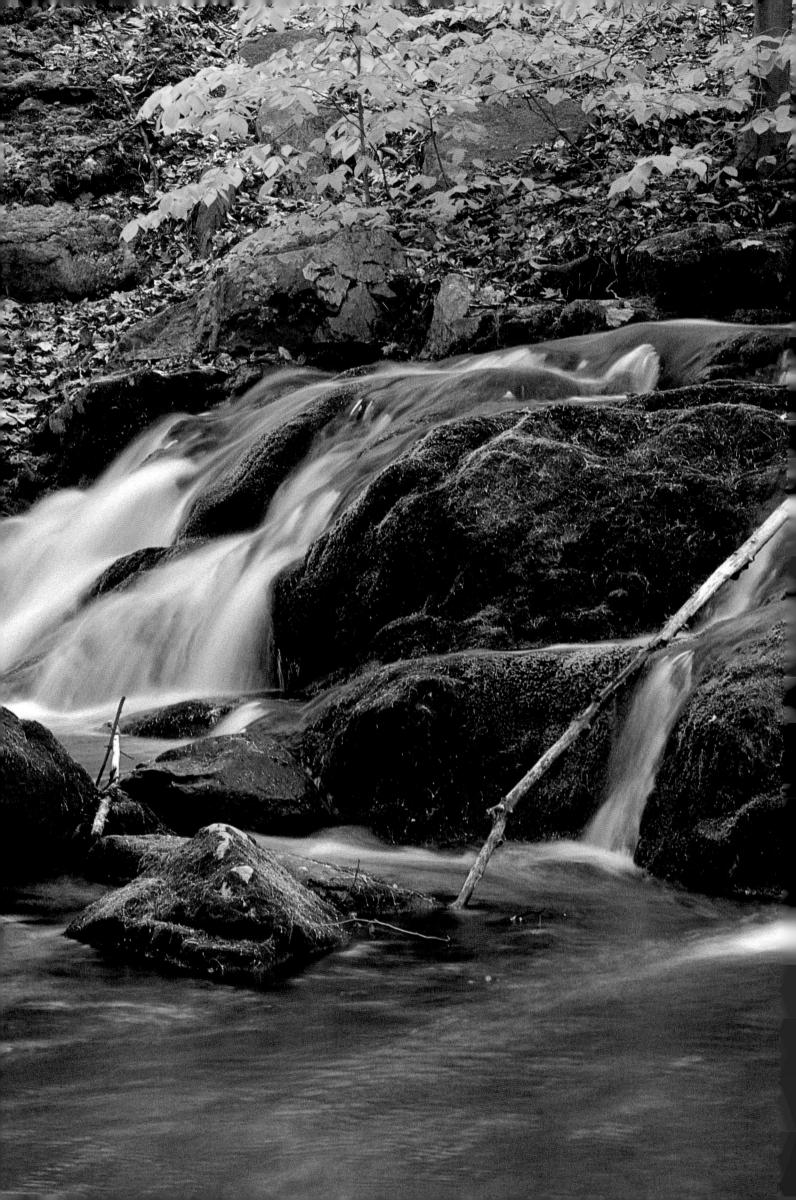

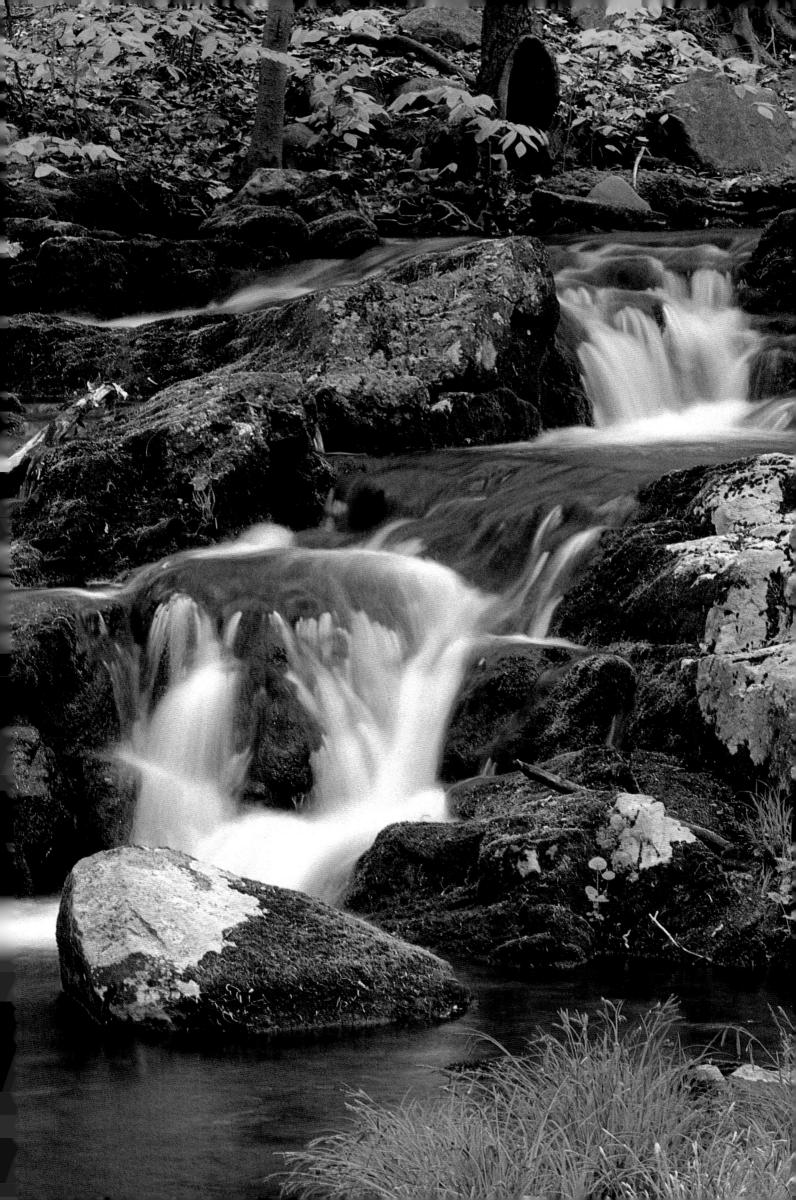

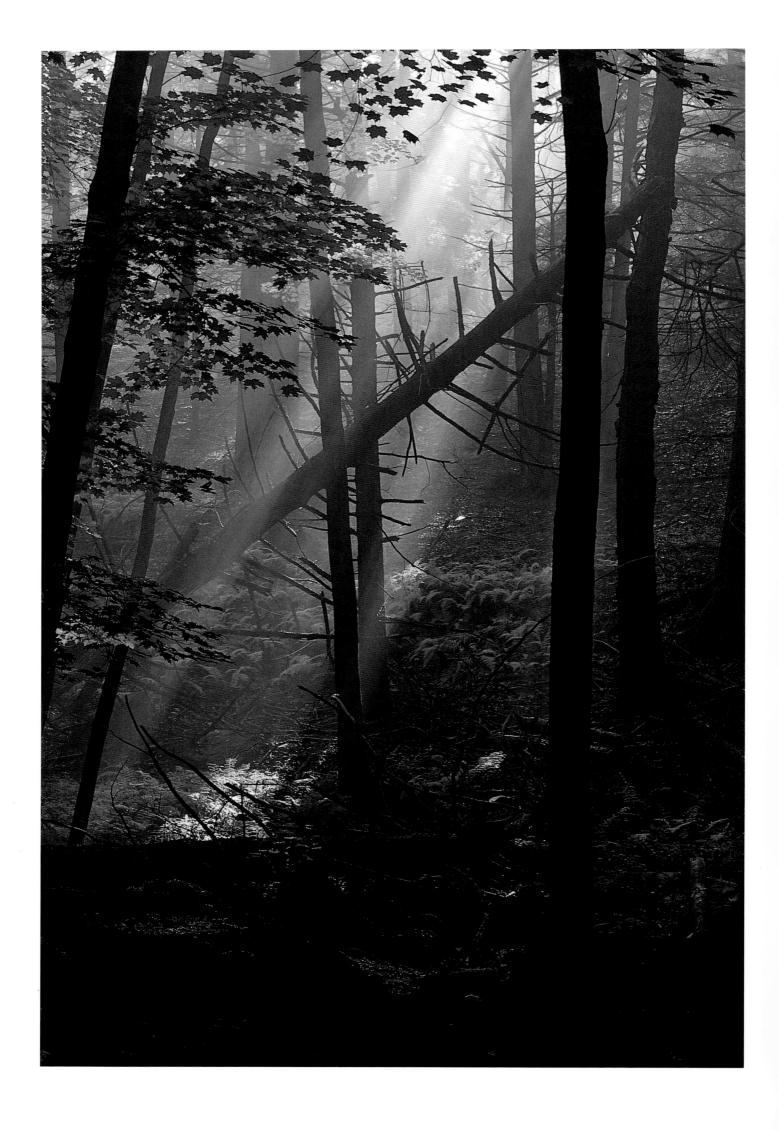

A CHIEF INTEREST TO THE WALKER IS THE GREAT EXPANSE OF WILD park property which neither the motorist nor the picnickers who crowd the "developed" areas ever see. In the early years of the park the walker had many dirt roads and miles upon miles of the wood roads built by the iron workers to follow, or he could choose his own way through the thickening woodland according to the topography, his taste, and his compass. As the park administration began to build roads and enlarge the ponds into lakes, the walker blundered into them, to his wrath, even when he had been able to keep himself fairly well oriented on his map. Many are the amusing stories old-timers can tell of coming out in unexpected spots, perhaps uncomfortably late in the day. With a job that must be reached on Monday morning there are limits to the pleasures of exploration. More unsatisfactory still was the difficulty of getting to the real tops of the wooded slopes or of finding the splendid views from cliff and ledge in which the region abounds. Now the blazed trails through the park have sought out these objectives for the hiker to enjoy but still many other "undiscovered" gems have been left for the experienced to find by himself.

The New York Walk Book, 1971

Harriman State Park.

Stand here by my side and turn, I pray,

On the lake below thy gentle eyes;

The clouds hang over it, heavy and gray,

And dark and silent the water lies.

WILLIAM CULLEN BRYANT

"The Show Shower"

Opposite: Harriman State Park. Overleaf: Popolopen Bridge.

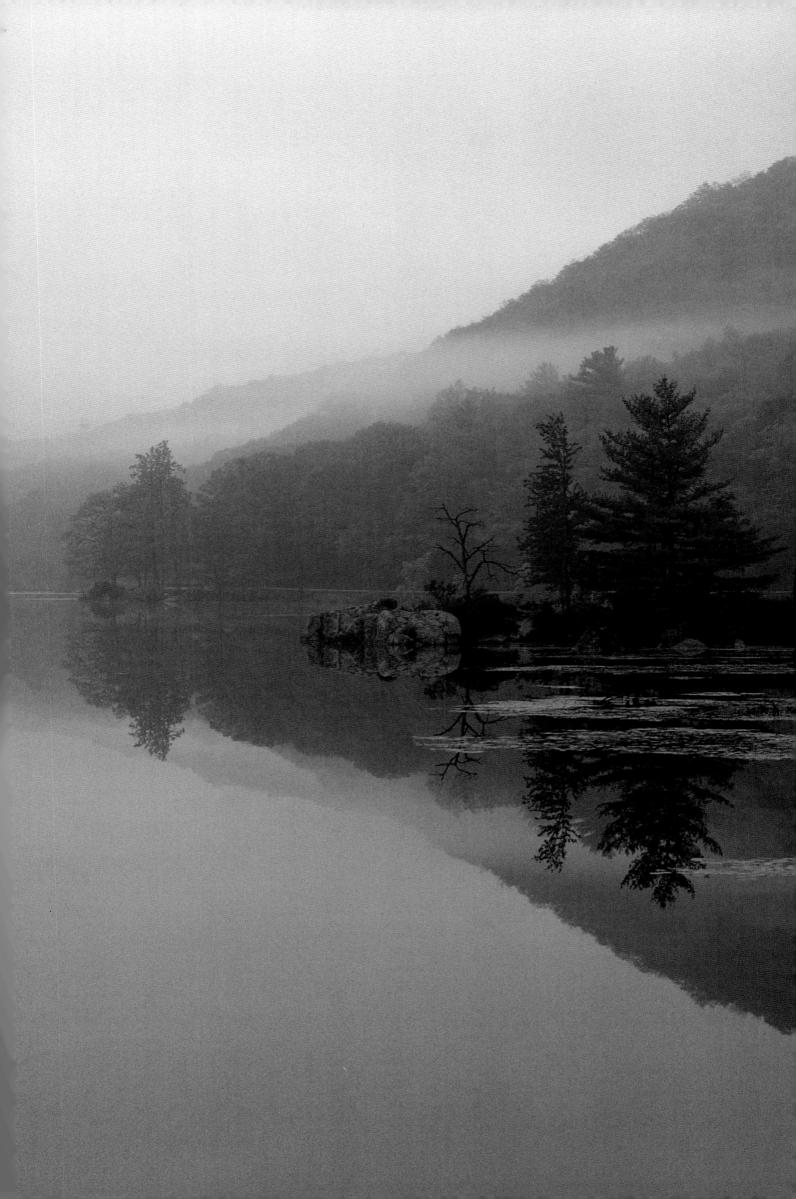

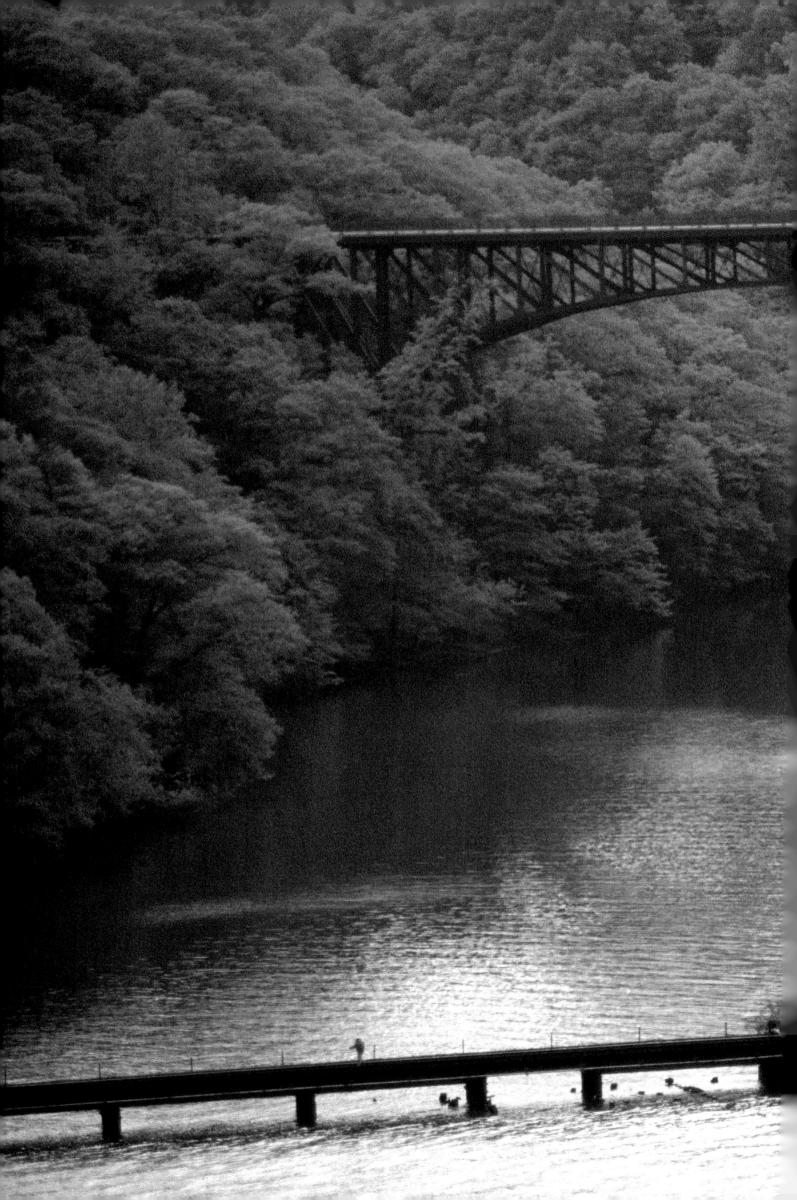

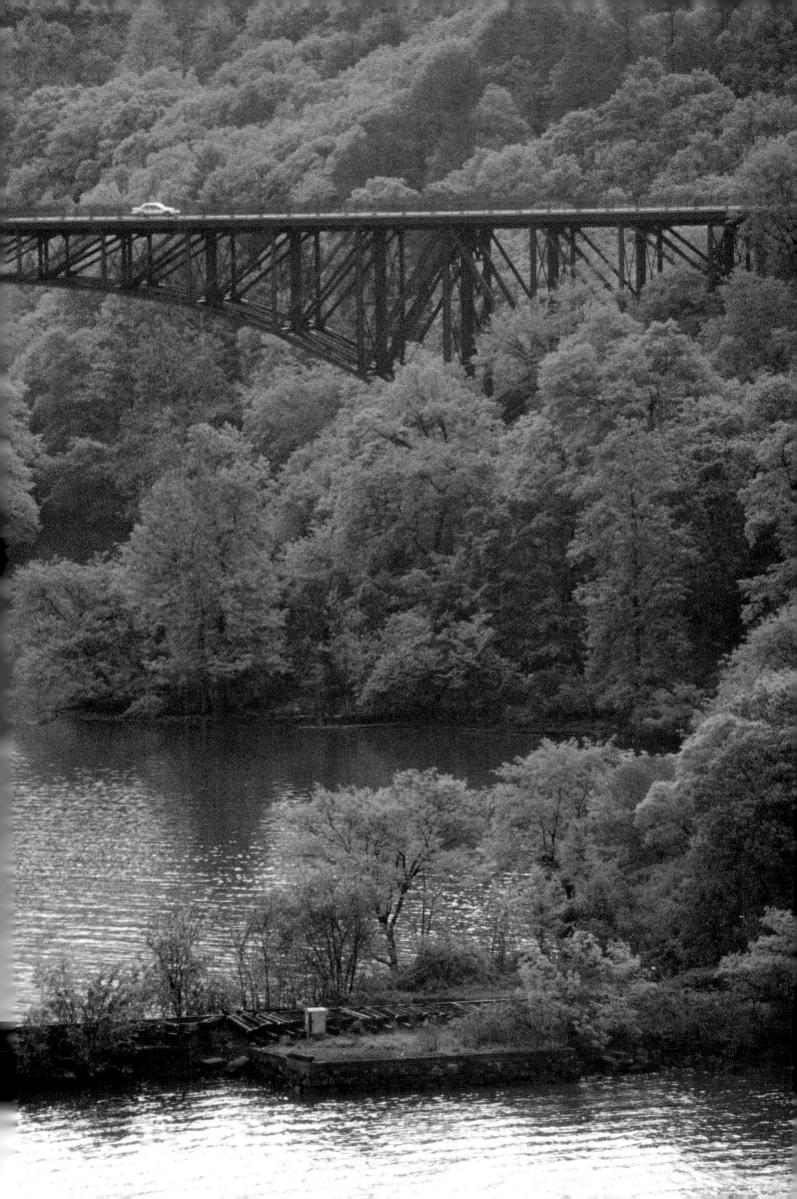

CORTLANDT MANOR HOUSE STANDS NEAR THE SHORE OF CROTON BAY. It was erected at the beginning of the last century, by John Van Cortlandt, eldest son of the first lord of the manor, and is now more than one hundred and fifty years old. Orloff Stevenson Van Cortlandt, father of the first proprietor of this estate, was a lineal descendant of the Dukes of Courland, in Russia. His ancestors emigrated to Holland, when deprived of the Duchy of Courland. The family name was Stevens, or Stevensen, van (or from) Courland. They adopted the latter as a surname, the true orthography of which, in Dutch, is Korte (short), and landt (land), a term expressing the form of the ancient Duchy of Courland. Orloff emigrated to America, and settled in New Amsterdam (New York), and in 1697 his son Stephen purchased the large estate on the Hudson, afterwards known as the Van Cortlandt Manor. By intermarriages, the Van Cortlandts are connected with nearly all of the leading families of NewYork – the Schuylers, Beekmans, Van Rensselaers, De Peysters, De Lanceys, Bayards, &c.The Manor House was built of heavy stone; and the thick walls were pierced with loopholes for musketry to be used in defense against the Indians. It has been somewhat changed in aspect, by covering the round stone with stucco. Its front, graced by a pleasant lawn, commands an extensive view of the bay, and of the Hudson beyond. In that bay, under the shelter of Croton Point, Hendrick Hudson anchored the Half-Moon, on the evening of the first of October, 1609; and such a resort were these waters for canvas-back ducks, and other water-fowl, that, as early as 1683, Governor Dongan came there to enjoy the sport of fowling. There, too, great quantities of shad were caught. But its glory is departed. The flood of 1841, that swept away the Croton Dam, almost filled the bay with earth; it is accumulating there every hour; and, in the course of a few years, the Van Cortlandt estate will have many acres of fine meadow land added to it, where once large vessels might ride at anchor. BENSON JOHN LOSSING

The Hudson: From the Wilderness to the Sea, 1866

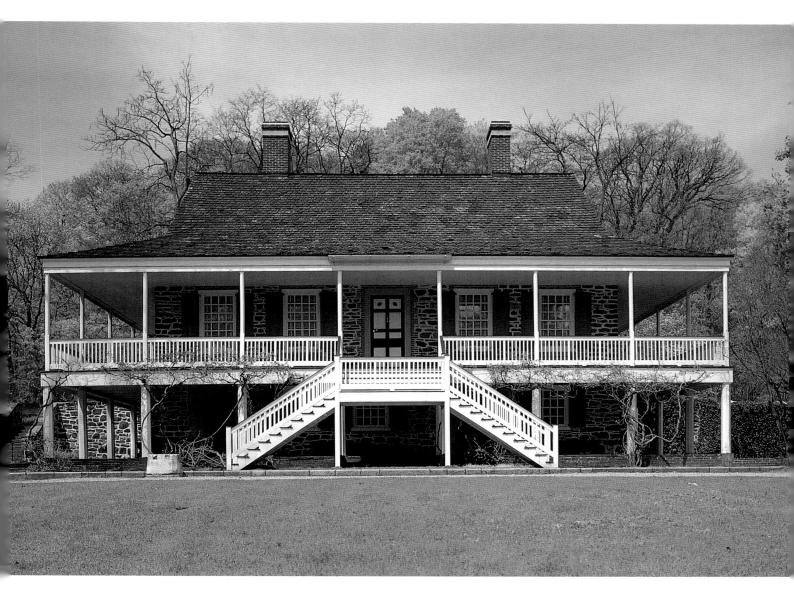

Van Cortlandt Manor, Croton-on-Hudson.

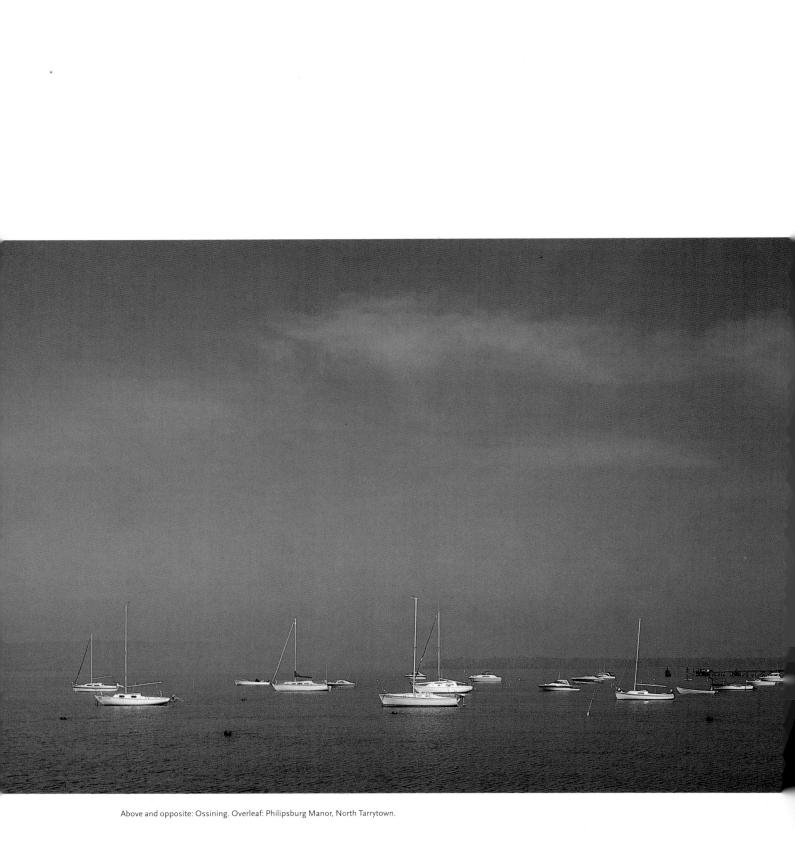

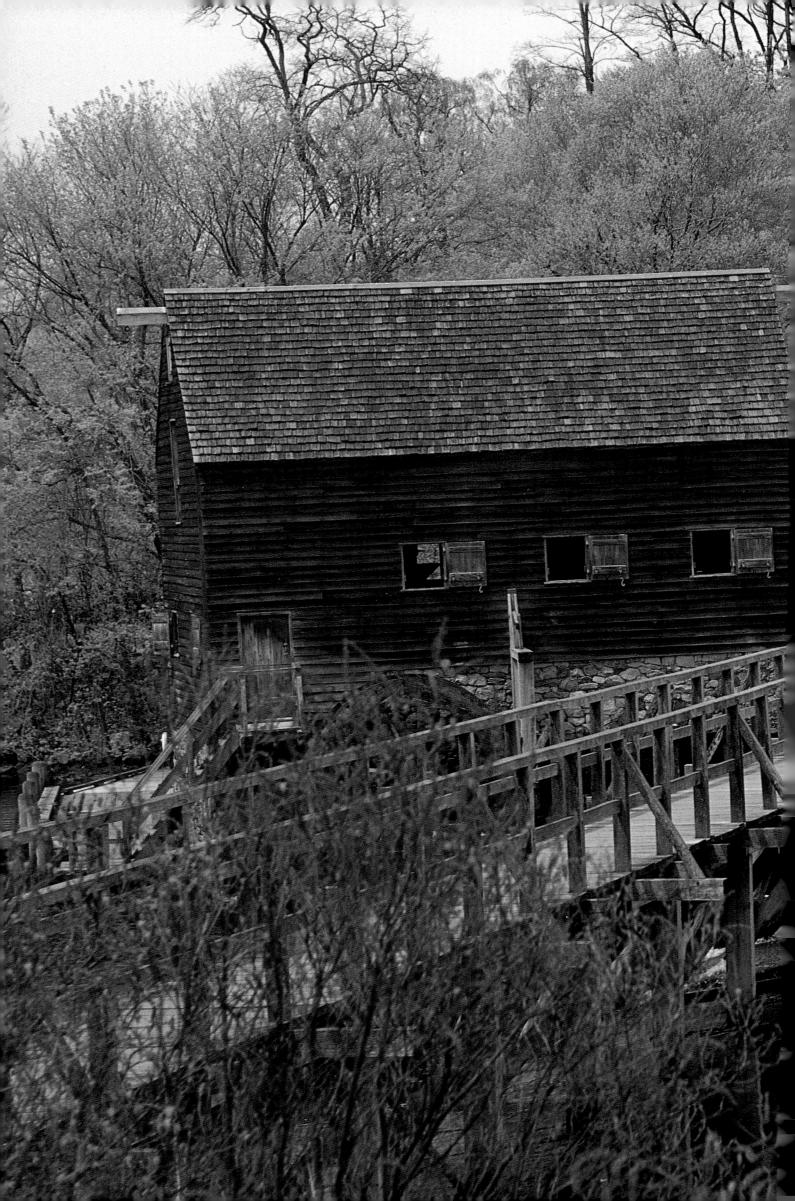

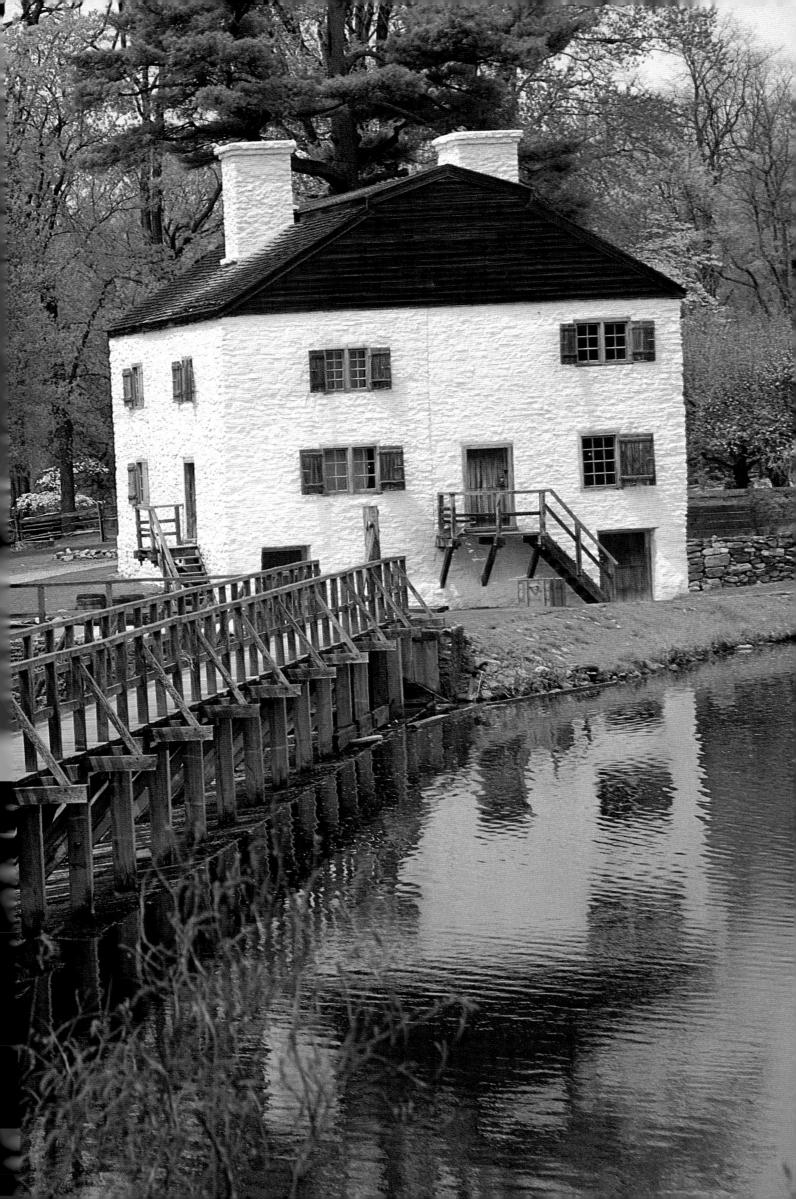

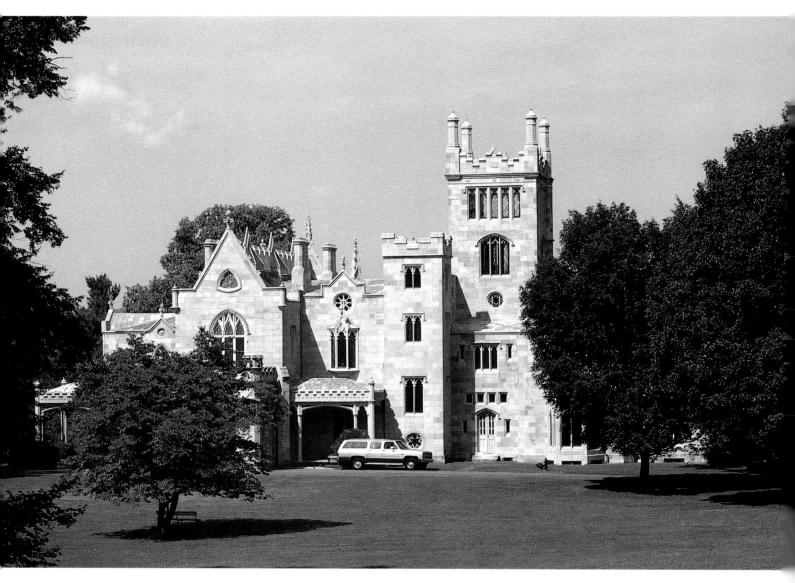

Lyndhurst, Tarrytown.

LYNDHURST, AS IT CAME TO US, PORTRAYED WITHIN THE SHELL of one architectural monument three important eras in American life.

The first period is revealed in the original core of the house, as designed in 1838 for General William Paulding by Alexander Jackson Davis, the well-known nineteenth-century American architect. The second period, that of the tower and the dining-room wing addition, was designed for George Merritt in 1864, also by Davis.

The third period began when Jay Gould in 1880 became its purchaser; he changed little, but added books and pictures and rebuilt the magnificent Merritt greenhouse which had burned shortly after he purchased the estate. Mr. Gould died in 1892 and his oldest daughter Helen, Mrs. Finley Shepard, continued to live at Lyndhurst until her death in 1938. She too made only minor alterations to the house but added furnishings, particularly her collection of religious art. Finally, in 1939 Gould's second daughter, Anna, the Duchess of Talleyrand-Perigord, returned from France to live in NewYork City and Tarrytown. She brought to the already crowded rooms at Lyndhurst the overflow of furnishings and art objects from her Pink Palace in Paris and her chateau at Versailles. After her death the estate came to the National Trust in 1964; the restoration began the following year.

Lyndhurst: A Property of the National Trust for Historic Preservation, 1965

SUNNYSIDE WAS DESCRIBED BY WASHINGTON IRVING IN *A CHRONICLE* of Wolfert's Roost as "a little, old-fashioned stone mansion, all made up of gable ends, and full of angles and corners as an old cocked hat." In the *Chronicle* he wished to give the impression that his house was a duplicate of the original abode erected on the spot by Wolfert Acker, one of the privy councilors to Peter Stuyvesant. Irving relates that Wolfert Acker had inscribed over the door his favorite Dutch motto "Lust in Rust" (pleasure in rest), which had led those who did not understand Dutch to refer to the establishment as Wolfert's Roost.

CLAY LANCASTER

"The Architecture of Sunnyside," 1947

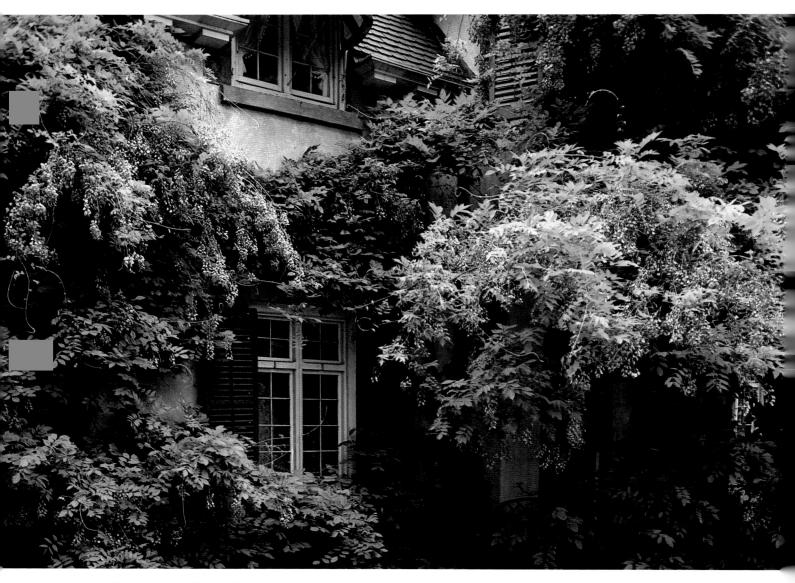

Above and opposite: Sunnyside, Tarrytown.

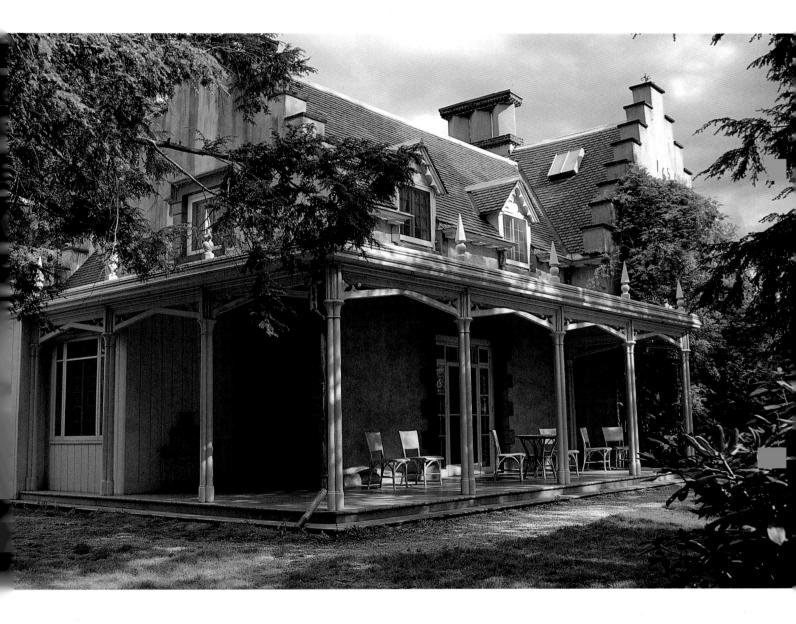

The Hudson of

COMMERCE

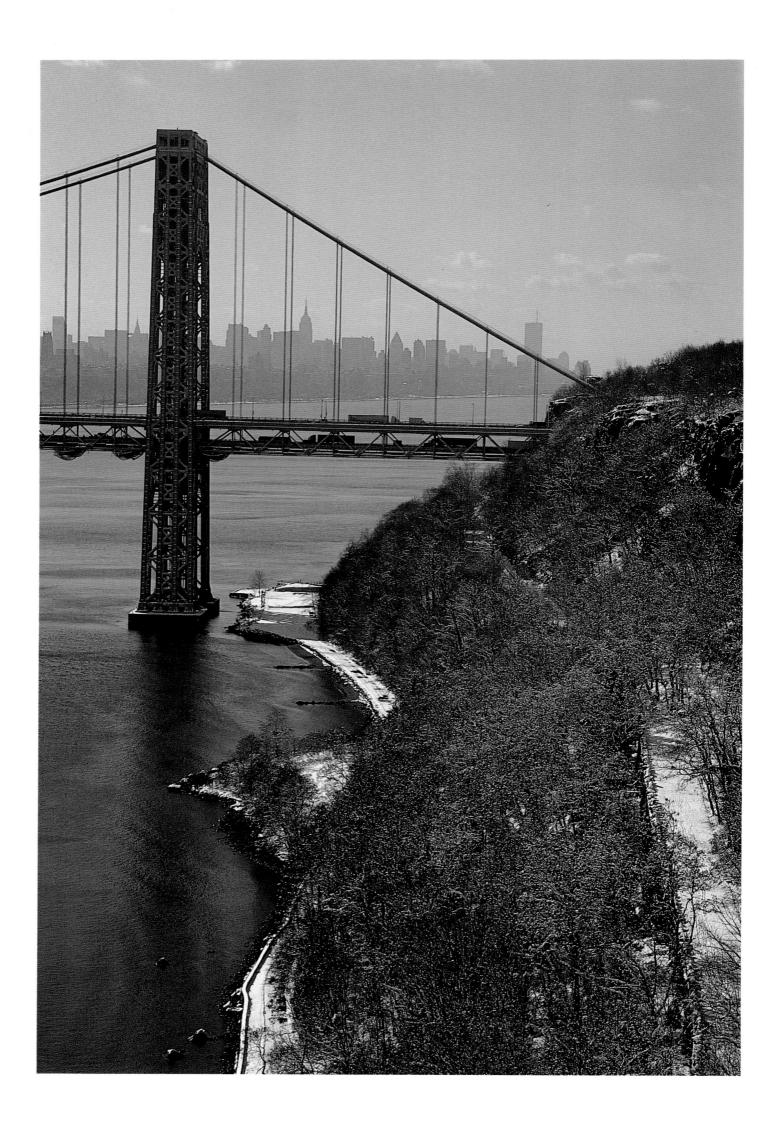

SHE IS THE ONLY CITY WHOSE LOVERS LIVE ALWAYS IN A MOOD OF wonder and expectancy. There are others where one may sink peacefully, contentedly into the life of the town, affectionate and understanding of its ways. But she, the woman city, who is bold enough to say he understands her? The secret of her thrilling and inscrutable appeal has never been told. How could it be? She has always been so much greater than any one who has lived with her. (Shell we mention Walt Whitman as the only possible exception? O. Henry came very near to her, but did he not melodramatize her a little, sometimes cheapen her by his epigrammatic appraisal, fit her too neatly into his plot? Kipling seemed to see her only as the brutal, heedless wanton.) Truly the magic of her spell can never be exacted. She changes too rapidly, day by day. Realism, as they call it, can never catch the boundaries of her pearly beauty. She needs a mystic...

Her air, when it is typical, is light, dry, cool. It is pale, it is faintly tinctured with pearl and opal. Heaven is unbelievably remote; the city itself daring so high, heaven lifts in a cautious remove. Light and shadow are fantastically banded, striped, and patchworked among her cavern streets; a cool, deep gloom is cut across with fierce jags and blinks of brightness. She smiles upon man who takes his ease in her colossal companionship. Her clean soaring perpendiculars call the eye upward. One wanders as a botanist in a tropical forest. That great smooth groinery of the Pennsylvania Station train shed: is it not the arching fronds of iron palm trees? Oh, to be a botanist of this vivid jungle, spread all about one, anatomist of the ribs and veins that run from the great backbone of Broadway!

To love her, one thinks, is to love one's fellows; each of them having some unknown share in her loveliness. Any one of her streets would be the study and delight of a lifetime. To speak at random, we think of that little world of brightness and sound bourgeois cheer that spreads around the homely Verdi statue at Seventy-third Street . . . Within a radius, thereabouts, of a quarter-mile each way, we could live a year and learn new matters every day. They call us a hustling folk. Observe the tranquil afternoon light in those brownstone byways. Pass along leisurely Amsterdam Avenue, the region of small and genial shops, Amsterdam Avenue of the many laundries. See the children trooping upstairs to their own room at the St. Agnes branch of the Public Library. See the taxi drivers, sitting in their cars alongside the Verdi grass plot (a rural breath of new-mown turf sweetening the warm, crisp air) and smoking pipes. Every one of them is to us as fascinating as a detective story. What a hand they have had in ten thousand romances. At this very moment, what quaint and many-stranded destinies may hail them and drive off? But there they sit, placid enough, with a pipe and the afternoon paper. The light, fluttering dresses of enigmatic fair ones pass gayly on the pavement. Traffic flows, divides, and flows on, a sparkling river. . .

So she teases us, so she allures. Sometimes on the el, as one passes along that winding channel where the walls and windows come so close, there is a felicitous sense of being immersed, surrounded, drowned in a great, generous ocean of humanity. It is a fine feeling. All life presses around one, the throb and the problem are close, are close. Who could be weary, who could be at odds with life, in such an embrace of destiny? The great tall sides of buildings fly open, the human hive is there, beautiful and arduous beyond belief. Here is our worship and here our lasting joy, here is our immortality of encouragement. Yes, perhaps O. Henry did say the secret after all: "He saw no longer a rabble, but his brothers seeking the ideal."

CHRISTOPHER MORLEY

"The Anatomy of Manhattan," Pipefuls, 1921

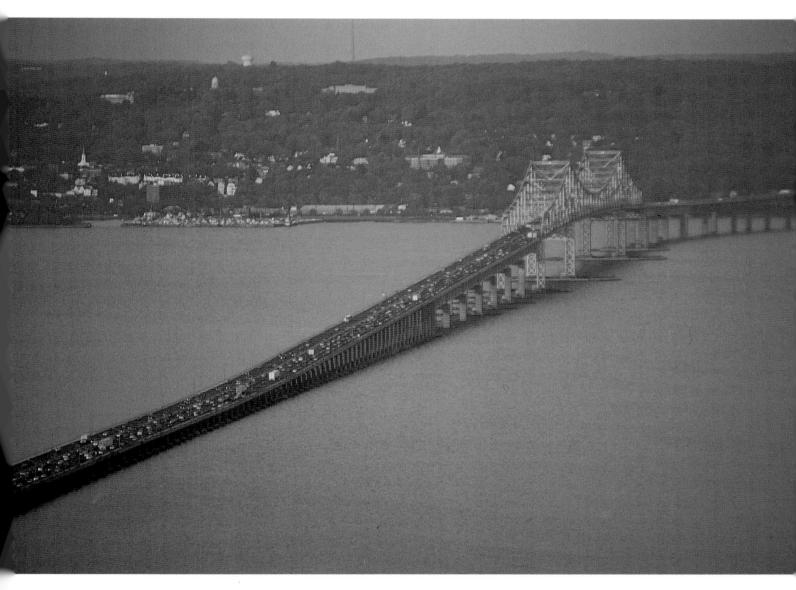

Above and overleaf: Tappan Zee Bridge, between Nyack and Tarrytown.

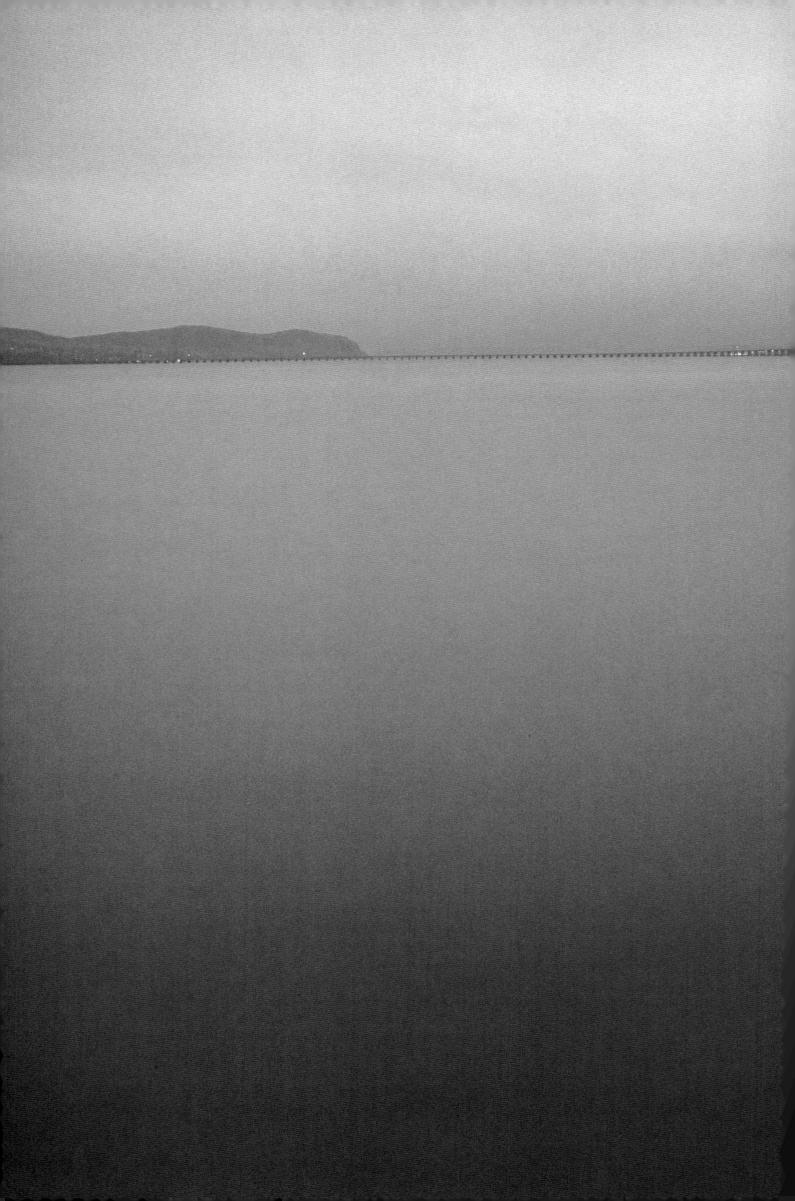

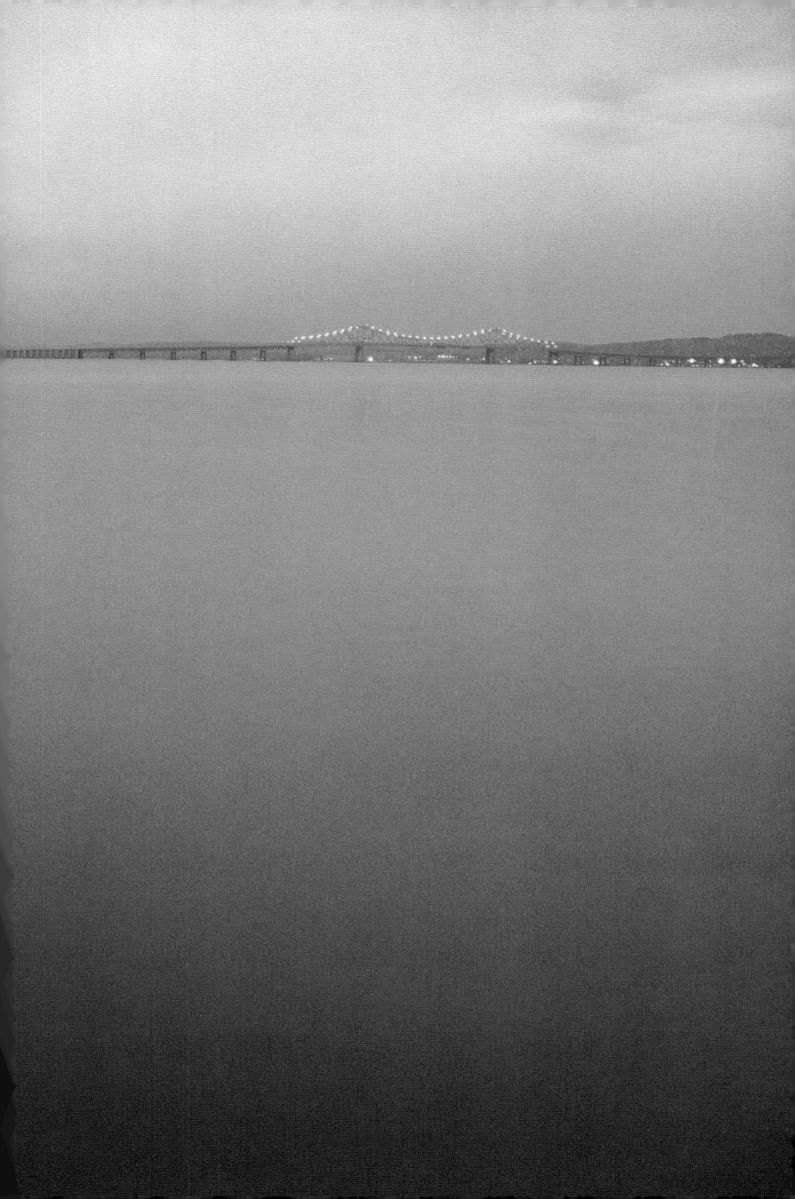

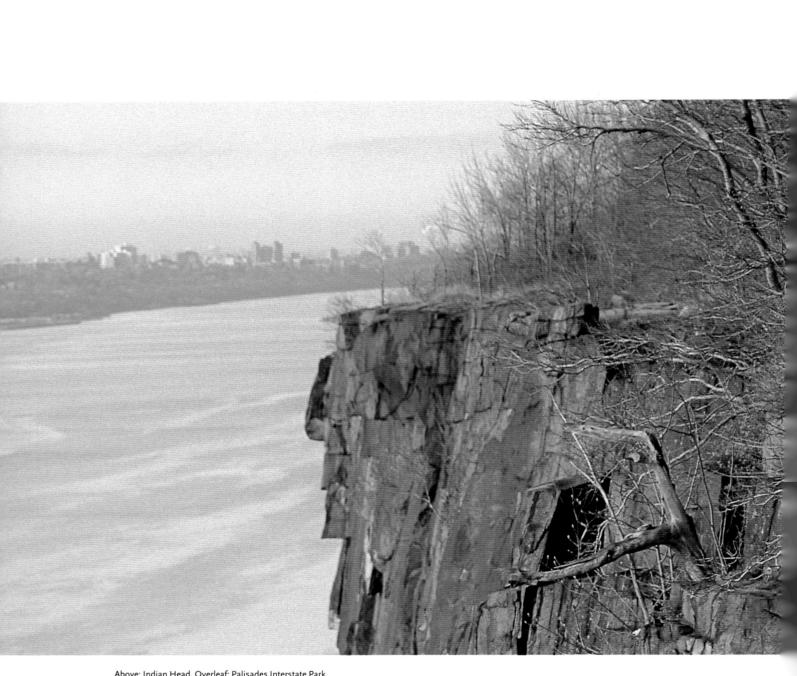

Above: Indian Head. Overleaf: Palisades Interstate Park.

TO THOSE WHO HAVE NOT EXPLORED THE LONG RIDGE OF TOWERING basalt that rims the northeastern edge of New Jersey, and become in tune with the spirit of its huge gray rocks, the Palisades of the Hudson remain a closed book. Travelers by the railway on the opposite shore, or by the river steamers, following the main channel, see only a nearly perpendicular wall, fringed with vegetation at its base and top. To them and to writers whose viewpoint is similar to theirs, "the great chip rocks," as the Dutch pioneers named them, are little more than natural curiosities of monotonous formation. A closer intimacy with the unspoiled portion of the ridge extending from Edgewater to Piermont unfolds unexpected charms.

Let him who would discover the wonders and beauties of these ancient cliffs paddle close to their winding base, landing here and there in the shady glades that tempt the river wanderer at frequent intervals. Near one of the cool and crystal springs that gush from crevices in the rocks, the explorer's tent should be pitched. There are a few points where the dizzy heights may be ascended, and a ramble through the wild woodland that surmounts the cliffs and a sight of the picturesque near and distant views will richly reward the climber.

As the edge of the precipice is reached, instead of a flat-faced wall the Palisades will be found in reality to consist of a series of bold and majestic headlands, diversified by innumerable rocky battlements, often separated by tiny valleys down which dash silvery cascades. Instead of the apparently even fringes of verdure surmounting the heights, a wild and pristine forest will be found which nature has richly stocked with an endless variety of tree, shrub, and flower. Here will the explorers who can read them find graven upon the stones in spite of ravages of time, records of the earth's creation full of significance and interest. Here, too, will he who cherishes Revolutionary associations be able to visit localities made famous by the armies of Washington and Cornwallis.

ARTHUR C. HACK

The Palisades of the Hudson, 1909

THE HUDSON HAS ALWAYS POSSESSED THAT CONTRADICTORY DUALITY OF

aesthetics and industry: the nation's first great highway of commerce – whose history is written in smoke, brick, steam, and rail - yet somehow a river of constant beauty.

RAYMOND L. O'BRIEN

American Sublime, 1981

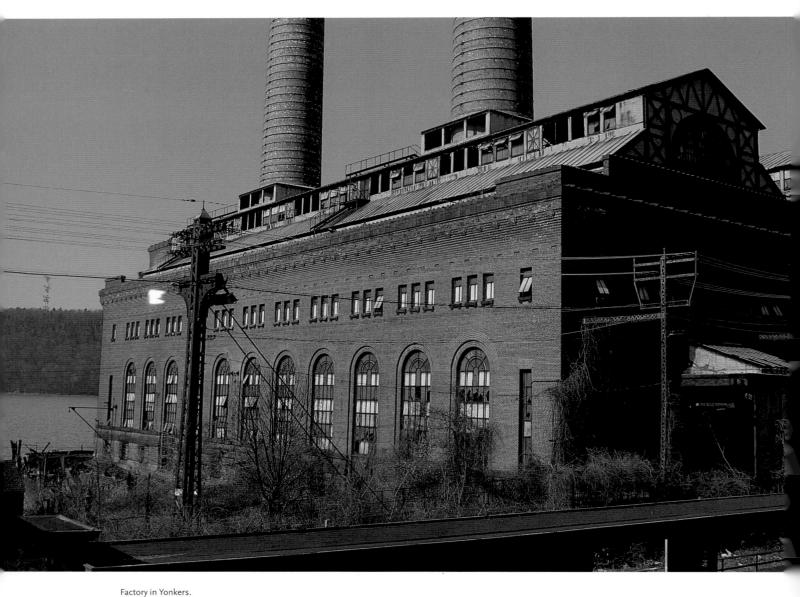

Haverstraw.

Above and opposite: Wave Hill, the Bronx. Overleaf: George Washington Bridge with Manhattan in the distance.

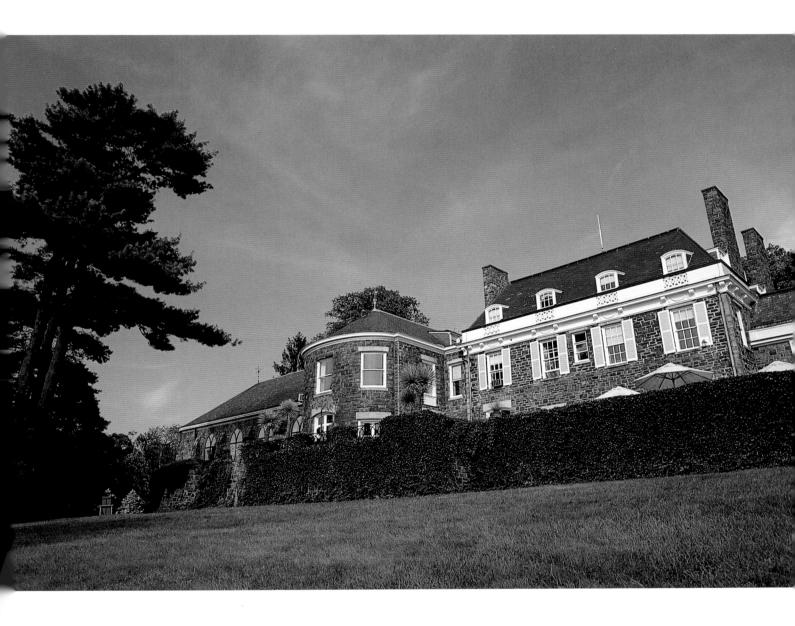

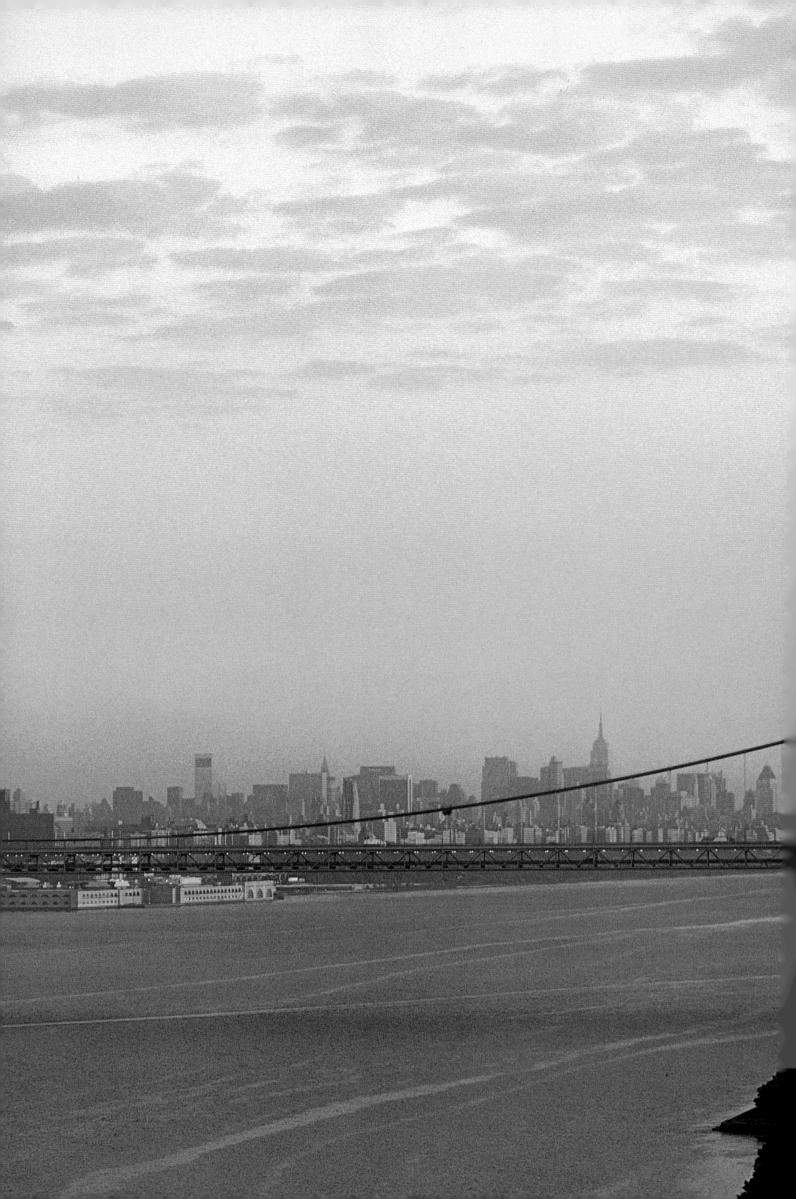

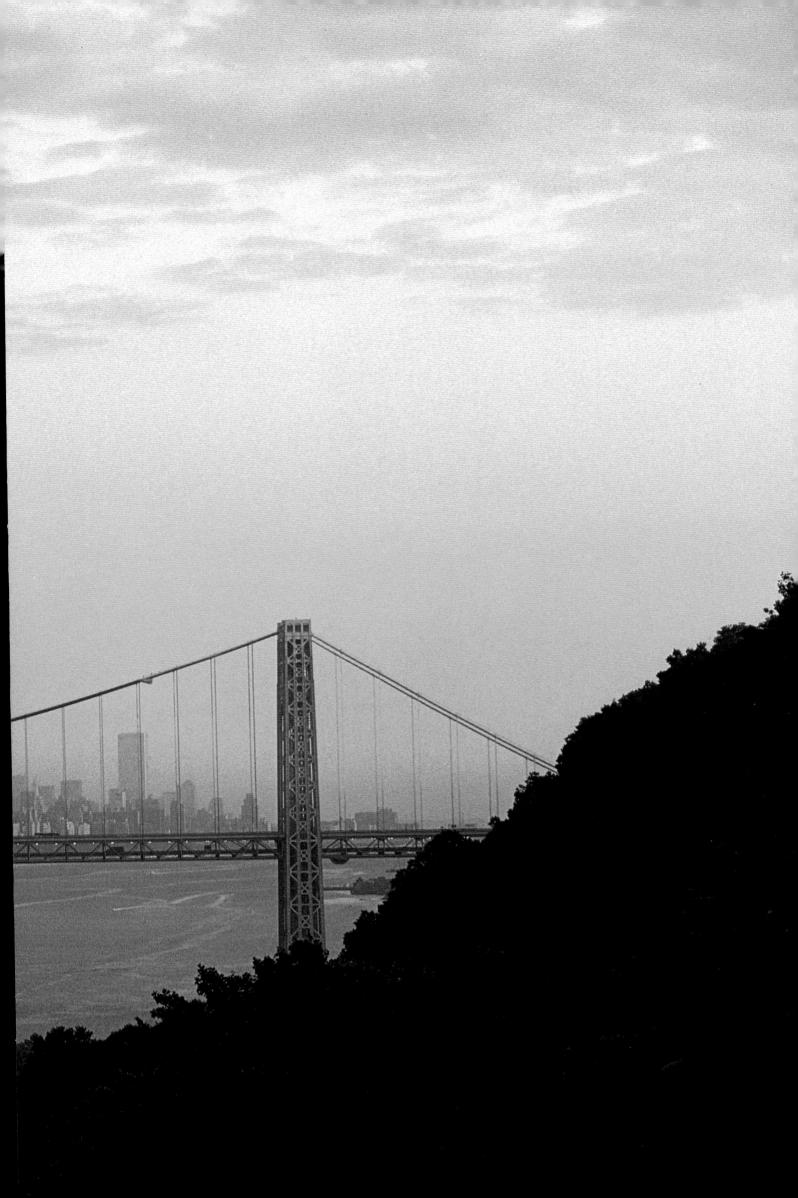

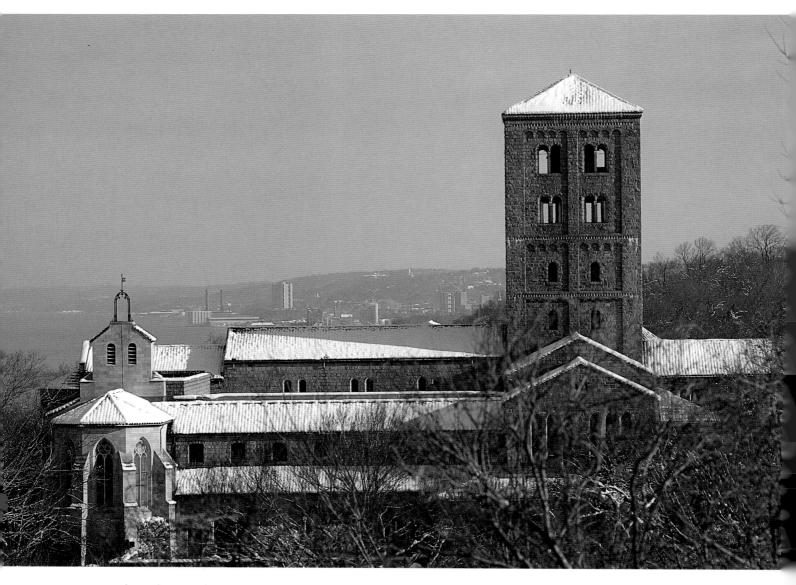

Above and opposite: The Cloisters, Fort Tryon Park. Overleaf: George Washington Bridge and Jeffries Hook lighthouse.

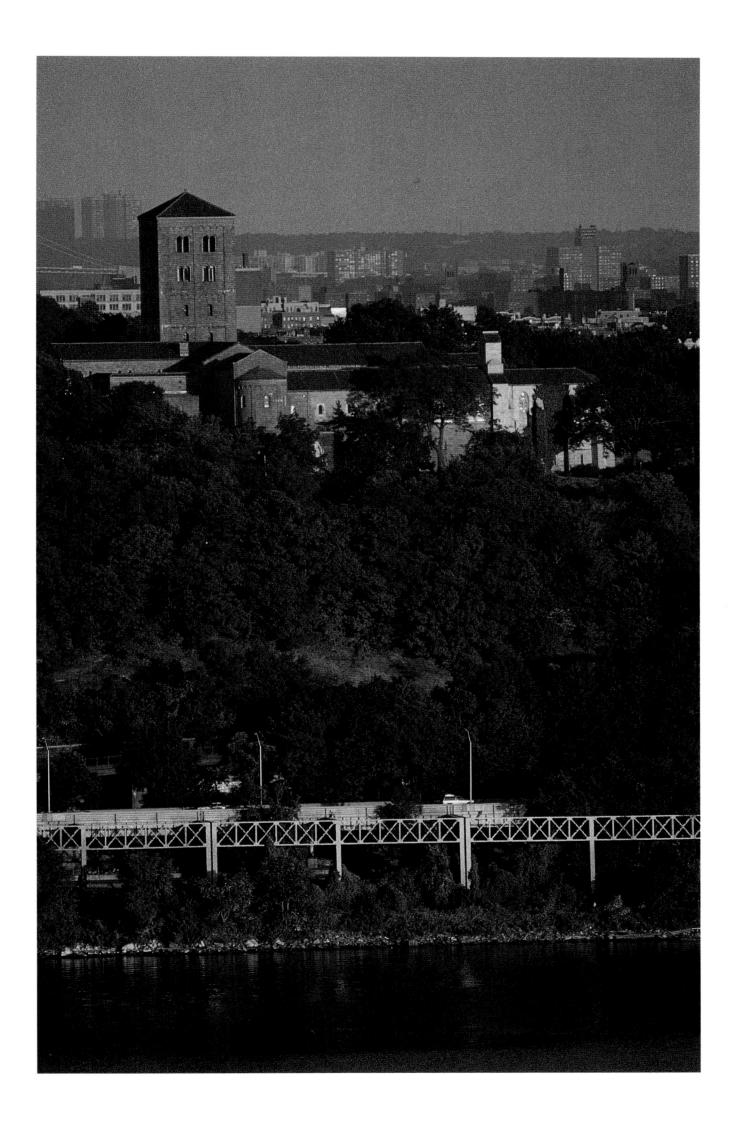

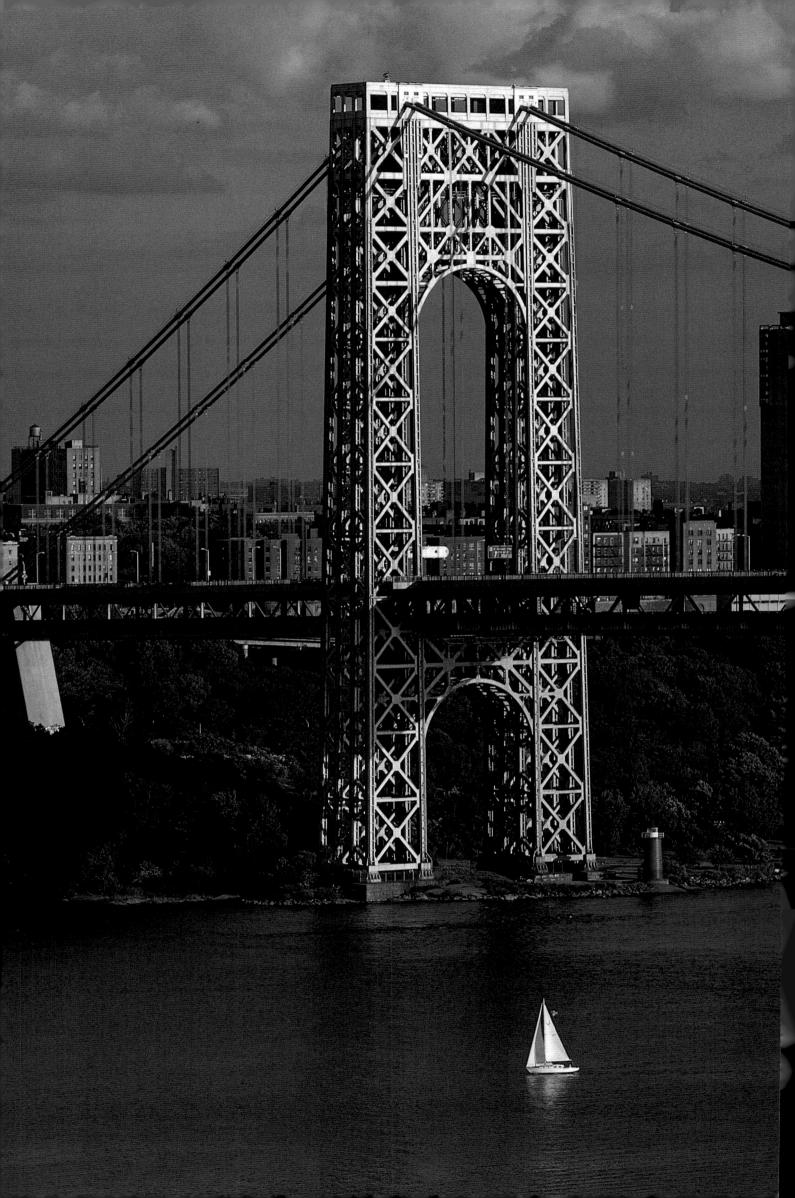

THE LITTLE RED LIGHTHOUSE KNEW THAT IT WAS NEEDED. THE BRIDGE wanted it. The man wanted it. The ships must need it still. It sent a long, bright, flashing ray out into the night. One second on, two seconds off! Flash, flash, flash! Look out! Danger! Watch me! it called. Soon its bell was booming out too. Warn-ing! Warn-ing! it cried. The little red lighthouse still had work to do. And it was glad.

And now beside the great beacon of the bridge the small beam of the lighthouse still flashes. Beside the towering gray bridge the lighthouse still bravely stands. Though it knows now that it is little, it is still *very, very proud*.

HILDEGARDE H. SWIFT AND LYND WARD

The Little Red Lighthouse and the Great Gray Bridge, 1942

George Washington Bridge and Jeffries Hook lighthouse.

George Washington Bridge.

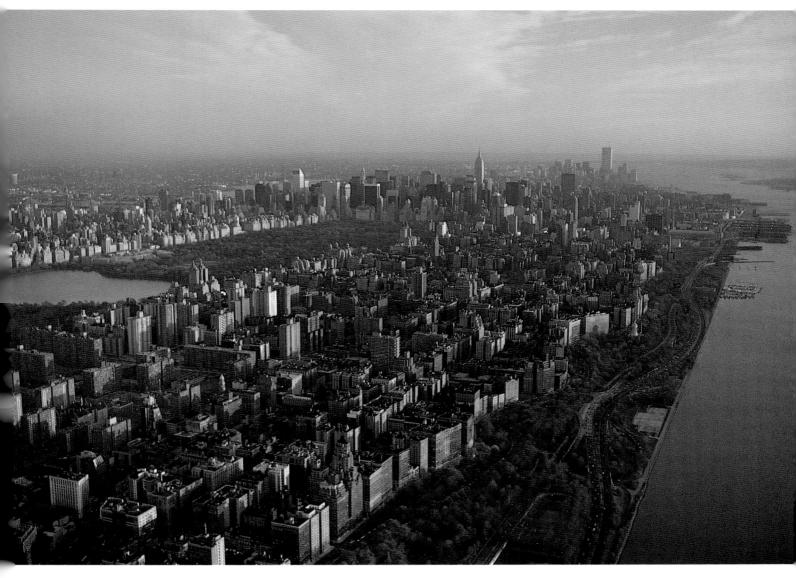

Manhattan's West Side.

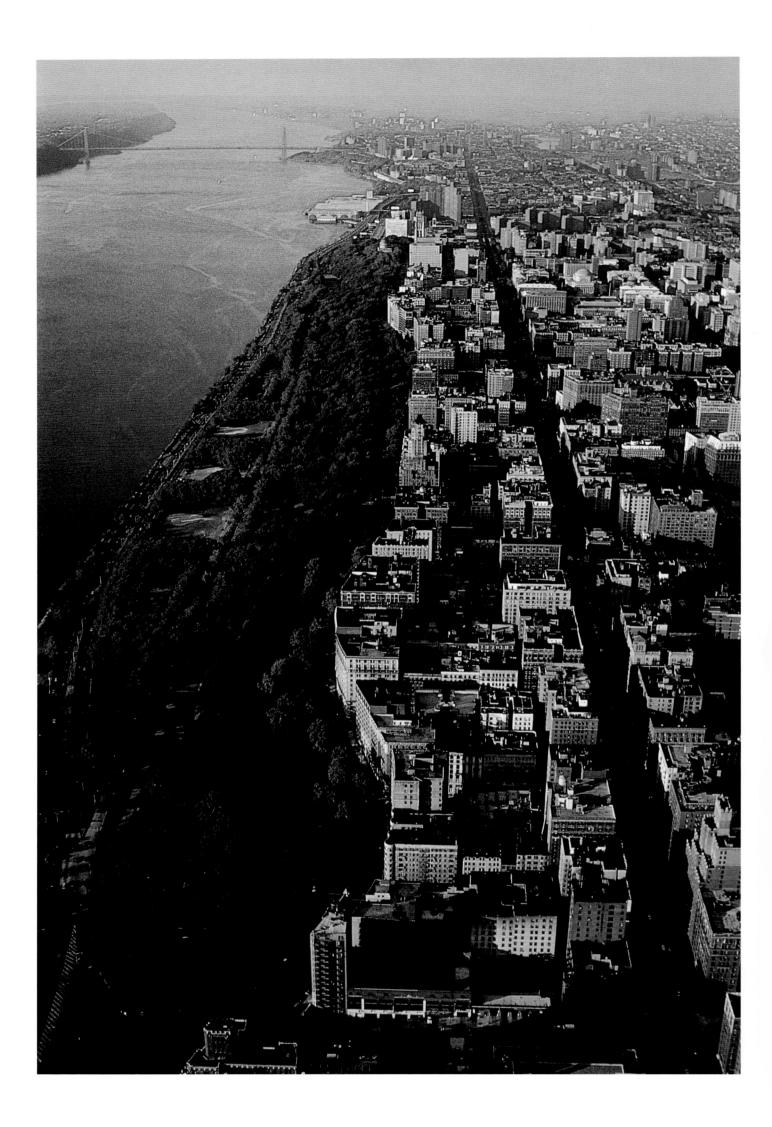

ONE SUNDAY IN 1914, ROBERT MOSES WAS CROSSING THE HUDSON BY ferry to picnic in New Jersey. With him were some college friends and their dates, one of whom was Frances Perkins, later the United States Secretary of Labor. As the ferry pulled out into the river, Moses leaned on the rail, watching Manhattan spread out behind the boat. Miss Perkins happened to be standing beside him and suddenly she heard Moses exclaim, "Isn't this a temptation to you? Couldn't this waterfront be the most beautiful thing in the world?"... Staring back at the bleak mud flats covered by a haze of smoke from the railroad engines, she heard Moses paint for her a picture of what the scene could be like on a Sunday - the ugly tracks completely hidden by the great highway, cars traveling slowly along it, their occupants enjoying the view, and along the highway stretching green parks filled with strollers, tennis players and families on bicycles. There would be sailboats on the river and motor yachts tied up in gracefully curving basins. And the thing that astonished her most, Miss Perkins was to recall, was that Bob Moses had the exact location of tennis courts and boat basins quite definitely in mind; the young Bureau staffer beside her was talking about a public improvement on a scale almost without precedent in turn-of-the-century urban America, an improvement that would solve a problem that had baffled successive city administrations for years.

ROBERT A. CARO

The Power Broker: Robert Moses and the Fall of New York, 1974

Riverside Park.

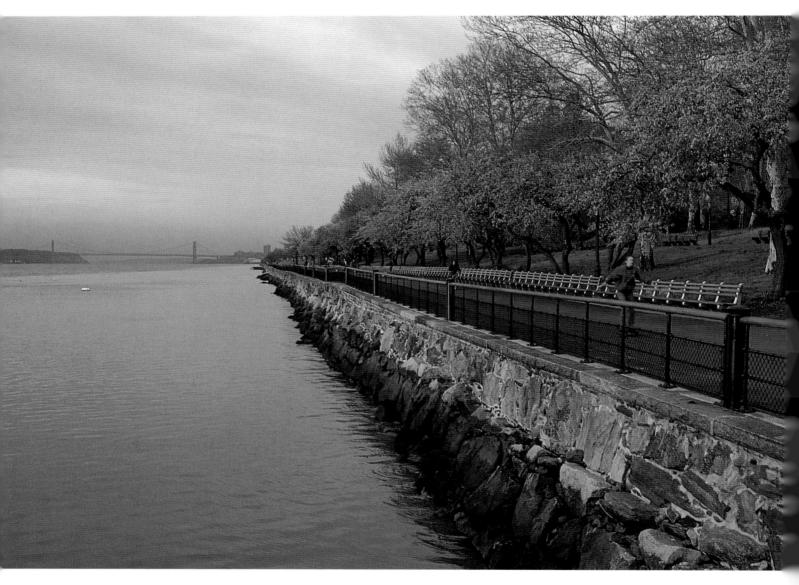

Riverside Park.

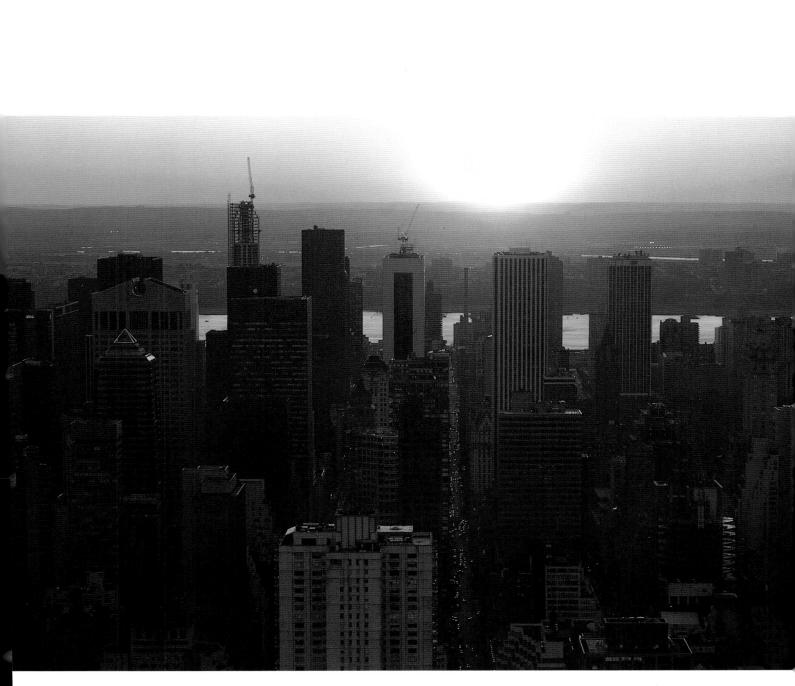

Midtown Manhattan.

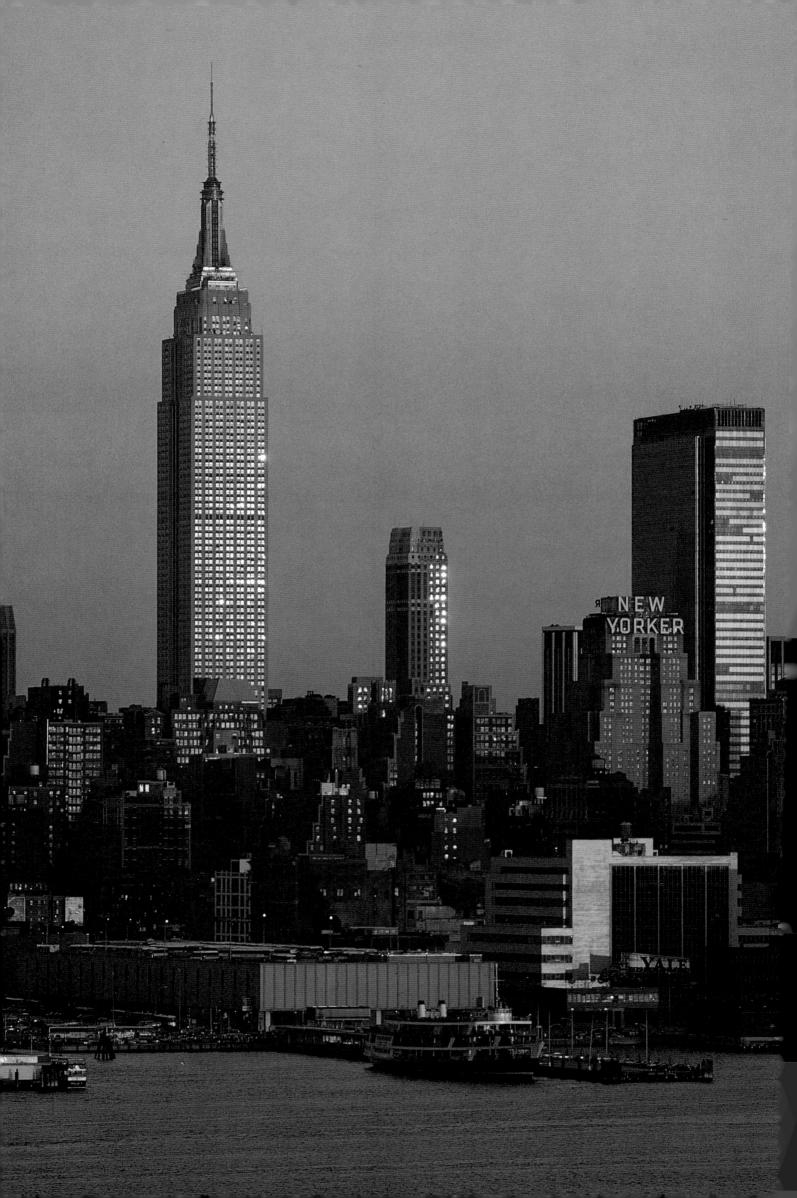

SO NOW WE COME TO NEW YORK CITY, THE INCOMPARABLE, THE brilliant star city of cities, the forty-ninth state, a law unto itself, the Cyclopean paradox, the inferno with no out-of-bounds, the supreme expression of both the miseries and the splendors of contemporary civilization, the Macedonia of the United States. It meets the most severe test that may be applied to definition of a metropolis – it stays up all night. But also it becomes a small town when it rains.

JOHN GUNTHER

Inside U.S.A., 1947

Midtown Manhattan and the Empire State Building.

NEW YORK WAS THE EASTERN TERMINUS OF OUR TRANSCONTINENTAL flight. At first, one saw a distant off-colored patch of earth with the North Atlantic sweeping endlessly beyond. Then the scene hardened into streets and buildings and wharfs as we approached and descended ... New York, symbolizing power, always brought my mind an intuition into conflict. When I first flew eastward to the city in my Spirit of St. Louis in 1927, I had experienced both repulsion and fascination. I was repulsed by its bigness, luxury, and artificial life, fascinated by the stupendous forces it commanded and by its influence in the material accomplishments of man.

CHARLES LINDBERGH

Autobiography of Values, 1976

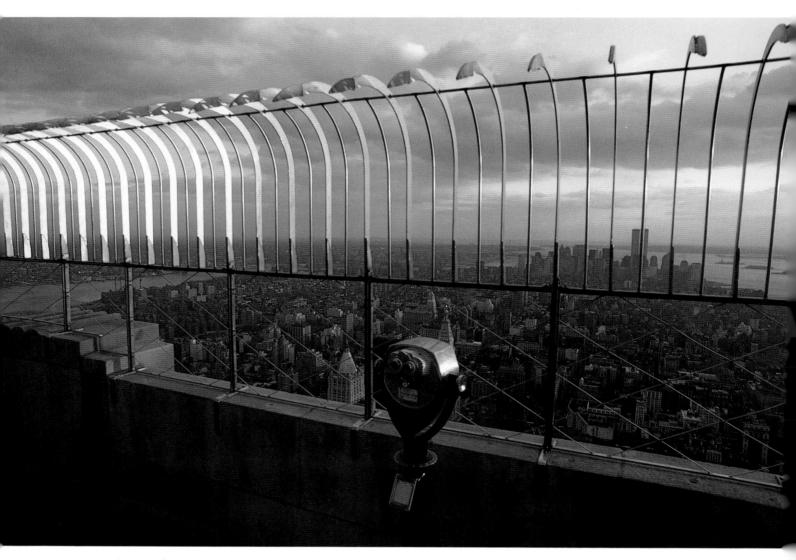

Above: View from the Empire State Building. Opposite: Empire State Building. Overleaf and second overleaf: West Side waterfront.

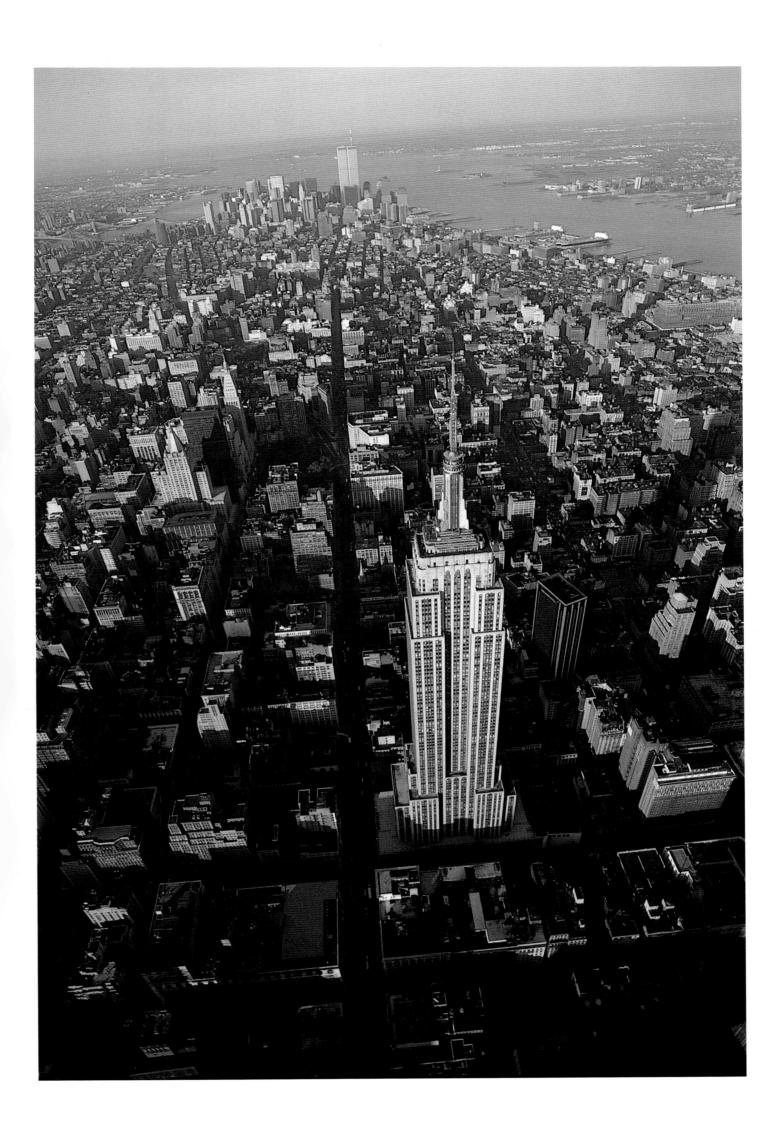

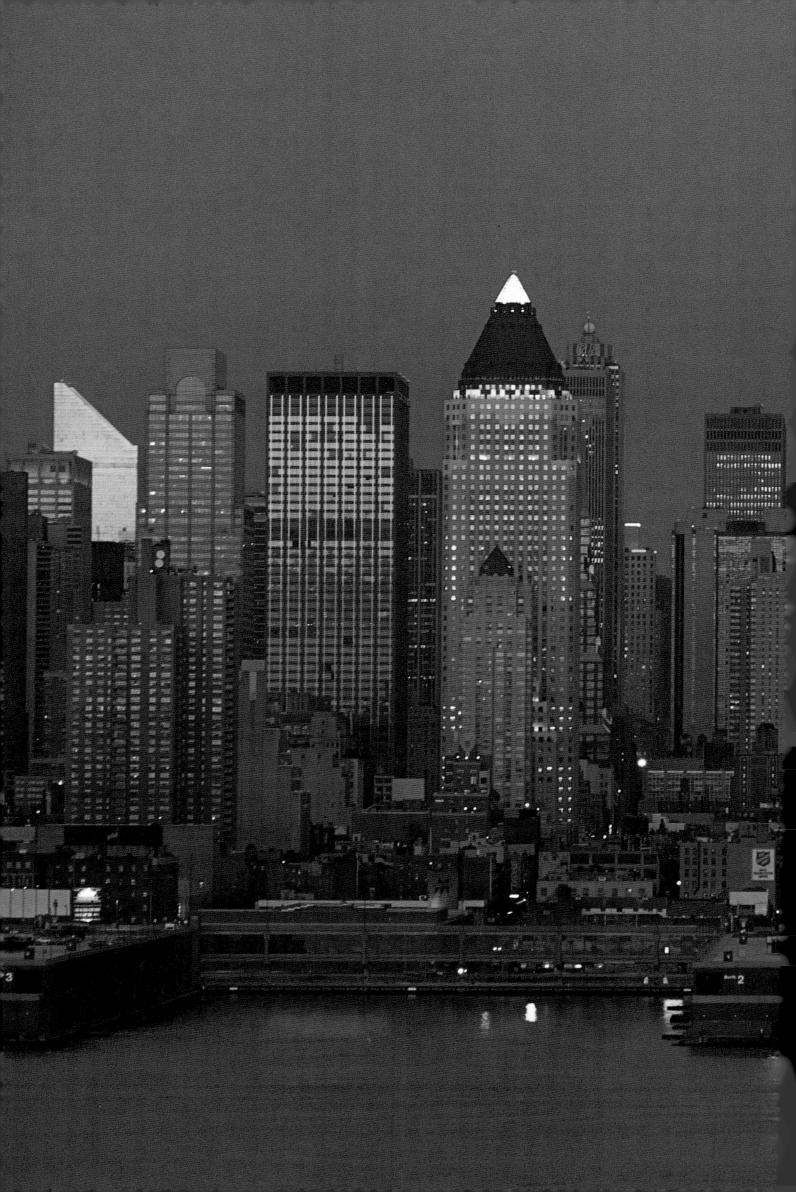

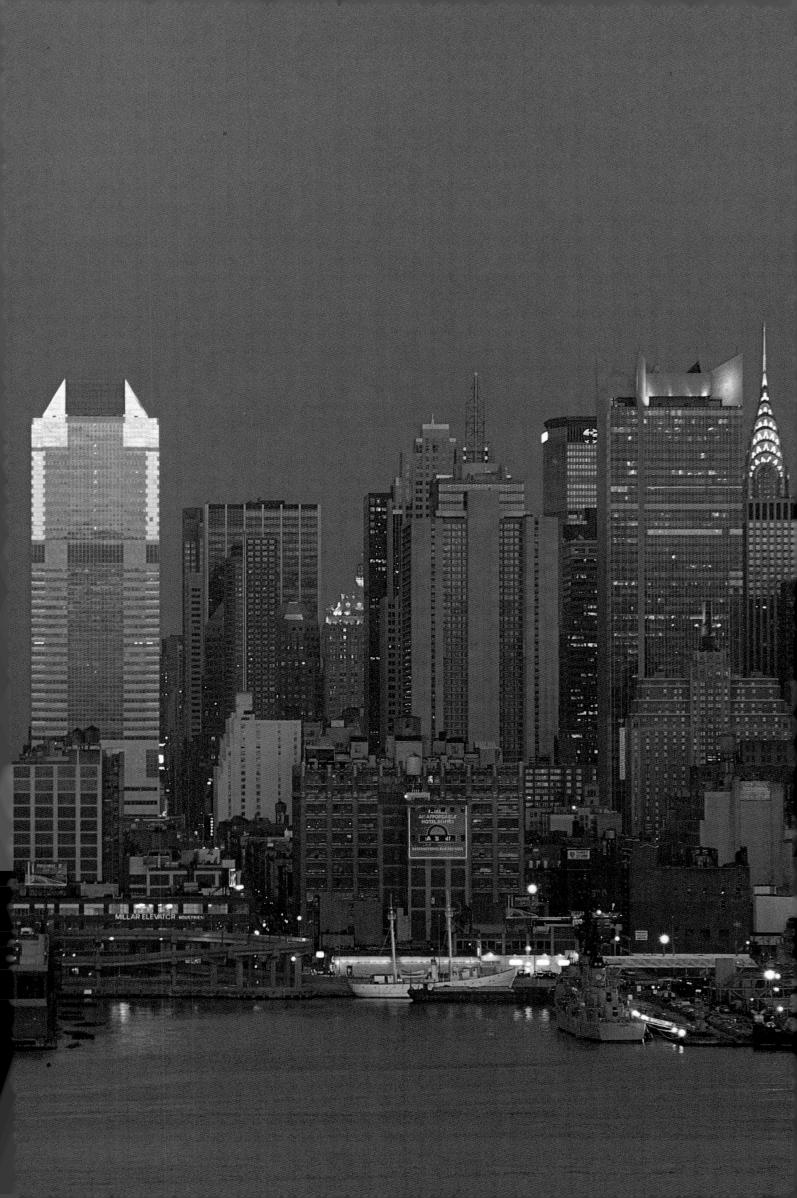

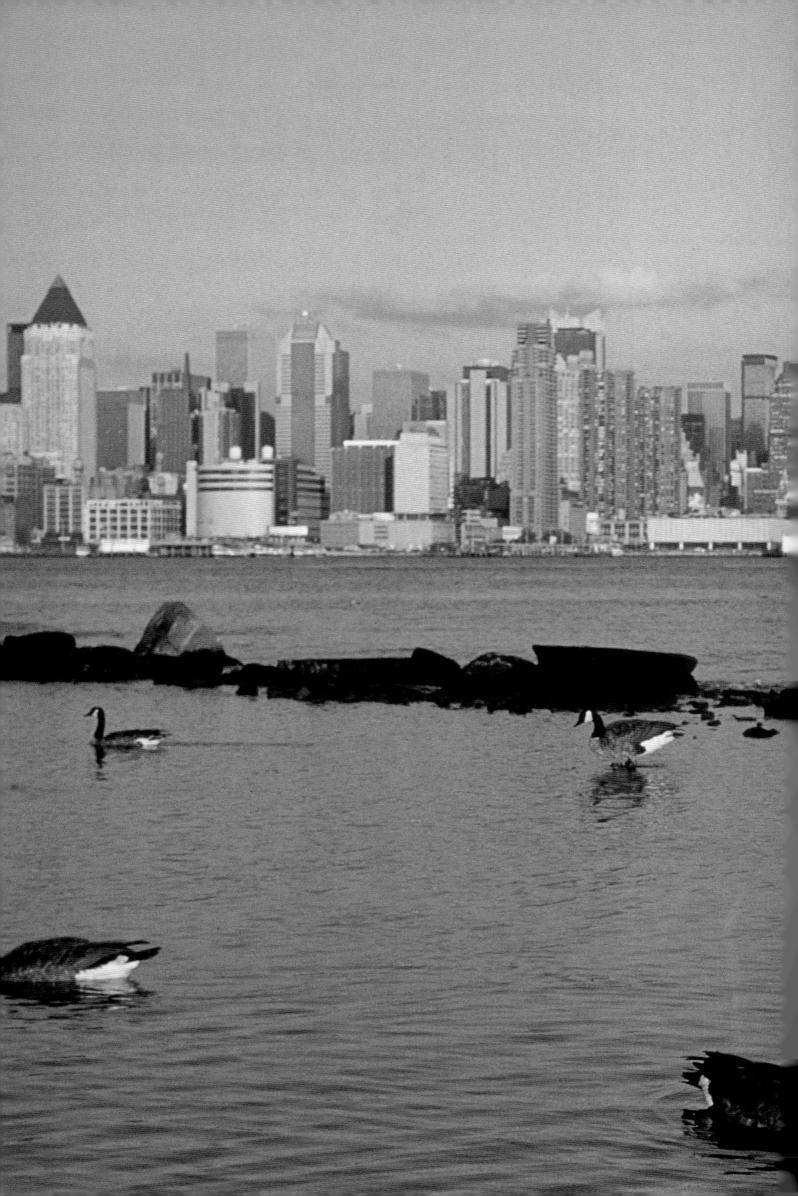

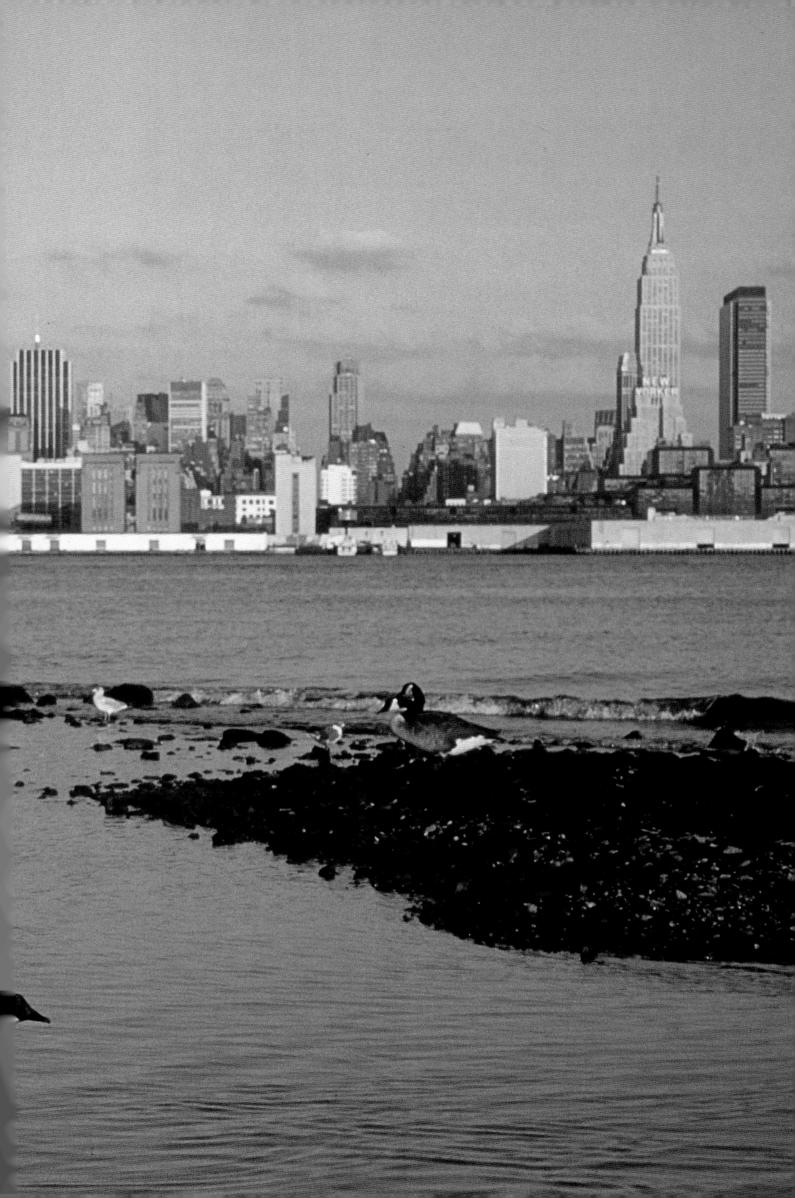

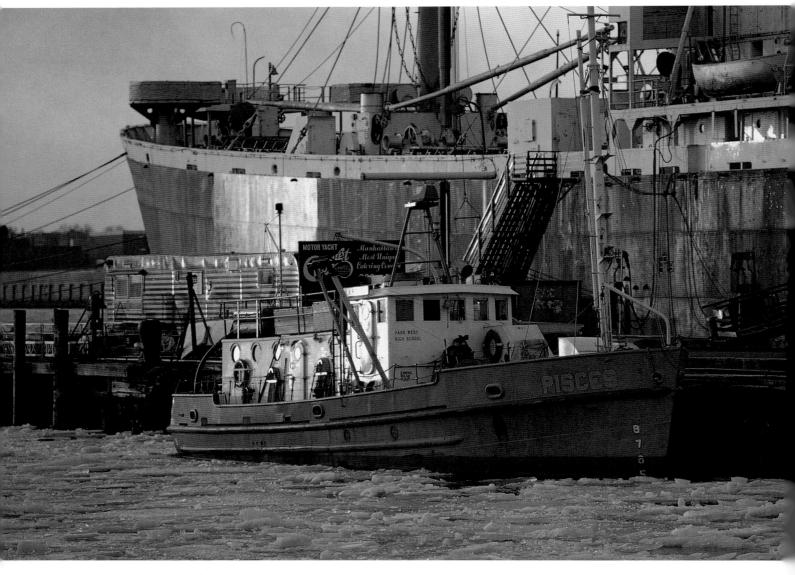

Boats docked along the Hudson.

Above: Manhattan from the west. Overleaf: Sihouetted skyscrapers.

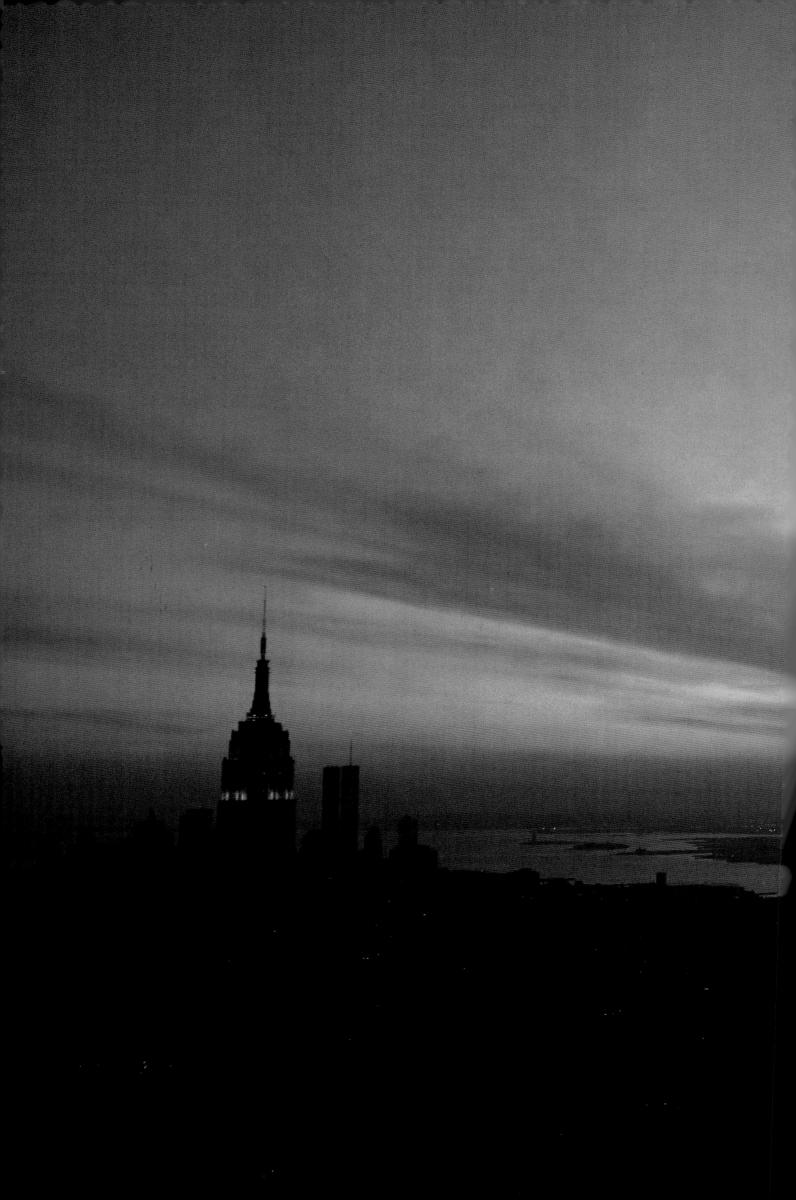

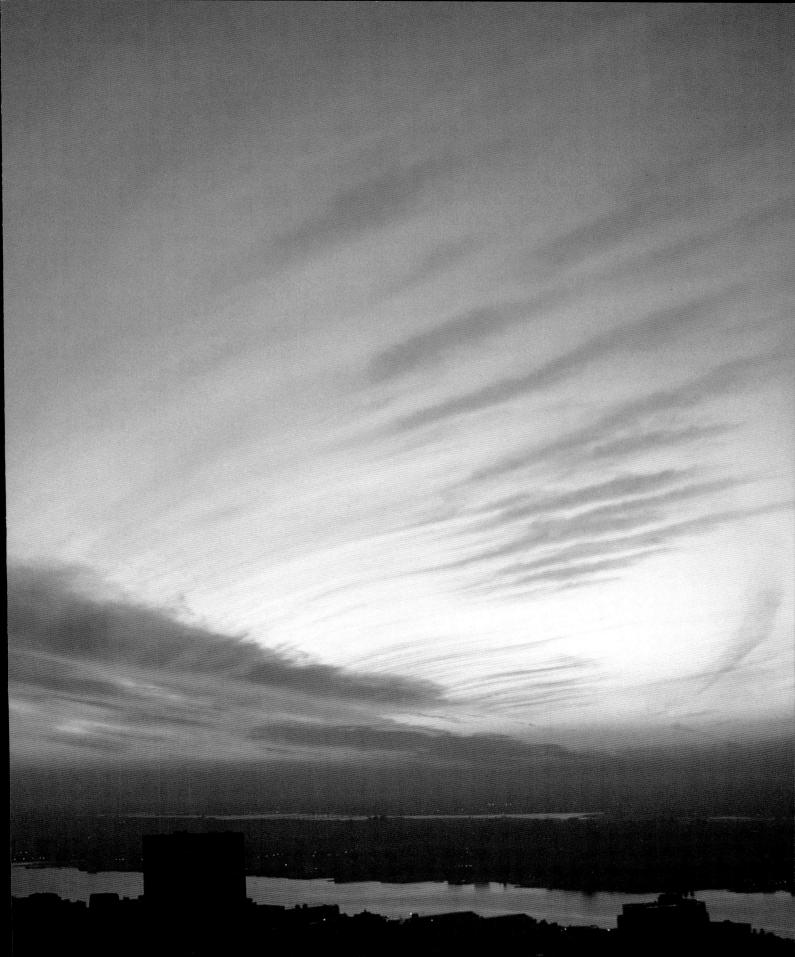

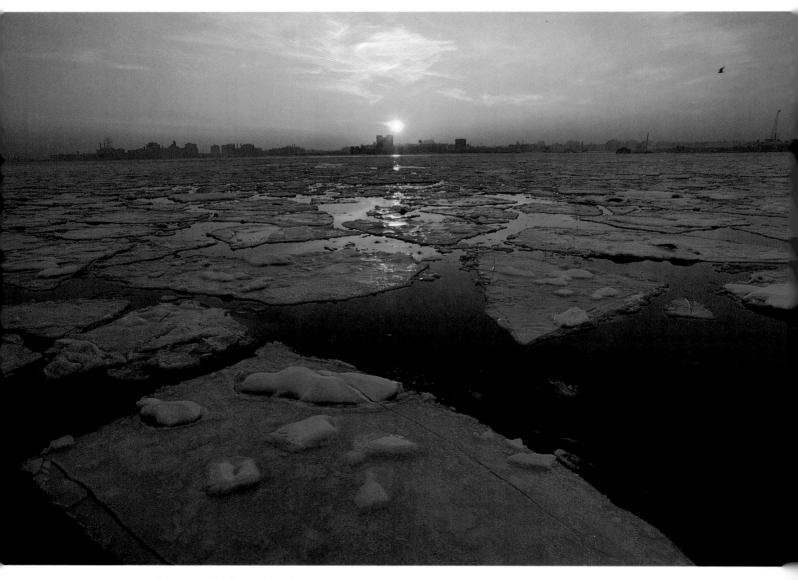

Above and opposite: Ice breaking on the Hudson.

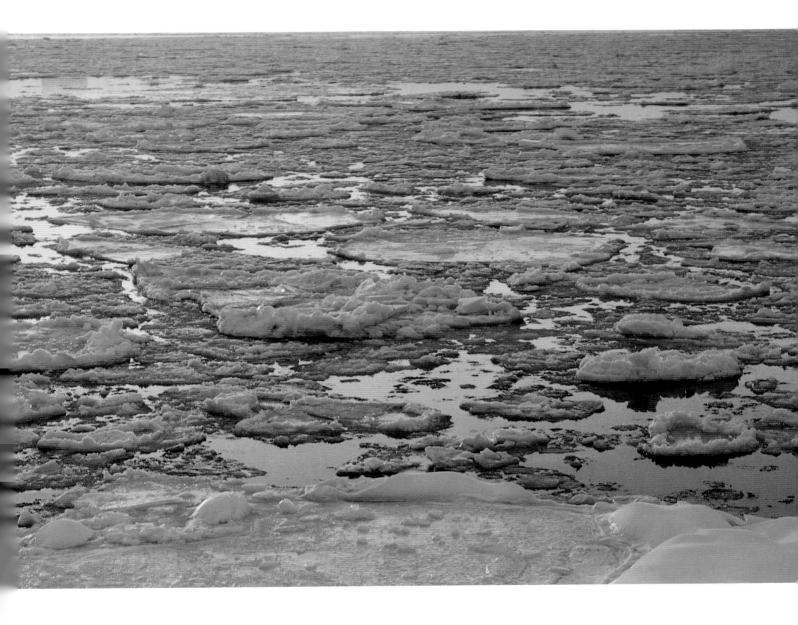

THE LINER STEAMS THROUGH THE NARROWS (THE NORMANDIE, QUEEN Mary, Bremen; the dozen greatest ships of the world, sailing from Liverpool, Southampton, Hamburg, Rotterdam, Havre, Genoa, head for that narrow strip of water and steam dexterously through it, turn precisely toward the slender island toward the north). Out of an early morning fog come brooding, ghostly calls. A dark blotch appears, takes from – *an anchored tramp: coffee from Brazil, rubber from Sumatra, bananas from Costa Rica* – and slowly disappears; another liner is suddenly moving alongside, also steaming northward, and then dissolves into the white nothing. Invisible ferries scuttle, tooting, across the harbor.

WPA FEDERAL WRITERS PROJECT

New York City Guide, 1930s

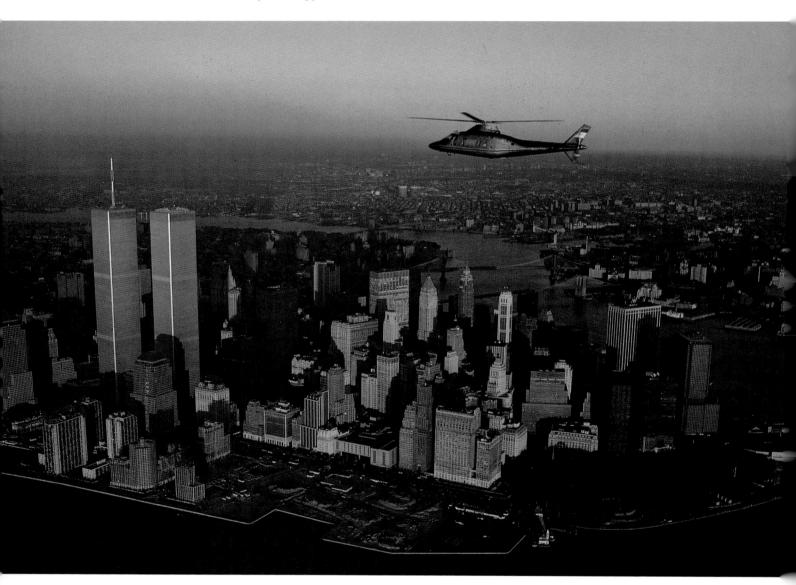

Lower Manhattan's financial district.

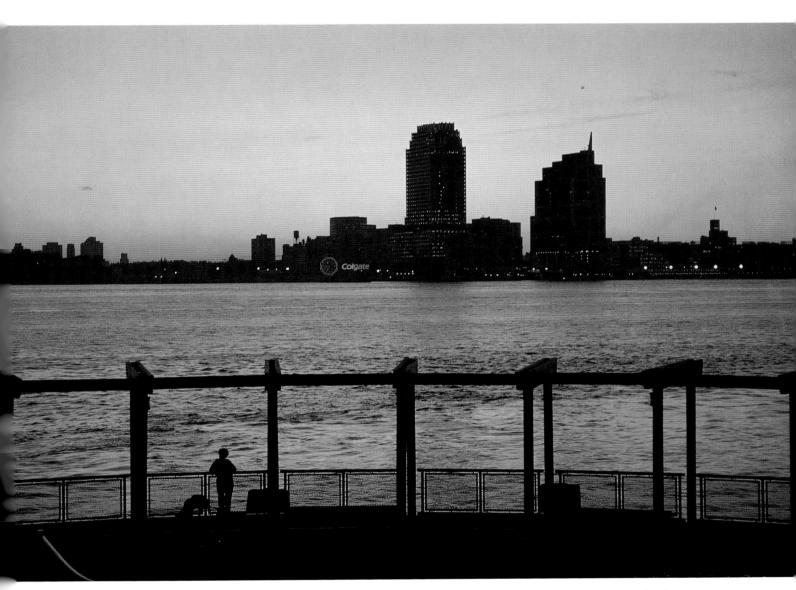

New Jersey shoreline.

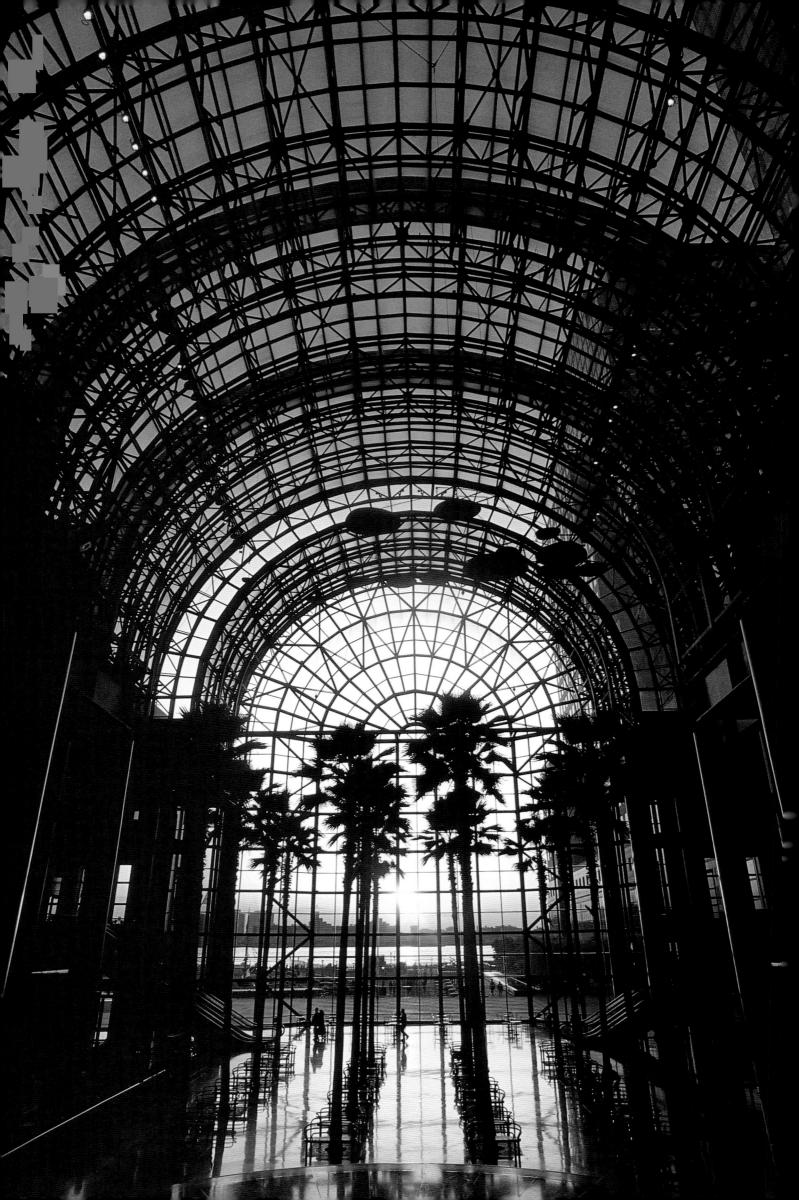

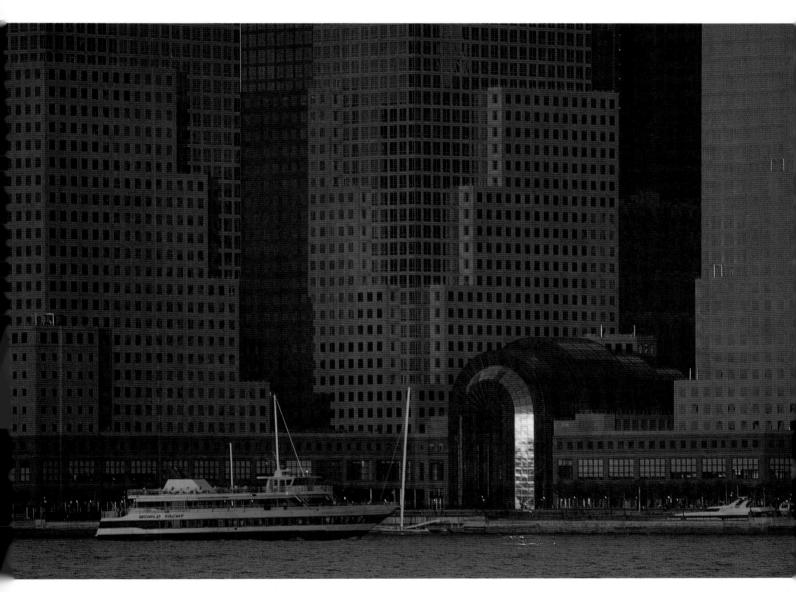

Above and opposite: Battery Park City.

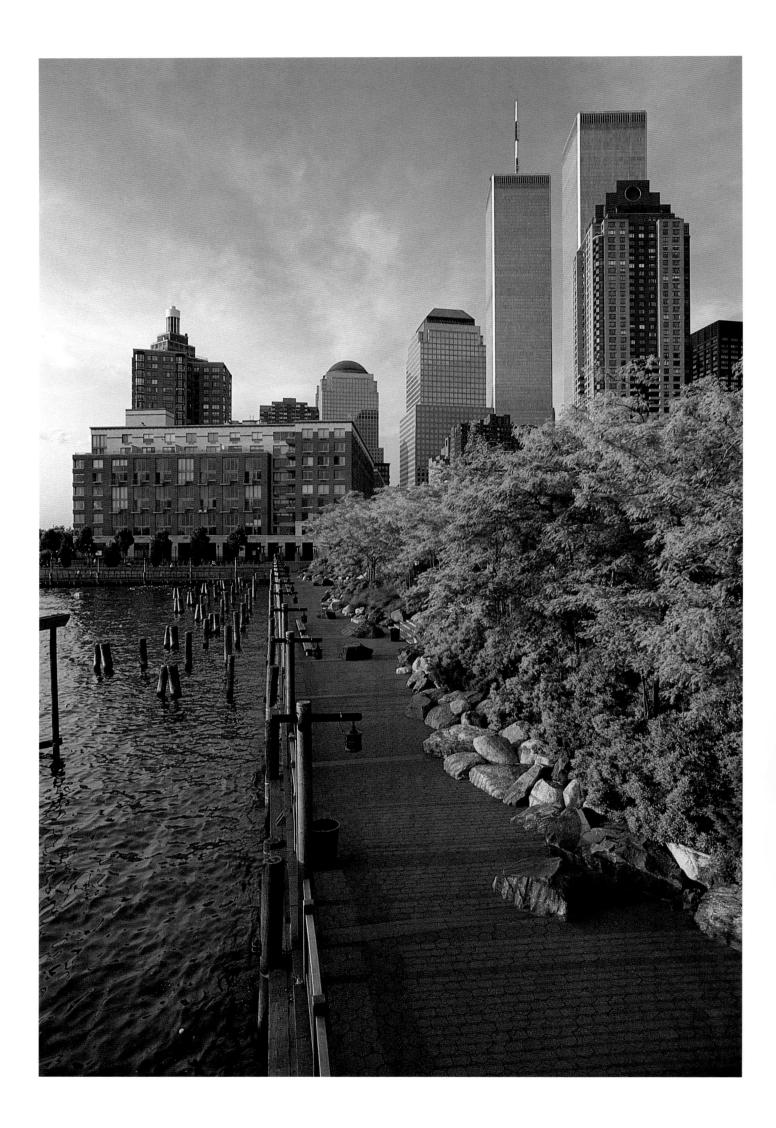

THE BEAUTIFUL METROPOLIS OF AMERICA IS BY NO MEANS SO CLEAN A CITY as Boston, but many of its streets have the same characteristics; except that the houses are not quite so fresh-coloured, the sign-boards are not quite so gaudy, and the gilded letters not quite so golden, the bricks not quite so red, the stone not quite so white, the blinds and area railings not quite so green, the knobs and plates upon the street doors, not quite so bright and twinkling. There are many bye-streets, almost as neutral in clean colours, and positive in dirty ones, as bye-streets in London; and there is one quarter, commonly called the Five Points, which, in respect of filth and wretchedness, may be safely backed against Seven Dials, or any other part of famed St. Giles's.

CHARLES DICKENS

American Notes, for General Circulation, 1842

Opposite: World Financial Center. Overleaf: The World Trade Center through the fog. Second overleaf: Manhattan's southern skyline.

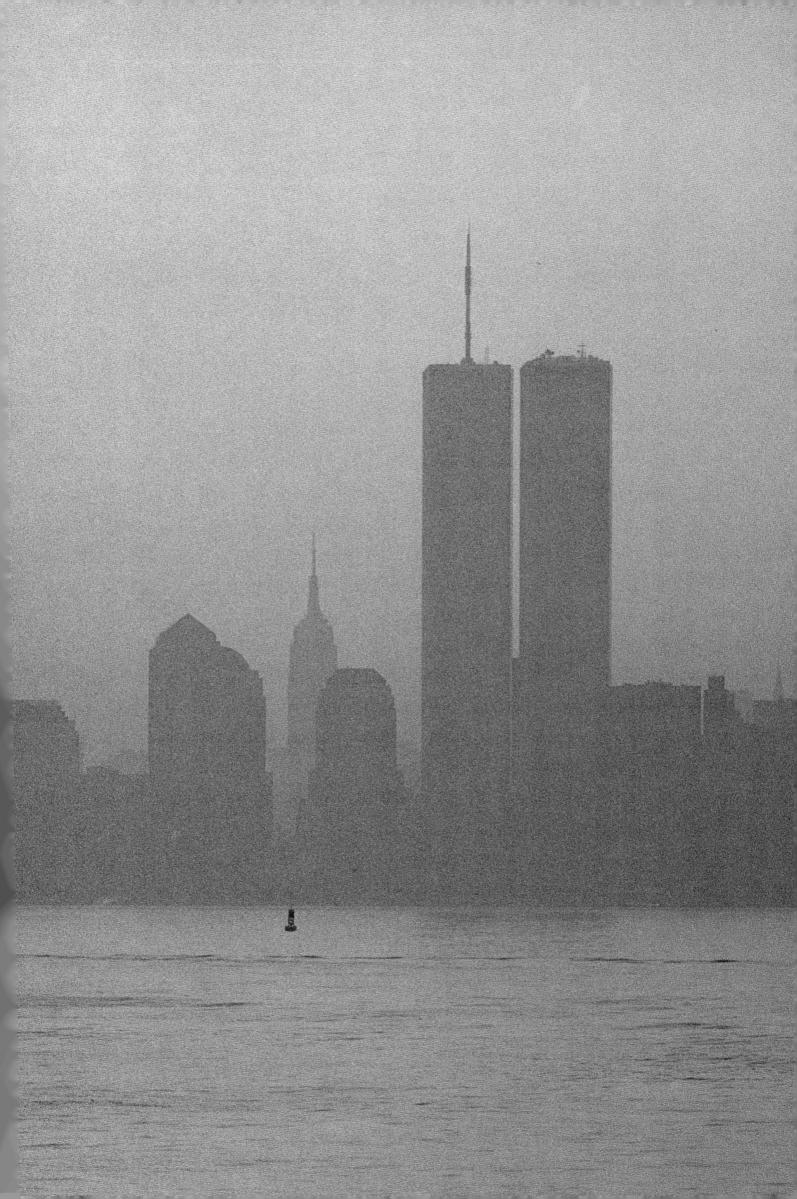

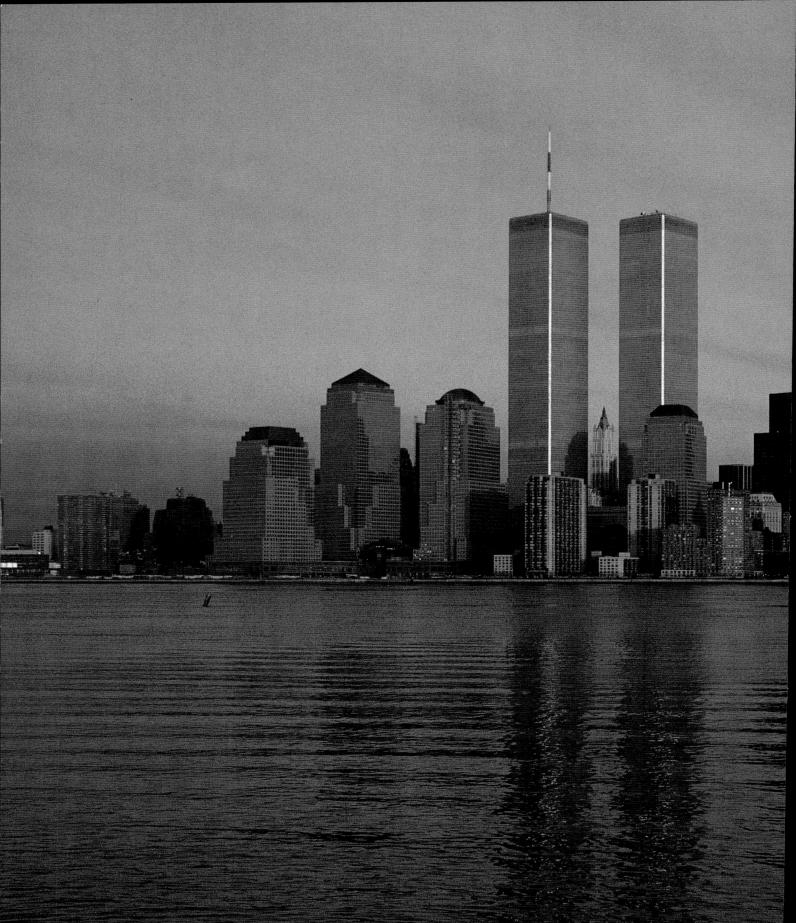

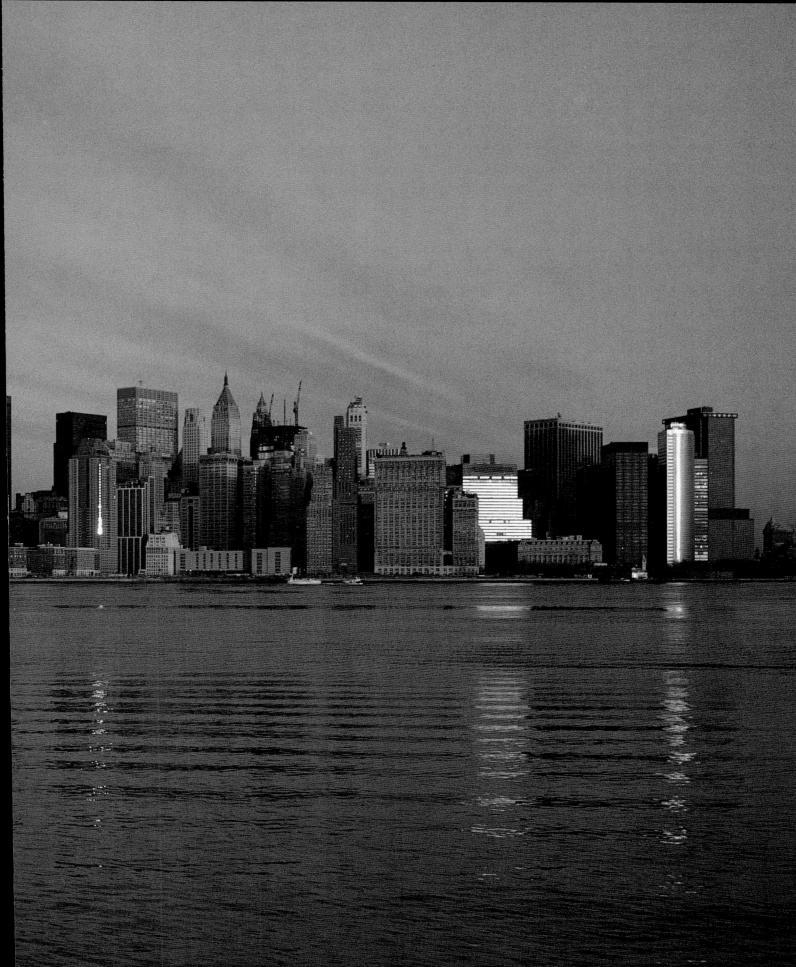

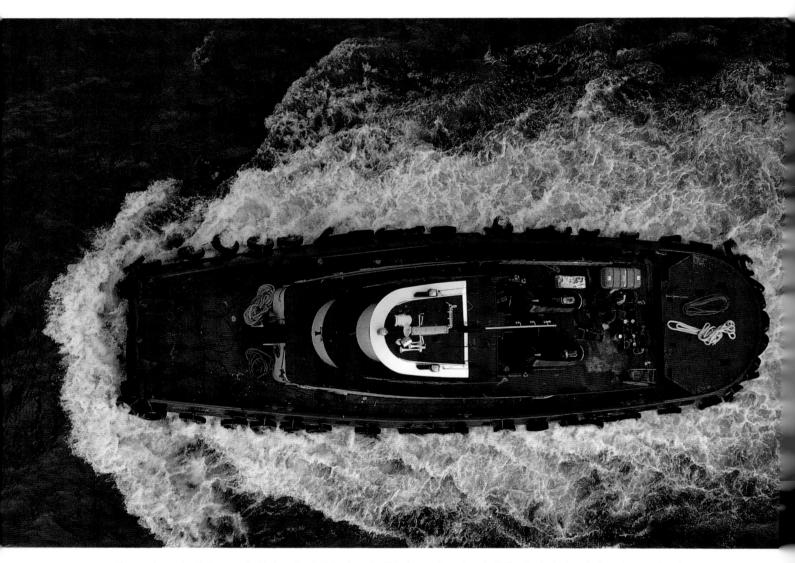

Above and opposite: Tugboats on the Hudson. Overleaf: Southern tip of Manhattan. Second overleaf: Ellis Island. Third overleaf: Manhattan's shorefront.

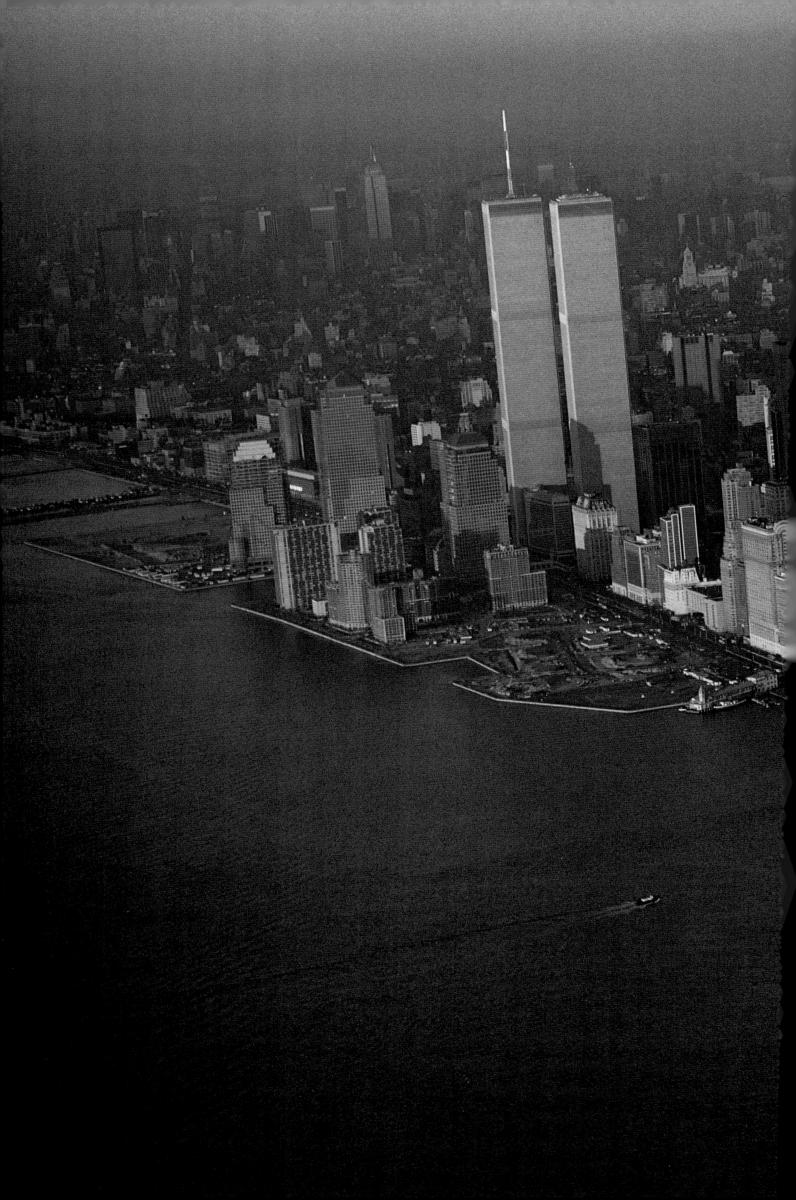

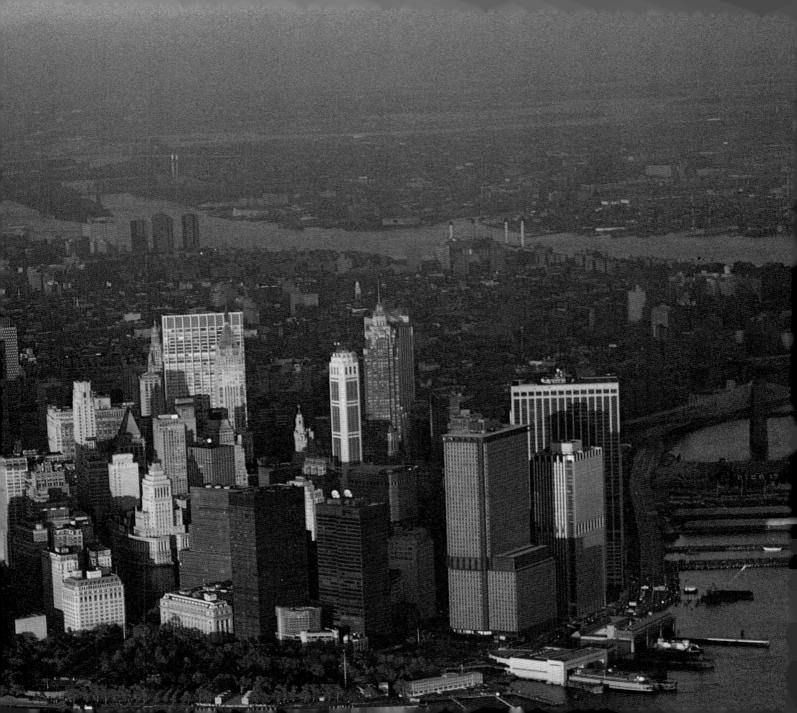

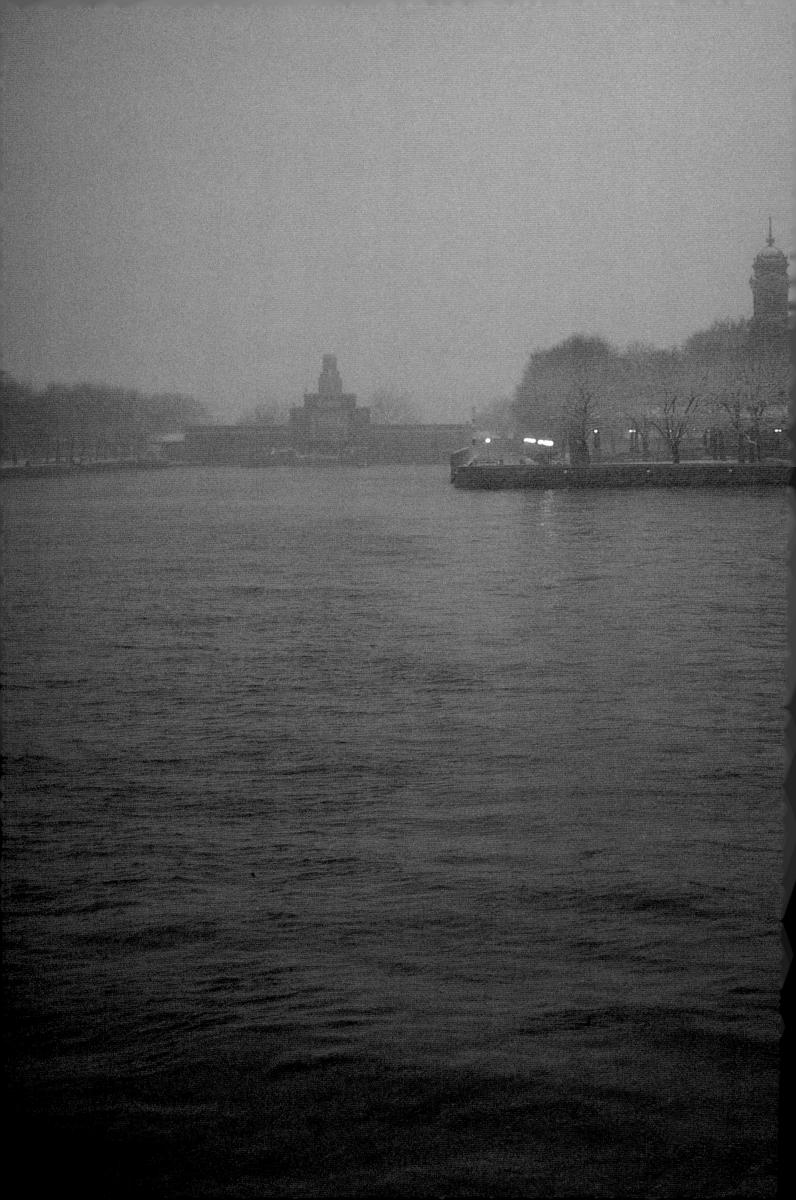

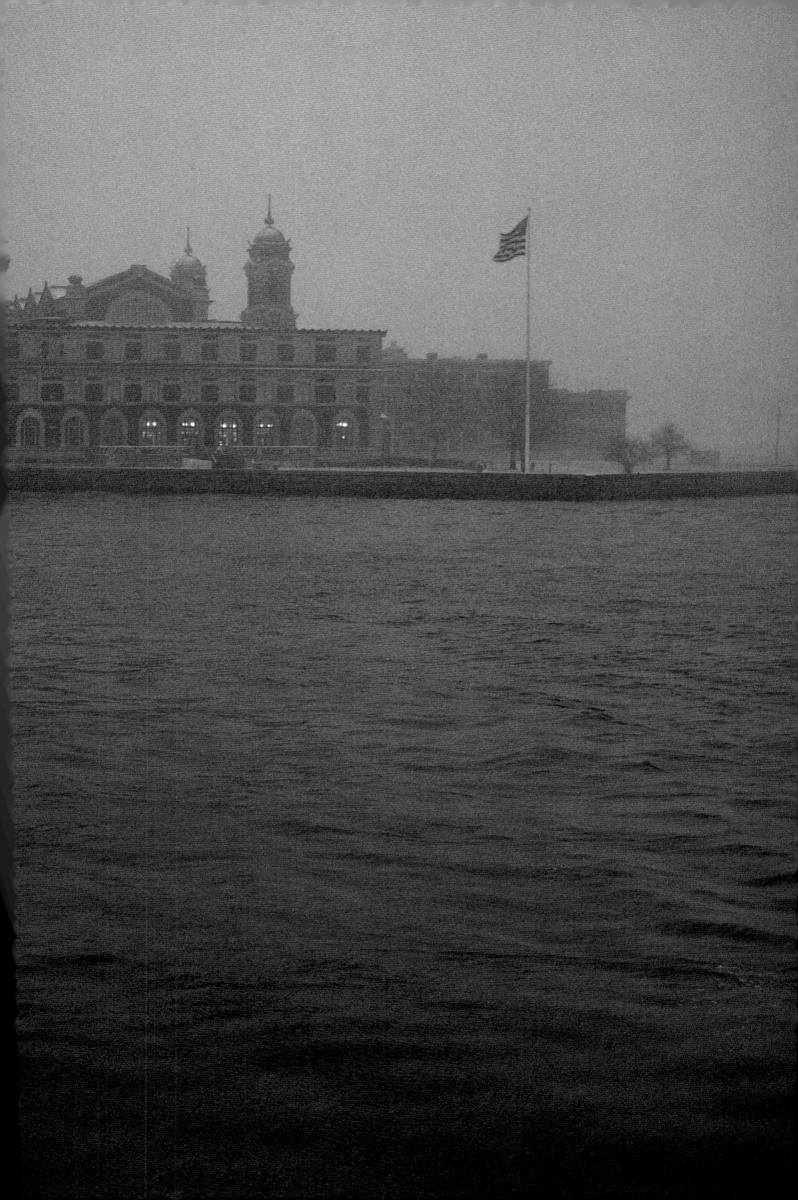

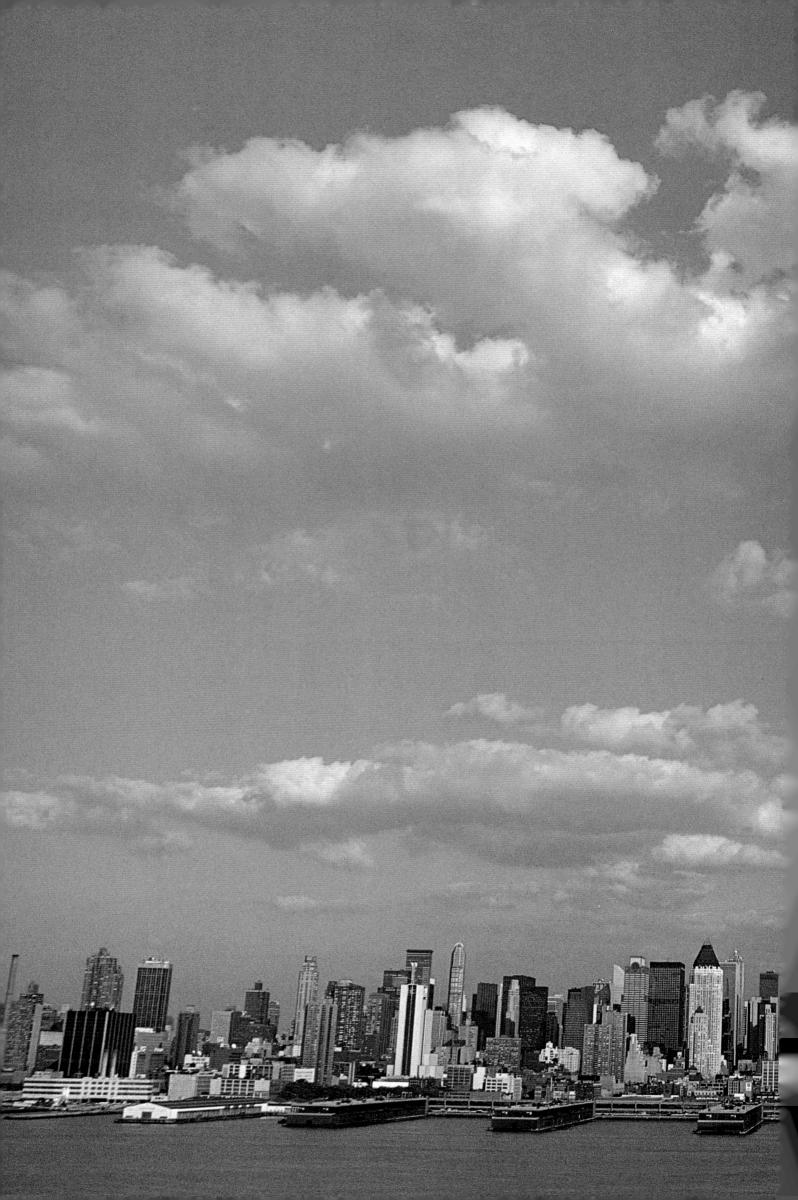

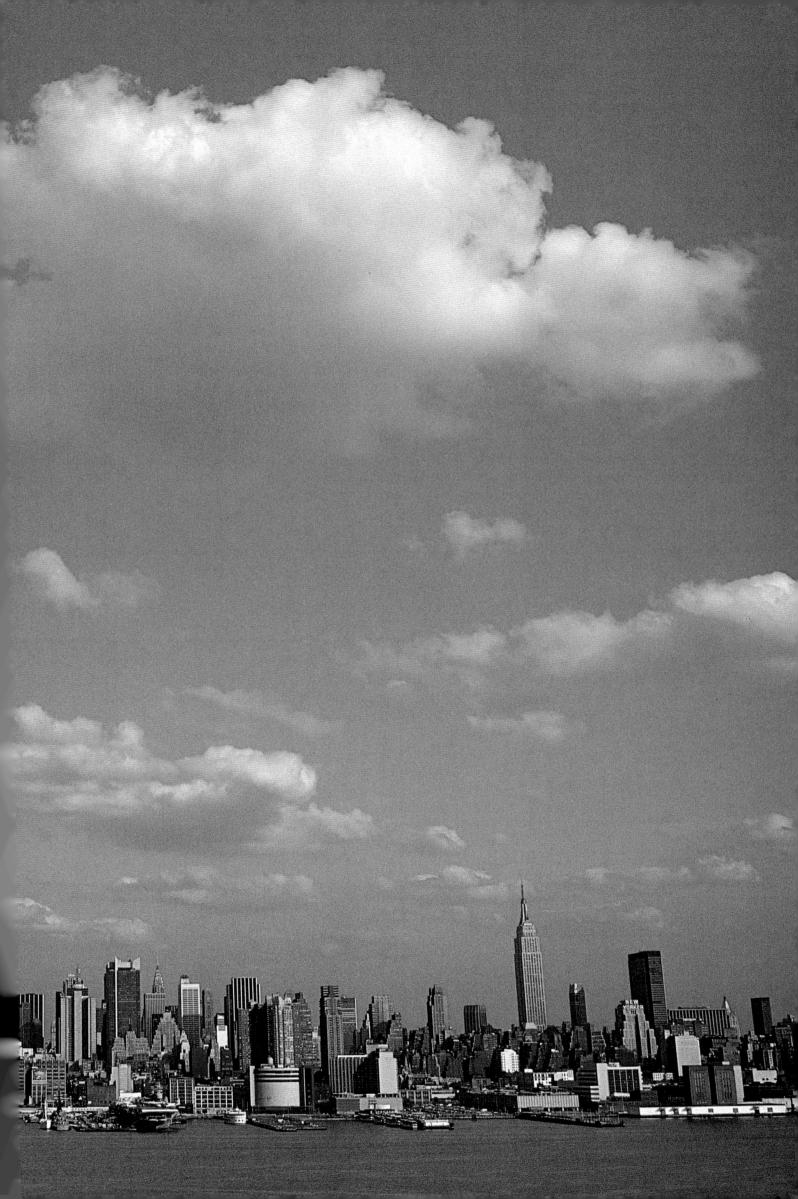

Where in its old historic splendor stands

The home of England's far-famed Parliament,

And waters of the Thames in calm content

At England's fame flow slowly o'er their sands;

And where the Rhine past vine-entwinëd lands

Courses in castled beauty, there I went;

And far to Southern rivers, flower-besprent;

And to the icy streams of Northern strands.

Then mine own native shores I trod once more,

And, gazing on thy waters' majesty,

The memory, O Hudson, came to me

Of one who went to seek the wide world o'er

For Love, but found it not. Then home turned he

And saw his mother waiting at the door.

GEORGE SIDNEY HELLMAN

The Hudson

Statue of Liberty.

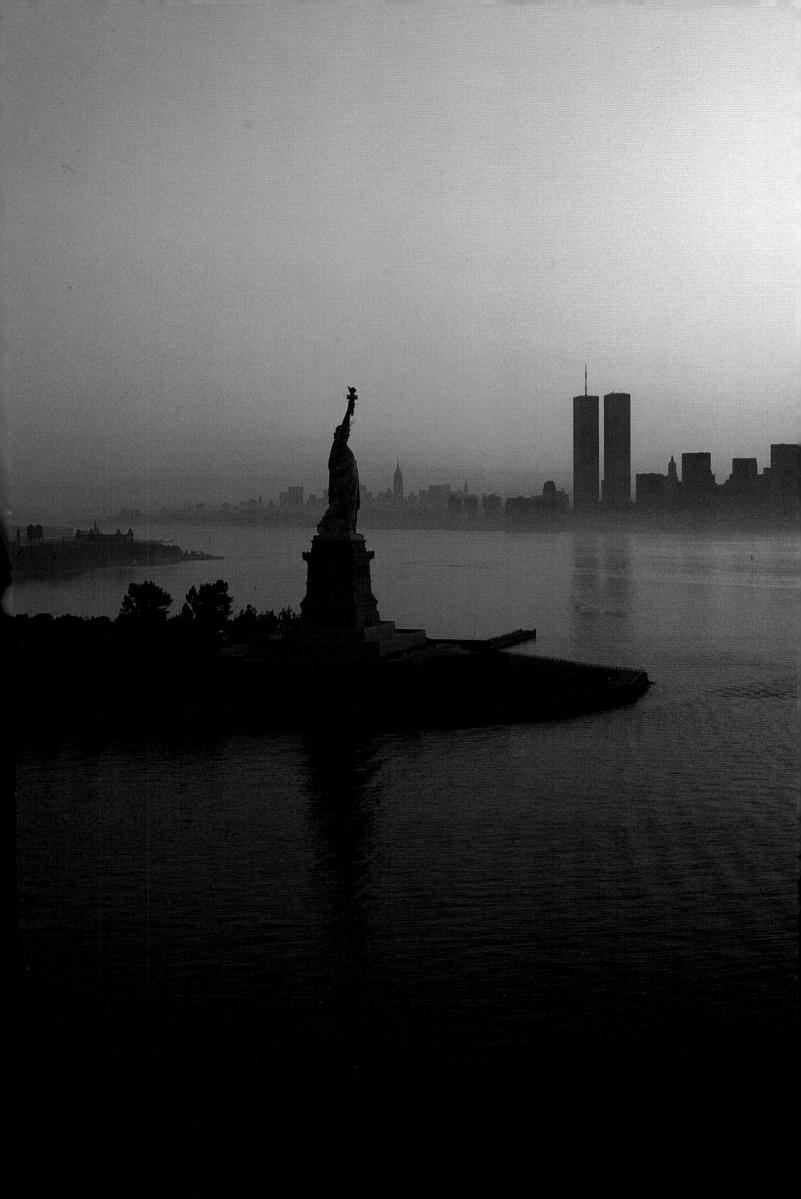

AFTERWORD

ARTHUR G. ADAMS

Early writers on the Hudson River were greatly concerned with aesthetic principles and theories of the sublime, and the picturesque. The artists, architects, and landscapers of the Hudson River School gave great emphasis to these qualities. The photographs of Jake Rajs emphasize another aspect of the Hudson Valley – pure beauty. His pictures, whether a grand panorama from a mountaintop or a breathtaking aerial view over the metropolis, a simple flower or a river-rafting group, bring out the innate beauty in the object and the atmosphere. Truly he is working in the tradition of the luminists. Compiling an anthology of Hudson River writings to complement Jake's pictures has also reopened my own eyes to the many aspects of beauty in the Hudson Valley. In these days of ecological concern, we too often forget the great beauty that still surrounds us. Too often we are blind to the familiar.

I have also revisited vast quantities of literature about the Hudson River with which I have long been very familiar – or so I thought until searching for harmonious correspondences between text and pictures. I have not followed any rigid plan in this selection, sometimes choosing a poem, a work of fiction, a traveler's account or history, or art or architectural criticism. I would like to make the reader-viewer as appreciative of the unique qualities of this beautiful region as I have become over the years. Indeed, working on this book became a sentimental journey, bringing back many years of exploration of the region on foot, by automobile, by rail, and by water – over old dirt roads and abandoned rail lines, up obscure canals and creeks.

My family was active for generations in Hudson River steamboating and railroading with the Delaware & Hudson Company and the Hudson Navigation Co. An interest in steamboats and railroads and canals, the local industries they served, and their history came early in my life, and I was fortunate to travel with my father throughout the region starting at an early age. When I obtained a driver's license in the mid-1950s, one of the

first things I did was obtain detailed government maps of the entire region between the Berkshires of New England and the Susquehanna River, and from the Adirondacks to the sea. I set out to travel every road, railway, and waterway in the region, including NewYork City and the metropolitan area. Since I have been in the sales business here for many years, I have come close to completing this ambitious plan. I have also become an active trail hiker, cartographer, and writer of hiking guidebooks, and so I have learned the old and new trails of the Palisades, Highlands, Shawangunks, and Catskills, and their many hidden beauties. And I have always been an avid reader of history. This is without a doubt the most fascinating region of the United States in terms of local military, political, commercial, social, and artistic history. Anyone who lives in this rich region is fortunate.

I became active quite early in scenic preservation work and environmental advocacy with many local organizations. In the 1980s I served as the founding president of the Hudson River Maritime Museum at Kingston, and brought together their first board of directors from among such well-known Hudson River families as the Livingstons, Reeses, Smileys, Keppels, Olcotts, and Chanlers. I met the descendants of the founders of the great Hudson River manors and houses – and visited the houses themselves. In writing guidebooks I have come to know many lesser-known families with equally deep roots in the valley, unique local characters, and mighty contemporary historians.

I envy Jake his youth and his own opportunity to have come to know the Hudson. I learned the river from the decks of a sidewheel steamboat, from hours spent learning to be a river pilot; Jake has become similarly acquainted with the roads, hills, mountains, streams, trails, and above all, the beauty and interest of the Hudson. I sincerely hope he will continue to bring his "eye for beauty" to many more locations in the region.

Finally, while we have artisans, artists, citizen groups, and individuals working to protect the river from pollution and other harm, much remains to be done to preserve our beautiful homeland. We must continue to clean the river and to protect wildlife. We must control urban sprawl and litter. We must maintain and groom hiking trails and parks. We must restore and protect historic buildings and maintain our lighthouses. We must preserve our cultural and technological heritage in libraries and museums. We must bring day-passenger steamers back to the river and judiciously restore and expand railway networks.

The work is endless; the rewards are infinite. I hope that visiting the HudsonValley through this book will inspire you to join in the unending great work.

268

POSTSCRIPT

JAKE RAJS

The health of the eye seems to demand a horizon. We are never tired, so long as we can see far enough. RALPH WALDO EMERSON, 1836

A photographic book is a visual story, a record of how far the eye can see. This book captures, I hope, the farthest reaches of my vision throughout the Hudson region. The river was a subject of my early photography, and the photographs in this book were taken over more than fifteen years. The beauty of the river forced me to explore it, as it had, I like to think, Henry Hudson, the Hudson River school of artists, and those who wrote of it so eloquently (and whose writings are excerpted throughout this book).

I discovered the Hudson as an eight-year-old, when I arrived in New York Harbor after a two-week voyage from Israel. Since then, I've lived in Manhattan, Brooklyn, New Jersey, and the Catskills. As I grew older my interest in and knowledge of the river increased. My boyhood friends and I discovered nature there; we explored its wild banks and watched spectacular sunsets. Crossing the river into the "big city" was an important ritual for a young photographer: it represented a journey to the center of the creative world. I've hiked many of the peaks of the Highlands and the region's mountain ranges; in the last five years I've made two treks to the very source of the river, Lake Tear of the Clouds in Adirondack Park. My first camping trip was in the Catskill Mountains; lying beside a lake and looking up to the millions of stars – the first time I saw them free of the city's light pollution – I felt the joy that comes from nature, and which I have always tried to keep at the forefront of my photography.

Today, this joy is the prize in the battle between the preservationists and the developers, fortunately for the most part won by the former. Yet the challenge – to create responsible, controlled development that threatens neither natural beauty or human community – still remains. I hope these photographs inspire others as the Hudson inspired me, so that the natural beauty of the land will be enhanced and preserved for future generations.

Many thanks to all the wonderful people throughout the Hudson Valley who helped with this book. Without their assistance and friendship, this book would not have been possible.

Anne, Chloe, and Olivia Rajs, Frances Wagner, the Millar family, Mark Speed, Jimmy Winstead, Grant Parrish, Tim and Sandy Hinkley, Jules Solo, Kevin McShane, Gianfranco Monacelli, Steve Sears, Andrea Monfried, Michael Rock, Susan Sellers, Pete Burns, Clearwater, Hudson River Keeper, Osborn Castle, Boscobel, United States Military Academy, West Point, Everett Nack, Belmar Vineyards, the apple growers in Hudson, and Historic Hudson Valley. Every effort has been made to secure the reprint rights to the excerpts reproduced in this book. Since some of the passages were not traceable, the publisher would be grateful to receive information from any copyright holder not credited herein. Omissions will be corrected in subsequent editions.

- 51 Cecil R. Roseberry, From Niagara to Montauk: The Scenic Pleasures of New York (Albany: State University of New York Press, 1982).
- 63 Edna Ferber, Saratoga Trunk (Garden City, N.Y.: Doubleday, Doran & Company, Inc., 1941).
- 92 From John K. Howat, American Paradise: The World of the Hudson River School. Copyright © 1987 The Metropolitan Museum of Art. Reprinted with permission.
- 99 Cynthia Owen Philip, Robert Fulton: A Biography (Franklin Watts, 1985).
- 113 Robert P. McIntosh, "The Forest Cover of the Catskill Mountain Region, New York, As Indicated by Land Survey Records," *The American Midland Naturalist* 69, no. 2 (October 1962).
- 148 Carole Decker, Ulster County Tercentennial 1683-1983 (Kingston: County of Ulster, 1983).
- 162 Charles S. Bannerman, The Story of Bannerman Island (Francis Bannerman Sons, Inc., 1962, 1973).
- 171 John Beardsley, A Landscape for Modern Sculpture (New York: Abbeville Press, 1985).
- 189 *The New York Walk Book,* New York–New Jersey Trail Conference (Garden City, N.Y.: Doubleday/Natural History Press, 1971).
- 201 "Lyndhurst: A Property of the National Trust for Historic Preservation," Historic Preservation 17, no. 2 (1965).
- 202 Clay Lancaster, "The Architecture of Sunnyside," *The American Collector: The Monthly Magazine of Art and Antiques* 16, no. 9 (1947).
- 207 Christopher Morley, "The Anatomy of Manhattan," *Pipefuls*, 1921, reprinted in *Christopher Morley's New York* (New York: Fordham University Press, 1988), reprinted by permission.
- 216 Raymond J. O'Brien, American Sublime: Landscape and Scenery of the Lower Hudson Valley (New York: Columbia University Press, 1981).
- 225 Excerpt from *The Little Red Lighthouse and the Great Gray Bridge* by Hildegarde H. Swift and Lynd Ward, copyright 1942 Harcourt Brace & Company and renewed 1970 by Hildegarde H. Swift and Lync Ward, reprinted by permission of the publisher.
- 229 Robert A. Caro, The Power Broker: Robert Moses and the Fall of New York (New York: Alfred A. Knopf, Inc., 1974).
- 233 John Gunther, Inside U.S.A. (Harper & Brothers, 1947).
- 234 Excerpt from *Autobiography of Values* by Charles A. Lindbergh, copyright © 1978 Harcourt Brace & Company and Anne Morrow Lindbergh, reprinted by permission of the publisher.

N. N. K.